Faces *of the* Frontier

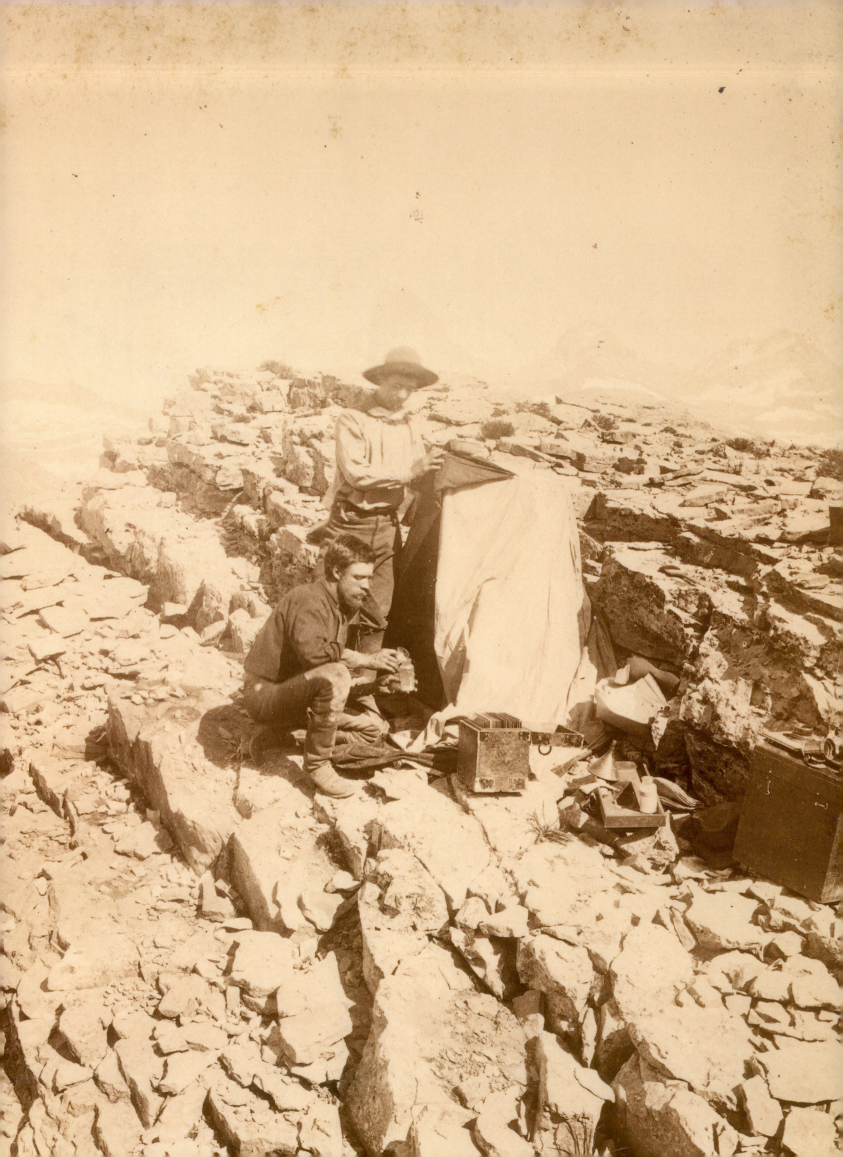

Faces *of the* Frontier

Photographic Portraits from the American West, 1845–1924

FRANK H. GOODYEAR III

With an Essay by
RICHARD WHITE

and Contributions by
MAYA E. FOO *and* AMY L. BASKETTE

University of Oklahoma Press : Norman

In Cooperation with the
National Portrait Gallery, Smithsonian Institution, Washington, D.C.

Library of Congress Cataloging-in-Publication Data

Goodyear, Frank Henry, 1967–
 Faces of the frontier : photographic portraits from the American West,
1845-1924 / Frank H. Goodyear III.
 p. cm.
 Includes bibliographical references and index.
 ISBN 978-0-8061-4082-7 (hardcover : alk. paper)
 1. West (U.S.)—Biography—Pictorial works. 2. Portrait
photography—West (U.S.)—History—19th century. 3. Portrait
photography—West (U.S.)—History—20th century. 4. West (U.S.)—Social
life and customs—Pictorial works. 5. West (U.S.)—In art—History. I. Title.
 F596.G684 2009
 978'.020222—dc22
 2009011858

The paper in this book meets the guidelines for permanence and durability of the Committee
on Production Guidelines for Book Longevity of the Council on Library Resources, Inc. ∞

1 2 3 4 5 6 7 8 9 10

Contents

Acknowledgments

DURING THE RESEARCH AND DEVELOPMENT of this exhibition, I benefited from the generous assistance and support of a number of people.

Let me first thank Richard White for contributing his essay to this catalogue. His scholarship on the history of the American West has long been at the center of the field, and I appreciate his involvement in this project.

At the National Portrait Gallery, I am fortunate to work with many outstanding individuals. For their help in the creation of this catalogue, I want to thank Amy Baskette, Dru Dowdy, Rosemary Fallon, Lizanne Garrett, Mark Gulezian, Ann Shumard, and Kristin Smith. Research assistants Sarah Campbell and Maya Foo and departmental volunteers Melissa Burnett, Elizabeth Ann Hylton, and Christopher Saks also made valuable contributions.

Other colleagues at the Smithsonian shared their expertise with me, including Paula Fleming, Toby Jurovics, Joanna Scherer, William Stapp, and William Truettner. I appreciate their kind advice and insights. In addition, a generous grant from the Smithsonian Women's Committee enabled the Portrait Gallery to construct a wooden-box stereoscope, thereby permitting visitors to see the exhibition's stereographs as they were originally intended.

My thanks also to the sixteen institutions that agreed to lend work to the exhibition. I wish to express much gratitude also to collectors George R. Rinhart and Larry J. West. The addition of photographs from their collections was critical to representing more fully the men and women who played significant roles in the transformation of the American West during this period.

And finally, let me acknowledge my family—the group most responsible for my interest in the American West. They have often been in my thoughts as I have worked to complete this project. To Mom and Dad, Alison and Charlie, Grace and Adam; my wife, Anne; and my grandfather Frank H. Goodyear, Sr., thank you for all your support.

FRANK H. GOODYEAR III
Associate Curator of Photographs
National Portrait Gallery, Smithsonian Institution
Washington, D.C.

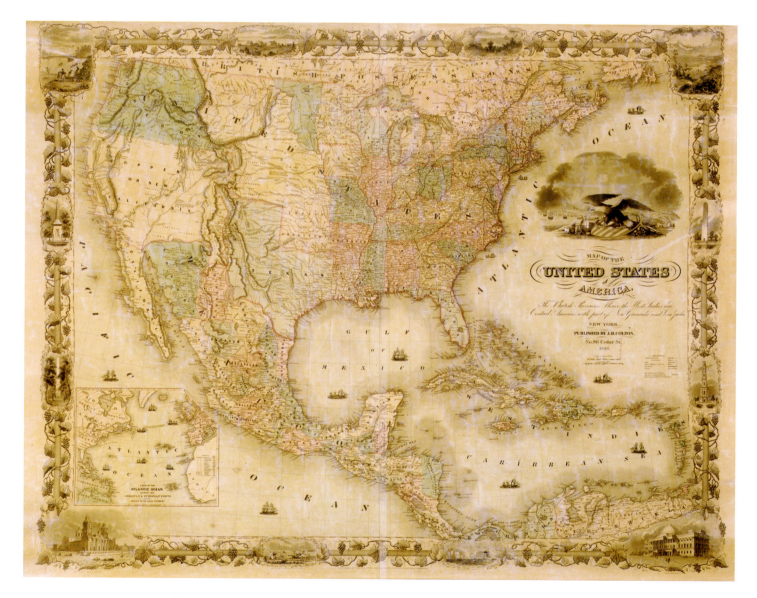

MAP OF THE UNITED STATES OF AMERICA . . . , 1849

George Woolworth Colton (1827–1901)

Geography and Map Division, Library of Congress, Washington, D.C.

Introduction

THE AMERICAN WEST WAS DRAMATICALLY RECONSTITUTED in the eight decades spanning the Mexican War and passage of the Indian Citizenship Act in 1924. This book tells the story of those changes through photographic portraits of the men and women who helped define this era. While the history of the trans-Mississippian West is centuries old, the period beginning with the annexation of Texas in 1845 and the outbreak of war with Mexico in 1846 witnessed an ever increasing number of encounters between people of different cultural traditions and fields of endeavor. These individuals, often working under the auspices of larger political and corporate entities, played a significant role in the exploration, development, and representation of this vast territory. Through their words and deeds, they contributed to the wholesale transformation of this region and its identity.

Coincident with these changes was the popularization of photography, a new visual technology first introduced in 1839 that proved influential in reshaping how Americans and others came to understand the West. More than any literary or artistic medium, photography made visible much of the region's great ecological and human diversity. Although it often reinforced preconceived notions, photography also gave rise to fresh ideas about the West—and in the process about America itself. It revealed new lands and new peoples and encouraged the nation's continued westward expansion. Yet until the early twentieth century, many people—especially Native Americans—did not have the opportunity to take up photography, and thus the portraits in this book constitute the work of one segment of American society. Intertwined within larger developments and conflicts, these images and others contributed to the American effort to comprehend and ultimately win control of this region.

Four general themes emerge as most significant in understanding the West's history during this period: land, exploration, discord, and possibilities. These matters were often central in the lives of those who were born in the West and those who later settled or worked there. While each is closely related to the other, the book's structure pivots on these four themes and thus emphasizes their larger importance to the men and women associated with the West at this time. Understanding these historic figures in terms of their relationship to western lands, their interest in exploration, their struggles against others, or their hopes and ambitions provides a larger context for their individual achievements. It also suggests the rich variety of their experiences. Indeed, in the years after the Mexican War, the West was a dynamic crossroads where people of diverse backgrounds and varied intentions encountered one another.

Since that time, a great number of near-mythic stories and ideas about the nineteenth-century West have arisen. These narratives are in part the product of writers, filmmakers, advertisers, and politicians of the more recent past. Their retelling of the story of the "Old West" has often clouded the history of a place that was poorly understood by many during this earlier period. Although one might critique these latter-day interpretations as departures from historic fact, it is important to acknowledge that the West's reinvention was under way from the time American explorers first passed into this area, and that the work of these twentieth-century interpreters simply builds upon what came before. Photography has also played a major part in constructing narratives about the West, and the portraits presented here are noteworthy not only as compelling records of remarkable lives but also as visual documents created as part of that emergent history.

By 1924, the year in which Congress granted citizenship to all Native Americans, an important chapter in the history of the West had largely been concluded. The American goal of connecting the West to the East through the conquest and settlement of the lands west of the Mississippi River was now realized. The process by which this work occurred involved and affected the lives of many people. The individuals whose portraits you will encounter in this book played a significant role in re-creating the American West. Although many are remembered for personal accomplishments, they did not work in isolation. By understanding their careers in the context of the period, a clearer picture of the West during this formative era comes into sight.

Faces *of the* Frontier

Portraiture in the Photography of the American West

FRANK H. GOODYEAR III

DURING THE SUMMER OF 1863, while Union and Confederate forces clashed at Gettysburg and elsewhere, three American soldiers affiliated with the First Oregon Cavalry happened upon a large waterfall while on reconnaissance in the eastern part of Oregon Territory. News of their "discovery" was initially slow to reach a wider public, as American settlers in the region were more fixated on the recent discovery of gold and on recurrent conflicts with various Native American tribes. Throughout the rest of the nation the news was either not received or made little impact.[1]

Four years later Charles R. Savage, a commercial photographer from Salt Lake City, made a special trip to the waterfall—now known as Shoshone Falls—and became the first to photograph this site. A second photographer, Timothy O'Sullivan, ventured there a year later under the auspices of the U.S. Geological Survey and completed his own series. Their photographic views—and woodcut engravings based on their photographs—commanded national attention within months after their return. Inspired in part by such images, journalists and other writers were soon referring to Shoshone Falls as "the Niagara of the West." Although written accounts helped publicize the site, photography was instrumental

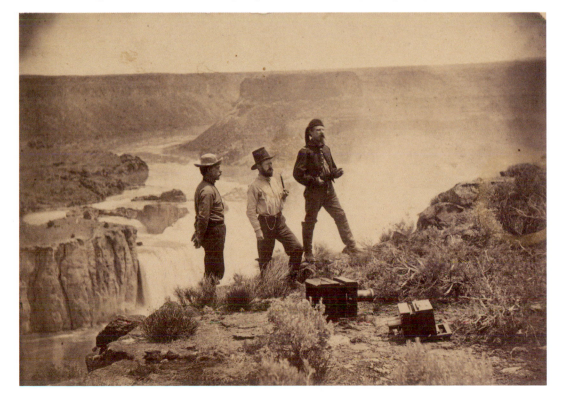

FIG. 1.1
**THREE MEN AT
SHOSHONE FALLS**
(figure at left is possibly
William Henry Jackson)
by an unidentified
photographer, albumen
silver print, c. 1877. *National
Portrait Gallery, Smithsonian
Institution, Washington, D.C.;
gift of Larry J. West*

in making possible the transformation of this natural landmark into an icon of the West.[2]

In addition to making such wonders visible to a broad audience, photography also fulfilled the desire to commemorate one's presence there and gave one something to take back and share with others. As the photograph of three men standing on a rock outcropping suggests (fig. 1.1), visitors often posed for their portrait there. With the waterfall serving as a theatrical backdrop, this picture—and others like it—further celebrated their accomplishment. In certain ways, this photograph shares much in common with landscape paintings and prints of the American West created during this same period. Works by Albert Bierstadt, Thomas Moran, and others tried similarly to capture both the newness of these places and their remarkable beauty. Whether an artist painted in the West or simply traveled there for inspiration, most aspired to create works that might figuratively transport viewers to the sites they depicted.[3]

While painters, draughtsmen, and photographers often composed their views from the same spot, and at times collaborated, important differences exist in the images that resulted and in the function that these images played within the larger culture. One important discrepancy is that people figure in the photographs of the nineteenth-century West to a greater degree than in the paintings and prints of this period. Numerous painters and printmakers from this era did of course incorporate individuals from the West into their works. Some artists—especially those who were drawn to depict Native Americans—saw portraiture as their primary mode of expression. However, to generalize about the visual culture of the trans-Mississippian West, it was through photography that Americans came to understand the people who lived, explored, worked, and settled there. Not only did photographers greatly outnumber painters and printmakers in the West, but their images—produced in multiple (after the period of the ambrotype's popularity) and often transformed into the form of an engraving or lithograph—circulated and were seen more widely than other images of this period.

Whereas painters and printmakers typically captured the region's character within a well-prescribed tradition, photographers often approached their subjects with different goals. Concern for representing a subject artfully was important, and photographers often owed much to earlier stylistic conventions. Yet at different times, photographers were also creating images for other purposes, including the promotion of such enterprises as scientific exploration, railroad travel, and industrial production. Though the specific reasons for photographing in the West varied, a larger thread binds together these photographers and those who supported them: namely, the desire to mark their presence there and to formalize their relationship with the place. This interest in inhabiting the land helps to explain the frequency with which people take center stage in photographs from the nineteenth-century West. The impulse of these photographers was not simply to document these "new" lands but to assist in establishing some type of claim on them. Even when photographers created views in which figures are physically small relative to the larger scene, or altogether absent from a landscape, the images continue to underscore how Americans were populating the West.

Timothy O'Sullivan's *Black Cañon, Colorado River, From Camp 8, Looking Above* (fig. 1.2) demonstrates the role that individuals—no matter their size—played in these views. Taken as part of a series that was meant to document Lieutenant George M. Wheeler's Survey of the Hundredth Meridian and later incorporated into his official report, this photograph serves to support the broader mission of the United States in the West. The figure huddled

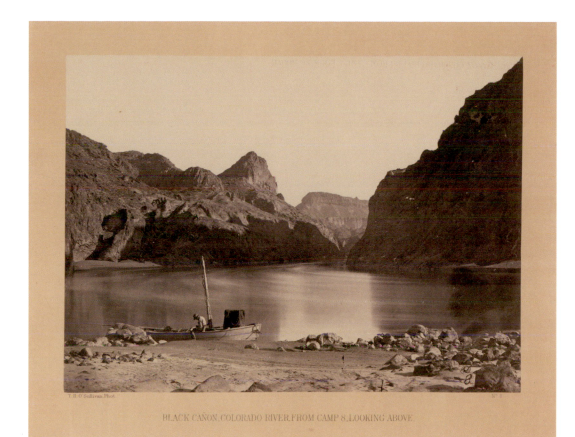

BLACK CAÑON, COLORADO RIVER, FROM CAMP 8, LOOKING ABOVE

FIG. 1.2
BLACK CAÑON, COLORADO RIVER, FROM CAMP 8, LOOKING ABOVE by Timothy O'Sullivan (1840–1882), albumen silver print, 1871. *Prints and Photographs Division, Library of Congress, Washington, D.C.*

over his work on the beached boat—possibly one of the survey's geologists or perhaps the photographer himself—acts as the trailblazer at the forefront of American expansionism. While paintings and prints also conveyed such themes, photography was especially effective in establishing an American presence in the West. The medium's supposed transparency, its being a product of a specific place, and its flexibility in being used within a variety of different contexts gave photography significant power in this regard.

As scholars have argued, photography transformed America's relationship with western lands. Less widely noted, however, it also had a similar impact regarding the nation's understanding of the people associated with the West. Photographs helped to solidify and at times realign public perceptions about figures both famous and little known. For individuals already in the national spotlight, photographic portraits kept their name and face in the public sphere, at times confirming expectations and at other times complicating conventional wisdom. For those who were less well known, portraits gave a face to a name, likewise complementing or undermining traditional associations. Since photography's introduction in the 1840s, human subjects have been ever present in the photography of this region. Whether a conventional portrait taken in a studio or a photograph created outdoors, these images have played a major role in the reshaping and repeopling of the American West.[4]

〉〉〉〉〉〈〈〈〈

AS IN THE EAST, the most common portraits from the West were those made in commercial studios. Westerners embraced with equal enthusiasm the ritual of having one's portrait made, and within only a few years after the opening of the first commercial ventures in the East, pioneers in the art of photography were establishing venues in the West to carry out this work. While studios were set up in bustling towns like St. Louis as early as 1846 and Salt

Lake City, Portland, and San Francisco by the early 1850s, this trade extended well beyond urban centers. Because of the popularity and relative affordability of photographic portraits, hundreds of practitioners opened up establishments during the latter half of the nineteenth century to cater to this demand.[5]

The early 1850s daguerreotype of a group of men standing next to a daguerreotype studio in the gold-mining region of northern California (fig. 1.3) provides evidence of how integrated photography became in the fabric of western life. Although some photographers created well-appointed studios, hoping to enhance photography's status, photographic portraits were not an exclusive product for the city sophisticate. Instead, as this image shows, studios were set up in often-remote locations and did not foster false pretensions. A portrait studio was primarily an economic enterprise, and practitioners gravitated to those places where opportunities presented themselves. Given the volatility of the western economy in the nineteenth century, many photographers were unable to sustain their careers beyond a few years. Those who did have long-term success often sold a variety of photographic products and other nonphotographic materials. Rather than specializing in portraiture per se, they branched out into other markets, including landscape photography, but also the sale of such items as Native American crafts. Portraits of famous people often sold well, and photographers went to great lengths to secure marketable likenesses.

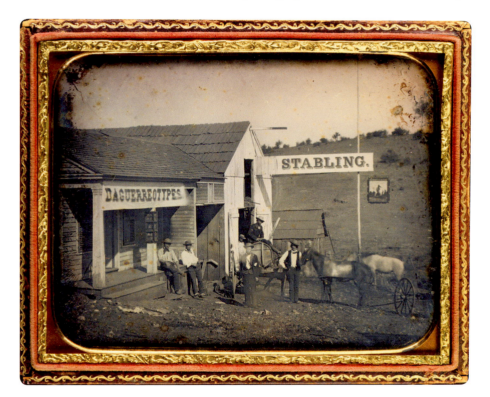

FIG. 1.3
DAGUERREOTYPE STUDIO, MOKELUMNE HILL, CALAVERAS COUNTY by an unidentified photographer, c. 1853. *W. Bruce Lundberg; photograph courtesy of the Oakland Museum of California*

In the West photographic studios were not always fixed structures. Many portraitists traveled throughout the region, taking their product directly into communities where photography had not yet taken root. Some of them outfitted wagons with all of the necessary equipment and journeyed from town to town, creating portraits and selling their wares. With more railroad lines being built every year, several photographers established relationships with railroad companies that permitted them to travel to the towns that grew up close to their tracks. Perhaps most famously, Frank Jay Haynes—who ran a commercial studio in Fargo, Dakota Territory—negotiated an agreement with executives of the Northern Pacific Railroad to operate a satellite studio in a specially designed railroad car (fig. 1.4). For twenty years beginning in 1885, Haynes Palace Studio traveled annually from Duluth, Minnesota, to Olympia, Washington, stopping in towns to create portraits of local residents and to sell views of famous landmarks in Yellowstone National Park and elsewhere.[6]

In general, the studio portraits that western photographers produced tended to follow portrait traditions established by Euro-American artists and photographers outside the region. As in the East, formulaic poses, symbolic props, and painted backdrops were

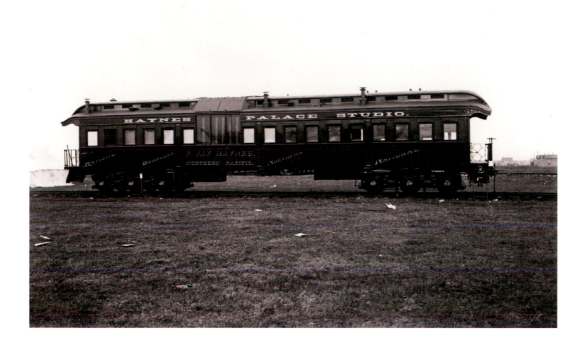

FIG. 1.4
**PALACE STUDIO CAR
(EXTERIOR)** by Frank Jay
Haynes (1853–1921), gelatin
silver print, 1901. *Montana
Historical Society, Helena*

fairly typical. In replicating conventional styles, these photographers created work that connected their clientele—and the new communities of which they were a part—to the larger nation. The portraits lessened their sense of displacement and aided in the West's transformation from a wild frontier to a civilized society. Though exceptions abound, the men and women who entered portrait studios in the West had little interest, at least initially, in asserting a specific regional identity, preferring instead to demonstrate that resettlement beyond the Mississippi River had not dramatically changed them. As time passed—and westerners felt a greater sense of belonging—photographers and the individuals whom they pictured were more likely to present a persona that included elements drawn from their new home.

The first opportunity that photographers had to present something of their new sense of place occurred when they brought their cameras outdoors. Self-portraits by Carleton Watkins (plates 35 and 56), Eadweard Muybridge (plate 36), and Frank Jay Haynes (plate 51) demonstrate the rich potential for using the landscape to fashion a new identity informed by their experiences in the West. Posing in the guise of a miner or against the backdrop of a redwood tree or a thermal geyser, these individuals assert their association with these specific locations. Americans were interested not only in these lands but also in those who would people them. No longer mere transplants from the East, these three photographers saw themselves in terms of this new geography. In picturing themselves in this manner, they helped to solidify the incorporation of the West into the larger Union and to allay anxieties about the West's settlement.

Despite the cumbersome equipment and sensitive chemistry that characterized nineteenth-century photography, practitioners increasingly worked outdoors. They did so in part because of the opportunities that presented themselves. One of the largest

contributors to this trend was the federal government. Having made a major commitment to explore and develop the trans-Mississippian West in the aftermath of the Mexican War, various agencies within the government employed photographers to assist in their work. The U.S. Geological Survey, a part of the Department of the Interior, was particularly active in hiring photographers to accompany survey expeditions into different parts of the West. Although some regarded photography principally as a scientific tool that could complement the measurements and writings of the Geological Survey's geologists, naturalists, and topographical engineers, photography served the equally important task of documenting and publicizing these expeditions.

As suggested in William Henry Jackson's group portrait of six members of Ferdinand V. Hayden's 1872 Yellowstone Survey (fig. 1.5), photography was meant to showcase the participants involved in fieldwork and, in doing so, to heroize the larger enterprise itself. Jackson's inclusion of himself in this and other photographs intimates that he regarded his own work not as a supplement but rather as a vital part of the survey. Composed in a manner similar to a studio group portrait, this photograph takes a convention of the medium and utilizes it in a new setting and for a wider purpose. Because survey expeditions were intended ultimately to prepare the region for American settlement, such images played an important role in establishing a Euro-American presence in the West.

Photographers also found employment with those corporations that took a lead role in building the transportation and industrial infrastructure of the West. Mining and lumber companies regularly hired photographers to create images that might advertise their

FIG. 1.5
HAYDEN PARTY SURVEY CAMP AT OGDEN, UTAH
by William Henry Jackson
(1843–1942), albumen
silver print, 1872. *George P.
Merrill Collection, Smithsonian
Institution Archives,
Washington, D.C.*

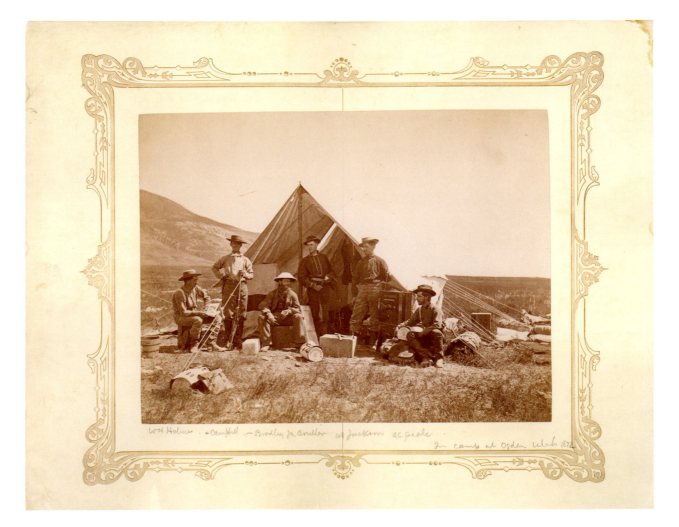

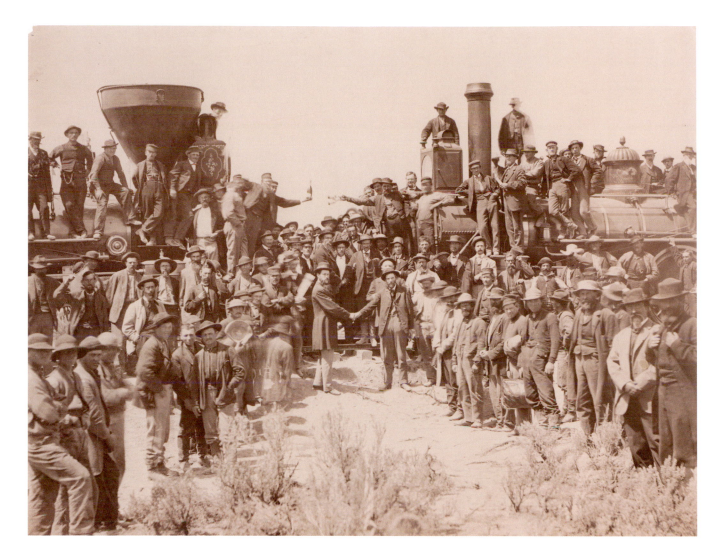

FIG. 1.6
EAST AND WEST SHAKING HANDS AT LAYING LAST RAIL by Andrew Russell (1830–1902), albumen silver print, 1869. *Yale Collection of Western Americana, Beinecke Rare Book and Manuscript Library, Yale University, New Haven, Connecticut*

enterprises. Railroad executives were also active in using photography to market their lines to would-be travelers. In the aftermath of the Civil War—a conflict that pitted North against South—the goal of building a transcontinental railroad helped to reunite the nation in part by refocusing its attention on the relationship between the East and the West.[7] Photography provided the best visual medium for documenting the construction's progress and awakening interest in western travel. Photographs such as Andrew Russell's 1869 image of the ceremony at Promontory Point, Utah, to mark the railroad's completion (fig. 1.6) transformed this moment into an iconic event. Understanding the national importance of the transcontinental railroad, three different photographers journeyed to this distant location to record the proceedings. This image and others like it centered primarily on the people who gathered at the meeting point of the Central Pacific and Union Pacific railroads. This group portrait reaffirmed both the sense of accomplishment associated with this project and the national belief in America's Manifest Destiny.

Photographic portraits also marked other ceremonial occasions in the West. Diplomatic exchanges with the region's Native peoples often involved photographers. Although the resulting images fulfilled various purposes, they acted principally to formalize a relationship between a particular tribal nation and U.S. authorities. For example, in the aftermath of the Battle of Wounded Knee—in which the U.S. military attacked and killed more than three hundred Lakota men, women, and children—several photographers descended on the battle site to create images for a news-hungry public. John Grabill's 1891 photograph of the Native leaders who met

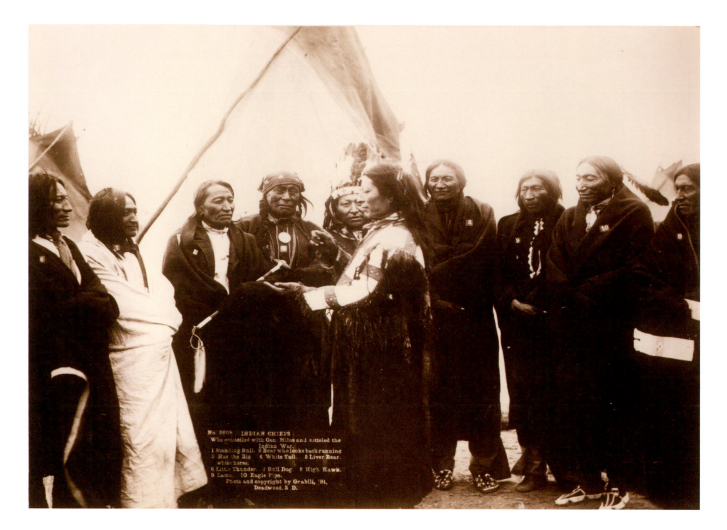

FIG. 1.7

INDIAN CHIEFS WHO COUNCILED WITH GENERAL MILES AND SETTLED THE INDIAN WAR by John Grabill (active 1886–1894), albumen silver print, 1891. *Yale Collection of Western Americana, Beinecke Rare Book and Manuscript Library, Yale University, New Haven, Connecticut*

with General Nelson Miles after the hostilities had subsided and who negotiated the truce that ended the immediate conflict (fig. 1.7) serves to document this event. It also acts to reaffirm the narrative that government officials hoped to convey about relations with the tribes of the West: in particular, that these once-hostile communities were now at peace, that "progress" was being made in addressing the "Indian problem," and that American settlement could continue.[8]

What this and other photographs do not adequately address are the various concerns and challenges that Native peoples themselves faced. These images, created for an American audience, render nearly silent the voices of those who struggled to deal with the increasing presence of the United States in the West. Photographs failed to picture the political unrest, the growing poverty, and the deterioration of traditional cultural practices. Nor did they reveal the Native efforts to reverse the damage inflicted on their communities. Prior to the early twentieth century, Native Americans did not have access to cameras with which to create their own photographs. Frequently photographed by others, they were limited in their ability to control how they were pictured within the dominant culture. Though Native Americans refused at times to be photographed or sometimes tried to appropriate the photographic ritual to meet their own ends, they remained almost always in front of the camera's lens during this period.[9]

Despite the antagonism that characterized these political affairs, portraits of Native Americans represented a significant subject for many photographers during the latter half of the nineteenth century and the first part of the twentieth. Commercial photographers found that such images sold well, and many went to great lengths to secure marketable photographs. Most popular were those likenesses of the chiefs and warriors whose names

appeared in newspaper headlines at the time. These portraits became the vehicles for imaginary encounters with the pictured subjects. Rather than providing critical insights into these lives, more commonly they furthered old stereotypes or permitted new fictions to be created about them. In the process, complex figures such as Red Cloud (plate 75), Sitting Bull (plate 77), and Geronimo (plate 79) became transformed into one-dimensional icons.

Photographic portraits of Native peoples were the product of different transactions and served other purposes during the nineteenth century. In the realm of political exchange, the ritual of having one's portrait made became an important part of visits by tribal delegations to Washington and elsewhere. In the era before photography's introduction, painters were often commissioned to complete portraits of important chiefs. Yet by midcentury, photography had become the medium through which these meetings were commemorated. A group portrait of an 1880 delegation of Jicarilla Apache at Washington's Corcoran Gallery of Art (fig. 1.8) is representative of the type of images that were created on these occasions. Whether the photograph was created in a studio or in some type of public setting, it served to formalize a relationship and a set of expectations. This ritual and other gift exchanges were important elements that gave structure to the interchange between tribal leaders and government authorities.

Photographers also used these and other occasions to create images that supported the burgeoning American and European interest in ethnographic study. During the latter half of the nineteenth century, academic departments, natural history museums, and government agencies were established to further the scientific investigation into Native American cultures. Photography was considered an invaluable tool for conveying useful information about tribal communities. In conjunction with delegation trips to Washington

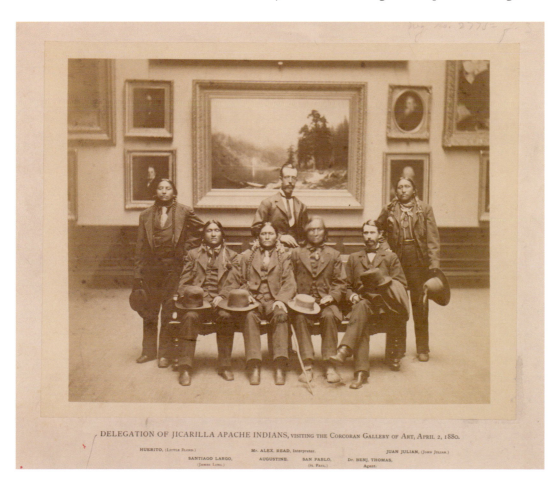

DELEGATION OF JICARILLA APACHE INDIANS, VISITING THE CORCORAN GALLERY OF ART, APRIL 2, 1880.

HUERITO, (LITTLE BLOND.) Mr. ALEX. READ, Interpreter. JUAN JULIAN, (JOHN JULIAN.)
SANTIAGO LARGO, AUGUSTINE. SAN PABLO, Dr. BENJ. THOMAS,
(JAMES LONG.) (ST. PAUL.) Agent.

FIG. 1.8
DELEGATION OF JICARILLA APACHE INDIANS VISITING THE CORCORAN GALLERY OF ART by an unidentified photographer, albumen silver print, 1880. *National Anthropological Archives, Smithsonian Institution, Washington, D.C.*

and elsewhere, photographers created studio portraits that at times transformed Native leaders into scientific specimens. On survey expeditions, compiling a photographic record of Native groups became an important part of the larger inventory of the West that these explorers were conducting.

John K. Hillers's photograph of Hedipa (fig. 1.9), a young Navajo woman who lived on a reservation in Arizona Territory, suggests an interest that he and others shared in collecting portraits centered on a subject's physiognomy. While not all such photographs removed their subjects from a larger context, the great majority of these images—including Hillers's portrait—conveyed little information about Native peoples beyond what they looked like and elements of their traditional material culture. The vision of most ethnographic photographers was highly selective, and the resulting views tended to align with prevailing cultural and scientific assumptions. Archived together with survey reports and collections amassed during travels in the West, photographic portraits by Hillers and others worked to support the Euro-American notion that Native Americans were markedly different—and inferior—both biologically and culturally.[10]

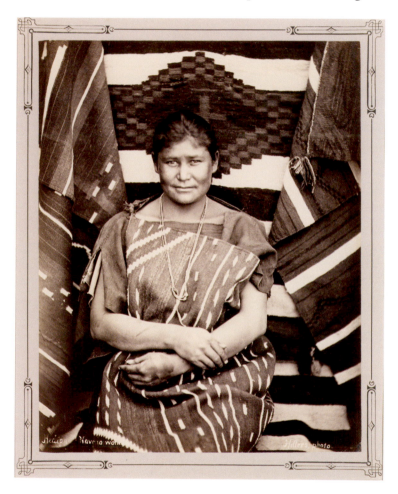

By the end of the nineteenth century, as the United States completed its subjugation of tribal nations, nostalgia for a mythic Indian past took root in American society. Together with painters and writers, photographers ventured throughout the West to document what they understood as the last vestiges of a once-noble, albeit primitive culture. Fearing that ancient Native traditions would vanish forever, a host of different photographers looked to use the camera to record what remained. None was as committed to this project as Edward S. Curtis, a Seattle photographer who spent more than thirty years building a vast visual archive dedicated to recording the heritage of tribal nations throughout the West. *Oglala Sioux in Ceremonial Dress, South Dakota* (fig. 1.10), a platinum print from 1905, typifies his approach. As in many of his photographs, Curtis brought together several elements—including a dramatic wilderness setting, a rich material culture, and nobly posed figures—to evoke the spirit of a bygone era. Rather than using his camera to document the significant changes that were occurring within Native communities, Curtis sought images that confirmed traditional associations and that might be marketable to a wide public. Though Curtis created more than forty thousand photographs from over eighty tribes, he—like other turn-of-the-century photographers who focused attention on Native Americans—compiled a body of work that was relatively limited in scope and that ultimately contributed to the repeopling of the West.[11]

Native Americans were not the only population whose history and presence were distorted by photography. Before the nineteenth century, the trans-Mississippian West was already home

FIG. 1.9
HEDIPA, A NAVAJO WOMAN by John K. Hillers (1843–1925), albumen silver print, c. 1880. *Smithsonian American Art Museum, Washington, D.C.; museum purchase from the Charles Isaacs Collection made possible in part by the Luisita L. and Franz H. Denghausen Endowment*

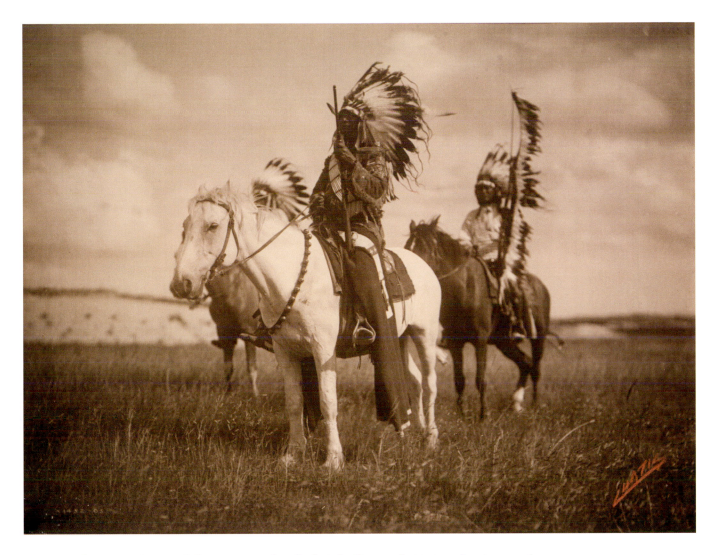

FIG. 1.10
**OGLALA SIOUX IN
CEREMONIAL DRESS,
SOUTH DAKOTA** by
Edward S. Curtis (1868–
1952), platinum print, 1905.
*Peabody Essex Museum, Salem,
Massachusetts*

to men and women of many different national and ethnic backgrounds. During the nineteenth century, it became even more diverse. While this characteristic of the West reveals itself occasionally in the photography of this period, significant populations—in particular, Hispanics, African Americans, and Chinese—were largely erased from the visual and written record. In the years after the Mexican War, these groups occupied a secondary status politically, economically, and socially relative to the Euro-Americans who settled there. For those from Mexico or Spain who lived in the West, military defeat and cultural prejudices resulted in a dramatic erosion in their historic standing. For many African Americans and Chinese immigrants, the West represented an opportunity to better the situations in which they found themselves. Labor was in constant demand in the nineteenth-century West, and many from these populations relocated there, hoping to take advantage of economic opportunities. Yet while some benefited, the great majority confronted racial discrimination and unfulfilled dreams. Little of the complexity of these different relationships is readily evident in the photography of this period. Because very few nonwhite immigrants took up photography either as a profession or a hobby until the early twentieth century, their perspective is largely missing.[12]

Although not unique, the daguerreotype portrait of an African American miner at Auburn Ravine is a rare photograph that records the presence of African Americans in California's gold mining region (fig. 1.11). Like individuals in other images from the goldfields, this unidentified figure looks up from the work that he is doing. Shoveling earth into a prospector's sluice, he is one of several thousand African Americans who ventured West at midcentury looking for a

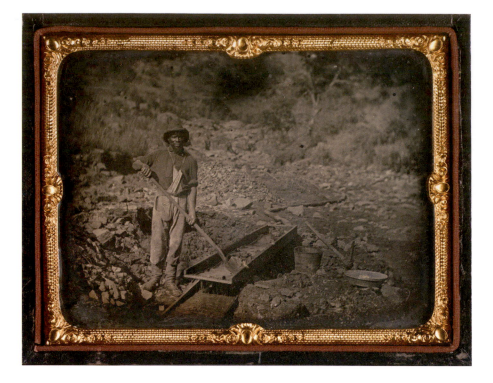

Fig. 1.11
Auburn Ravine
attributed to Joseph B.
Starkweather (c. 1822–?),
daguerreotype, 1852.
*California State Library,
Sacramento*

new beginning. While some found rewards for their efforts, most remained at best marginalized within the larger culture. At worst they found themselves once again enslaved and forced to work for others. The specific circumstances that led to the creation of this photograph are unknown; however, it bears witness to the contributions of those African Americans who came West and participated in its resettlement.

In the three decades between the gold rush and the adoption of the Chinese Exclusion Act in 1882, several hundred thousand Chinese immigrated to the United States. Like African Americans, but in much larger numbers, they ventured to this region seeking employment. Similarly, they encountered oppressive discrimination and at times violence, yet most remained because jobs were available and return passage to China was largely out of reach. Though the Chinese represented a majority of the workforce that was building the Central Pacific Railroad and constituted a significant part of the population in California's goldfields, photographers largely failed to record their presence. Photographers did document the railroad's construction and were present in the gold camps. However, their interest was not the laborers but rather the material progress that was occurring at these sites. Some photographs do exist that show the Chinese at work, yet their presence is secondary to the main subject. They are the faceless—almost invisible—workforce that is behind these projects.

While rarely pictured in these contexts, the Chinese did attract curiosity seekers, some of whom carried cameras. In particular, San Francisco's Chinatown—or "Tangrenbu"— became a destination for non-Chinese who traveled there to experience something of the unique Chinese culture. Having been segregated into a crowded ten-block area, the Chinese were largely unable to control how others saw them. Especially in the era after the Chinese Exclusion Act—legislation that shut down immigration and further contained the Chinese politically and socially—non-Chinese ventured into Chinatown with increasing frequency. Few were the occasions when a Chinese man or woman sought to have his or her photograph taken; instead, they became the object of someone else's gaze.[13]

Of the different individuals who photographed Chinatown during this era, Arnold Genthe is most famous for his turn-of-the-century archive documenting this community. His photograph *A Holiday Visit, Chinatown, San Francisco* (fig. 1.12) demonstrates his characteristic interest in representing the Chinese as a picturesque people amid the dark and narrow streets of Chinatown. A newly arrived immigrant himself, Genthe foregrounds the traditional costumes of his subjects and the lively activities in which they engage. His photographs, often taken surreptitiously, provide a seemingly close-up glimpse of a culture about which few in San Francisco or the West had much understanding. However, while

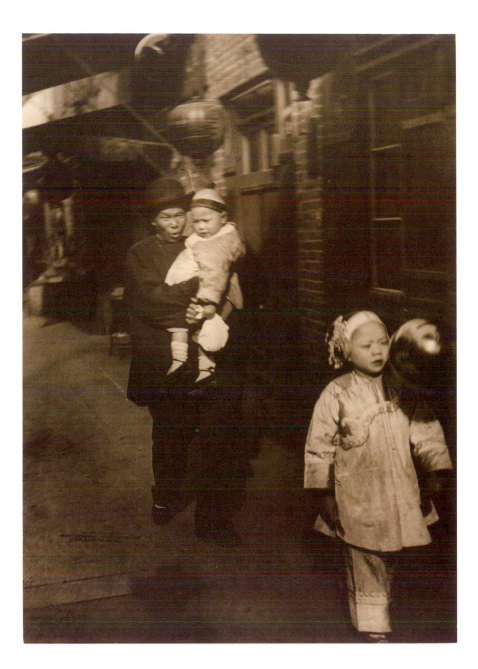

Fig. 1.12
A Holiday Visit by
Arnold Genthe (1869–1942),
gelatin silver print, 1896–
1906. *Museum of Modern Art,
New York City; gift of Albert M.
Bender*

he had access to the streets of Chinatown, his pictures and the manner in which they were presented tend to reveal little about the actual hopes and challenges that the Chinese people faced at the time. Like Edward S. Curtis's soft-focus photographs of Native Americans, Genthe's photographs of Chinatown render his subjects an exotic and timeless people, thereby further marginalizing them in the eyes of Euro-American society.

❭❭❭❭ ❬❬❬❬

PHOTOGRAPHIC PORTRAITURE WAS NEVER a static tradition. Over time, as photographic technology changed and as more people picked up cameras, the genre continued to grow and fulfill new purposes. This expansion was as true in the West as it was in the East. In the era before the portable, easy-to-operate Kodak camera, few nonprofessionals owned their own cameras. The introduction of the Kodak in 1888 allowed men and women without previous training or commercial ambition to step out and create their own pictures. Given photography's popularity and the Kodak's relative affordability, they did so in large numbers. Also in this period, those who historically had had limited access to photography—in

particular, ethnic minorities—acquired cameras and began to create the first images of their own communities on their own terms. Although women had operated or assisted in commercial photographic studios prior to the Kodak, the number who ventured into photography after its introduction skyrocketed.[14]

The addition of new practitioners from a more diverse set of backgrounds tended to expand and complicate the manner in which the West and its peoples were understood. While traditional assumptions continued, the sheer volume of images contributed to a growing tension about the region's character by the century's end. Rather than one monolithic territory, the West became increasingly the sum of many discrete parts.

Of the many subjects on which photographers focused attention during this period, portraiture—in all its different manifestations—remained of primary importance. Karl Struss's image of two fashionable women with a Kodak camera (fig. 1.13) suggests something of the vogue for photography at the beginning of the twentieth century. As this image communicates, people enjoyed not only being photographed but also creating their own photographs. Likewise, building one's own collection of photographs became a popular pastime. Gathered together in albums, these images allowed people to construct their own visual narratives about their communities, their families, and themselves. As a form of self-expression, these albums invariably featured portraits of personal significance.[15]

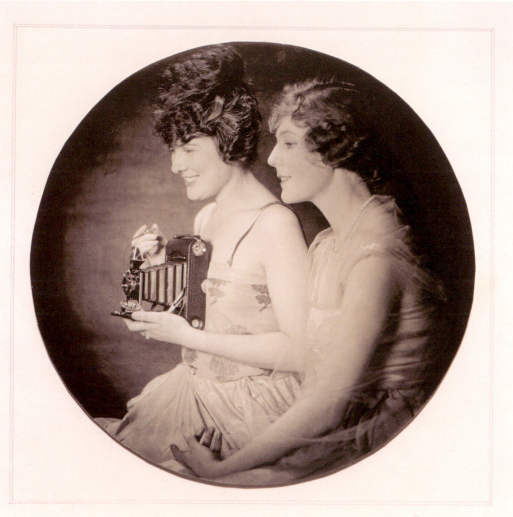

FIG. 1.13
TWO WOMEN WITH KODAK CAMERA by Karl Struss (1886–1981), bromide print, c. 1914. *Oakland Museum of California; gift of the Burden Photography Fund*

A successful commercial and fine art photographer in New York City, Karl Struss helped to bring new ideas about photography to the West. Educated at the Clarence White School of Photography and a member of Alfred Stieglitz's Photo-Secession, he decided in 1919 to relocate to southern California to work in the burgeoning film industry. In addition to working as a cinematographer for Cecil B. DeMille and other early Hollywood directors, Struss also created strikingly modern portraits of leading actors and actresses. These images—which owed much to the earlier tradition of theatrical portraits—popularized the industry for publicity shots of Hollywood stars. While Struss was not the first photographer in the West to incorporate modernist aesthetics into his work, he was among a new generation interested in exploring further the medium's creative possibilities.[16]

Many ideas about photography's artistic potential were transported into the West from outside the region. Photographers like Struss and Dorothea Lange, together with photographic journals from the East, were important for introducing new insights about photography and modern expression. Yet not all of these ideas came from somewhere else. Beginning in the 1890s, various men and women from the West began to take a leading role in shaping photography's artistic future. As in the East, camera clubs were established in different cities throughout the region to support amateur and professional photographers, many of whom aspired to create images worthy of exhibition. These organizations did much to encourage an interest in fine art photography. In the work of such figures as Adam Clark Vroman, Anne Brigman, Imogen Cunningham, Laura Gilpin, Johan Hagemeyer, and Ansel Adams—to name only several of the many outstanding photographers who came of age during the first quarter of the twentieth century—the West became recognized nationally for its achievements in the so-called "new photography."[17]

In the realm of artistic portraiture, many experimented with new approaches to this traditional genre. Perhaps most noteworthy was Edward Weston, who in 1911 at age twenty-five opened a photographic studio in Tropico, California. Well known today for his modern landscapes and still-life studies, Weston began his career as a portraitist. As Weston's *Epilogue* (fig. 1.14) makes clear, though, his ideas about portraiture differed considerably from established conventions. In this and other works from the period, composition, lighting, and the placement of the figure are all reconsidered. While clearly indebted to the pictorial photography movement—and its emphasis on the medium's artistic potential—Weston was beginning at this time to move toward the "straight" aesthetic that would become the hallmark of modernist photography. Although he later abandoned the soft-focus approach evident in *Epilogue,* he had come to understand that the camera permitted him to see his subjects in ways that the eye could not. Weston returned to portraiture at various times throughout his career.[18]

Figures like Weston were influential in reconsidering what a fine art portrait might look like. However, while he and others were responsible for developing a western modernism, it was the larger phenomenon of photography itself—as practiced by amateurs and professionals alike—that played a more significant role in reshaping the history of the American West. During the years between the Mexican War and the Indian Citizenship Act of 1924, the period that this exhibition considers, photography was influential in mediating the American public's understanding of many aspects concerning this region. Eyewitness to its exploration, settlement, and industrial development, photography influenced the ideas and directed people's responses regarding its lands and peoples. Extraordinary transformations occurred during this period, and photography helped to make many of them possible.

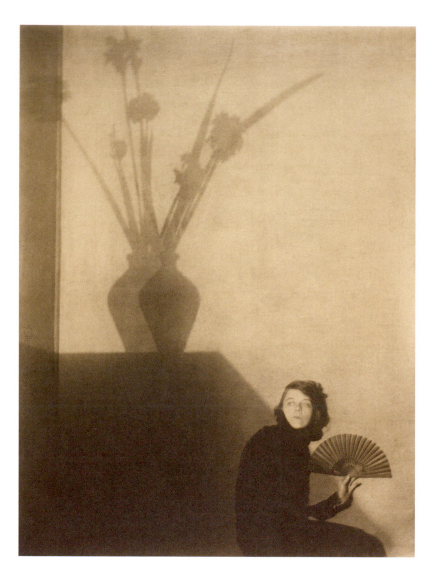

FIG. 1.14
EPILOGUE by Edward
Weston (1886–1958),
platinum/palladium print,
c. 1919. *Smithsonian
Institution, National Museum
of American History, Behring
Center, Washington, D.C.*

No change during this period was as large as the wholesale reinvention of the West's larger identity. At the time of the Mexican War, the vast western expanse was little understood by those who lived beyond it. Conflicting ideas existed about these lands and the people who occupied them. While most Americans subscribed to the ideology of Manifest Destiny, a few questioned the drive to expand the nation's borders to the Pacific. By the new century, however, the West had been fully incorporated into the larger Union, and the region was increasingly seen not as a single entity but rather as a complex amalgam of different elements. Specific regions, industries, and peoples each contributed to the West's makeup. The portraits in this exhibition highlight many of the key figures who remade the West during this eighty-year period. At the same time, the photographs themselves—like other portraits from the West—should also be regarded as more than records of these past lives. As powerful conveyors of information, these photographic portraits helped to give the West its face and in the process to complicate America's larger understanding of itself.

Notes

1. The first Euro-American account of Shoshone Falls was actually recorded fourteen years earlier. In August 1849 George Gibbs (1815–1873) of the Regiment of Mounted Riflemen happened upon the site with two military officers and a guide while traveling the Oregon Trail with a U.S. military expedition from Fort Leavenworth to Fort Vancouver. For more about this expedition, see Raymond W. Settle, ed., *The March of the Mounted Riflemen* (Glendale, Calif.: Arthur H. Clark, 1940).

2. "The Niagara of the West," *Deseret News* (December 18, 1867): 1. For more about Savage and O'Sullivan, see Bradley W. Richards, *The Savage View: Charles Roscoe Savage, Mormon Pioneer Photographer* (Nevada City, Calif.: Carl Mautz, 1995); Joel Snyder, *American Frontiers: Timothy O'Sullivan, 1867–1874* (New York: Aperture, 1981); and Robin Kelsey, *Archive Style: Photographs and Illustrations for U.S. Surveys, 1850–1890* (Berkeley: University of California Press, 2007).

 While photography was vital in the transformation of Shoshone Falls, the medium did not always play the primary role in the remaking of other notable western landmarks. Witness the history of Yellowstone, where the paintings and prints of Thomas Moran and others were as important as the photographs created by early cameramen. See Peter Hassrick, *Drawn to Yellowstone: Artists in America's First National Park* (Seattle: University of Washington Press, 2002).

3. The most notable effort to link landscape painting and photography is Weston Naef, *Era of Exploration: The Rise of Landscape Photography in the American West, 1860–1885* (New York: Metropolitan Museum of Art, 1975).

4. For a more complete history of nineteenth-century American photography, see Alan Trachtenberg, *Reading American Photographs: Images as History, Mathew Brady to Walker Evans* (New York: Hill & Wang, 1989); Martha Sandweiss, ed., *Photography in Nineteenth-Century America* (New York: Abrams, 1991); Martha Sandweiss, *Print the Legend: Photography and the American West* (New Haven, Conn.: Yale University Press, 2002); and Keith Davis, *The Origins of American Photography: From Daguerreotype to Dry-Plate, 1839–1885* (New Haven, Conn.: Yale University Press, 2007).

5. Studies about the first generation of commercial photographers in the West include Dolores A. Kilgo, *Likeness and Landscape: Thomas M. Easterly and the Art of the Daguerreotype* (St. Louis: Missouri Historical Society Press, 1994); and Drew Heath Johnson and Marcia Eymann, ed., *Silver & Gold: Cased Images of the California Gold Rush* (Iowa City: University of Iowa Press, 1998).

6. Freeman Tilden, *Following the Frontier with F. Jay Haynes: Pioneer Photographer of the Old West* (New York: Knopf, 1964); and Montana Historical Society, *F. Jay Haynes, Photographer* (Helena: Montana Historical Society Press, 1981).

7. Sandweiss, *Print the Legend,* 156–206; Glenn Willumson, *Iron Muse: Picturing the Transcontinental Railroad* (Berkeley: University of California Press, forthcoming, 2010).

8. Richard Jensen, R. Eli Paul, and John Carter, *Eyewitness at Wounded Knee* (Lincoln: University of Nebraska Press, 1991).

9. Regarding the photographic representation of Native peoples in nineteenth-century America, see Paula Fleming and Judith Luskey, *The North American Indians in Early Photographs* (New York: Harper & Row, 1986); James Faris, *Navajo and Photography: A Critical History of the Representation of an American People* (Albuquerque: University of New Mexico Press, 1996); Carol Williams, *Framing the West: Race, Gender, and the Photographic Frontier in the Pacific Northwest* (New York: Oxford University Press, 2003); and Frank Goodyear, *Red Cloud: Photographs of a Lakota Chief* (Lincoln: University of Nebraska Press, 2003).

10. Concerning the use of photography in ethnographic research, see Martha Banta and Curtis Hinsley, *From Site to Sight: Anthropology, Photography, and the Power of Imagery* (Cambridge, Mass.: Harvard University Press, 1986); and Elizabeth Edwards, ed., *Anthropology and Photography, 1860–1920* (New Haven: Yale University Press, 1994).

11. Mick Gidley, *Edward S. Curtis and the North American Indian, Incorporated* (New York: Cambridge University Press, 1998).

12. Among the different studies of these groups in the West, see David Montejano, *Anglos and Mexicans in the Making of Texas, 1836–1986* (Austin: University of Texas Press, 1987); and Ronald Takaki, *Strangers from a Different Shore: A History of Asian-Americans* (Boston: Little Brown, 1989).

13. Anthony Lee, *Picturing Chinatown: Art and Orientalism in San Francisco* (Berkeley: University of California Press, 2001).

14. For more about women and photography at the beginning of the twentieth century, see Judith Davidov, *Women's Camera Work: Self/Body/Other in American Visual Culture* (Durham: Duke University Press, 1998); and Bronwyn Griffith, ed., *Ambassadors of Progress: American Women Photographers in Paris, 1900–1901* (Hanover: University Press of New England, 2001).

15. Nancy West, *Kodak and the Lens of Nostalgia* (Charlottesville: University of Virginia Press, 2000); and Sarah Greenough and Diane Waggoner, *The Art of the American Snapshot, 1888–1978: From the Collection of Robert E. Jackson* (Princeton: Princeton University Press, 2007).

16. Bonnie Yochelson et al., *New York to Hollywood: The Photography of Karl Struss* (Albuquerque: University of New Mexico Press, 1995).

17. Michael Wilson and Dennis Reed, *Pictorialism in California: Photographs, 1900–1940* (Los Angeles: J. Paul Getty Museum, 1994).

18. Theodore Stebbins, Karen Quinn, and Leslie Furth, *Edward Weston: Photography and Modernism* (Boston: Museum of Fine Arts, 1999).

The West Is Rarely What It Seems

Richard White

PORTRAITS SEEM AN IDEAL VEHICLE for capturing the American West. In popular culture the West has become synonymous with individualism, and portraits by definition are portrayals of individuals—even group portraits break down into individual people. But little in the West is as it seems. Academic historians long ago reacted against popular portrayals of the West as a theater of clichéd and trivialized individualism. Instead, they emphasized how large and seemingly impersonal entities—governments, corporations, labor unions, political parties, and social movements—have made the West for a century and a half a place of big government and large corporations. A collection of individuals in portraits, no matter how representative, cannot capture these large institutions. Most historians would go further. On close examination these portraits don't even really reveal individuals. Look at enough of them and you realize it is not people but personas—the scout, the explorer, the American Indian, the corporate leader—that we see.

These portraits neither add up to a history nor reveal individuals. Paradoxically, however, recognizing their limits results in questions that lead to a kind of back door that allows access both to the history and to the individuality that these portraits obscure. Yet asking the right questions means forgetting one of the oldest clichés about photography: that a picture is worth a thousand words. Nearly the opposite is true. Pictures demand thousands of words.

The questions that I ask about these portraits arise from a historian's conceit: I think I know these long-dead people. They are often more alive to me than the people among whom I spend my days, and this belief still alarms my wife after many years of marriage. To varying degrees I claim to know William Cody, Sarah Winnemucca, Clarence King, Sitting Bull, Henry Villard, James J. Hill, Collis P. Huntington, John C. Frémont, and others. I have read their mail, their diaries, and the sometimes intimate accounts of those who knew them. I know their fears, their weaknesses, and the lies they told. I know their doubts, their conceits, and their sometimes overwhelming sense of failure. I know their busy self-creating. I take such pains to know them because I think they mattered. I know that their lives could have turned out differently, and if their lives had turned out differently, so in many cases would their times. This knowledge makes me try to see beyond the iconic types they inhabit in their portraits. I wonder why these people posed this way. What did they seek to accomplish? Why did these often complex and contradictory people seem to settle for being preserved as icons?

That so many of the subjects of these portraits were artists, photographers, writers, and show people who fabricated versions of the West and of themselves provides a clue. These subjects are not victims of the camera; they conspire with it. Some—Mark Twain,

Calamity Jane, Buffalo Bill, Lola Montez—don't even give their real names; instead we have nom de plumes or stage names that signal a process of self-invention well under way before these subjects sat before the camera. The camera will not give them away. Given the technology of the time, candid shots are rare; no one is taken by surprise. Portraits are deeply problematic declarations of individual invention because a portrait can never be the full creation of its subject. The photographer frames, arranges, and to a degree controls the final product. There are also the audiences, always changing, that read meaning into the images, and the meanings they read usually come from the expectations they carry to the picture. They recognize the iconic types that the individuals inhabit.

The interactions of subjects, photographers, and audiences raise real and important issues in interpretation, but they are not my primary concern. I want to keep the focus on the people who posed before the camera and the idea that their portraits are less a declaration of who these people were than evidence of how they wanted to present themselves and be remembered.

Alfred Doten (fig. 2.1) gave some sense of how this process worked. Doten wrote one of the great diaries of the American West. He came to California with the gold rush, worked on farms in the Santa Clara Valley, moved to Nevada, invested in mines, and became one of the state's leading newspapermen. He kept his diary for more than fifty years, from 1849 to 1903, and recorded everything that came his

FIG. 2.1
ALFRED DOTEN
(1829–1903) by an unidentified photographer, albumen silver print, c. 1870s. *University of Nevada–Reno Library; Special Collections, Alfred Doten Collection*

way: work, western entertainment, and his sexual adventures—sometimes written in a code that was laughably easy to break. He wrote very occasionally on getting his picture taken, on watching others get their picture taken, and on receiving picture albums.

On Monday August 23, 1858, Doten went up to Mountain View, California, near where I now live in Silicon Valley. "There is a daguerrean artist now at Elliot's," Doten wrote. "[He] has his tent set up for a salon, just back of Elliot's house—takes very good pictures. Mr. Shumway had his likeness taken on three plates—one was only a bust, but the other two were full length ones—standing up in his every day dress. They looked very natural—check shirt & overalls— shirt collar standing up over his ears—hat on—pants open in the front &c. &c. &c."[1] Mr. Shumway's everyday dress was something of a calculation. He was not a workingman. He was not a miner, nor was he a farmer. He was postmaster, storeowner, and money lender.[2] He was quite consciously memorializing himself as something else: a westerner.

Five years later Doten mentions going to San Francisco to "Dyer's, Clay St. bet' Montg'y and Kearney & got 12 photograph cards of myself taken for $4.00."[3] Doten gave one to a Mrs. Walters and one to a Mrs. Lucas for her album. He also gave one to a Mrs. Ross.[4] Doten was

leaving California for Nevada and the photographs were tokens. Leaving farming behind, he was about to become something else, somewhere else. He had pictures taken of how he wished to be remembered. He distributed them and then left.

In Nevada in 1864 Doten mentioned a final portrait. By then he was in Virginia City where on December 1 he visited the Sutterly Brothers' Photographic Gallery. James K. Sutterly presented him "with a nice little photograph album, with old Winnemucca and himself in it." Chief Winnemucca (Sarah Winnemucca's father) was a Paiute Indian leader from Nevada. An album with Sutterly and Winnemucca marked what would have been simply a photograph album as a *western* photograph album. Winnemucca served the same purpose as Mr. Shumway's "check shirt" and overalls: it marked westerness.[5] Yet Winnemucca served an additional purpose. Although all of the people in Sutterly's album

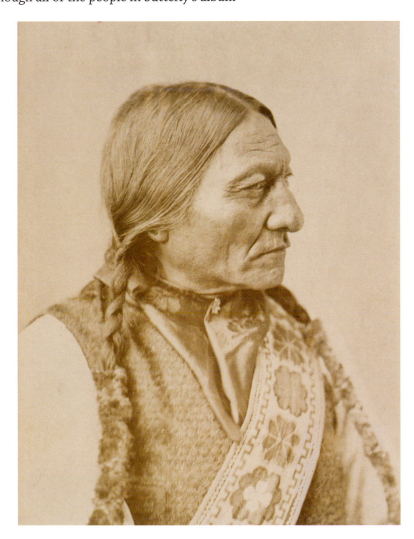

Fig. 2.2
SITTING BULL (c. 1834–1890) by William Notman (1826–1891), albumen silver print, 1885. *National Portrait Gallery, Smithsonian Institution, Washington, D.C.*

were contemporaries inhabiting a single time and a set of intersecting spaces, Winnemucca was included to show a transformation. He was the Indian past; the whites were the present and the future.

Doten's accounts of these portraits indicate their complexity. Individuals sought to associate their likenesses with something larger. Nineteenth-century western portraits became iconic by standing for Indians, or the West, or the cowboy. The portraits Doten mentioned did the same thing as the portraits of Sitting Bull (fig. 2.2), Geronimo (fig. 2.3), and even Sarah Winnemucca (plate 106): they turned individuals into symbols. Complicated human beings vanished into their representations. Clarence King and John C. Frémont were reduced to agents of the great age of American exploration and government-financed science in the West. William T. Sherman and his generals, or George Armstrong Custer (fig. 2.4), or Nelson A. Miles (plate 80)—these men all stood for conquest even when, like Custer, they suffered defeat and died. They were subsumed into some supposed American Destiny. Henry Villard, James J. Hill, and Collis P. Huntington (plates 17, 18, and 16) stand before us in the gallery as individuals, supposedly dominant and domineering, but morph into the corporate leader, the railroad builder, or the robber baron.

These formal portraits are a strange amalgam. The pictures seem to proclaim an "I" but like an Escher print they morph into a "They." In a single sentence the portraits shift grammatically between the first person singular and the third person plural. The subject of the portrait was often complicit in this shift between the individual and the iconic, between the discrete human being and the larger collective, but photographers could take the initiative. By the time Edward S. Curtis took his famous portraits of Indians at the end of the

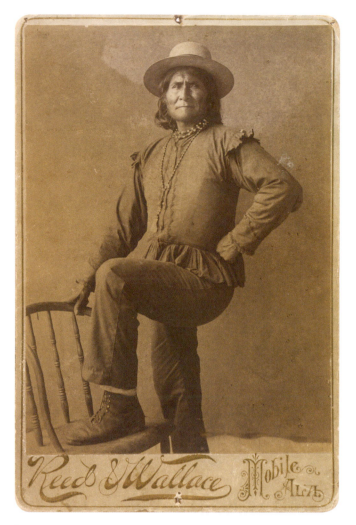

FIG. 2.3
GERONIMO (1829–1909)
by Reed & Wallace Studio
(active 1890–1910?), albumen
silver print, 1890. *National
Portrait Gallery, Smithsonian
Institution, Washington, D.C.*

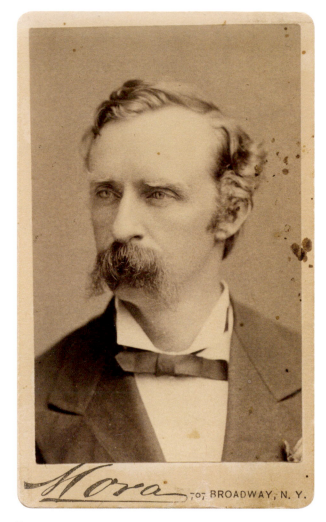

FIG. 2.4
GEORGE A. CUSTER
(1839–1876) by José Maria
Mora (1849–1926), albumen
silver print, c. 1870. *National
Portrait Gallery, Smithsonian
Institution, Washington, D.C.*

nineteenth century, the props and costumes he usually provided could overwhelm the more complicated individuality of his subjects.[6]

Curtis knew what Indians were supposed to look like before he found his actual subjects. That is why he dressed them, posed them, and "wiped away" the more complicated lives that Indian peoples already led. He was hardly alone in this. The studio portrait of Rain-in-the-Face (fig. 2.5) is a standard Indian portrait with eagle feather headdress and fancy dress. It was a portrait of the man many whites believed killed Custer. Rain-in-the Face became the image of *the* Lakota warrior, and that warrior, as he was supposed to, seemed oddly incongruous in a nineteenth-century photographer's studio. He was meant to stand for a vanishing past, but Rain-in-the-Face was not some vestige of the past incongruously thrust into Victorian modernity. He was a complicated man with a complicated life. There are other pictures of him as well. There is, for instance, a portrait now in Chicago's Newberry Library of Rain-in-the-Face sitting with short hair and a dark suit. Put the two portraits together and his life seems as modern and as complicated as Frank Cushing's, a white man whose portrait appears not only with Zunis but cross-dressing as a Zuni (plate 49). The portraits promise to reveal individuality, but they can just as easily deliver a disguise. The thousands of words

that these pictures supposedly eliminate reappear in the secret life of the portrait—the details about the sitter the portrait seeks to disguise or distort. It is the words more than the portrait that rescue the individual from being merely a type.

In her book, *Life Among the Piutes,* Sarah Winnemucca supplied the words that can shift the meaning of the portrait included in this exhibition. As Chief Winnemucca's daughter, she wore what can loosely be described as her Indian princess garb, which she quite self-consciously donned for the camera and for white audiences. On the surface, it served the function of Rain-in-the-Face's headdress or the props Curtis carried with him: it identified her as an Indian. Sarah Winnemucca's outfit was not just a conceit of the photographer. She carefully contrived it to make her into something that existed only in nineteenth-century Victorian imaginations—an Indian princess. The Paiutes were not a hierarchical society. Winnemucca was not a king and his daughter was certainly not a princess. But if whites wanted princesses, Sarah Winnemucca would give them a princess if this gave her the necessary status to speak for the Paiutes. She would use that status to dispute both the division of time that gave Paiutes the past and whites the future, and the racial division of Nevada's space that gave whites pretty much anything they wanted.

Sarah Winnemucca inhabited a representation of herself in order to do individual work in the world. She was an Indian reformer who often praised the U.S. Army and was at odds with white Indian reformers who were drawn heavily from liberal Protestant churches that had cooperated with Ulysses S. Grant's "peace policy." The peace policy was an early example

Fig. 2.5
**Rain-in-the-Face,
Sioux** (c. 1835–1905),
by Elbridge Ayer Burbank
(1858–1949), oil on canvas,
not dated. *The Newberry
Library, Edward E. Ayer Art
Collection, Chicago, Illinois*

of a faith-based initiative under which the churches took over supervision of most Indian agencies and superintendencies. It was a grand disaster. Winnemucca's attacks on the corruption of Christians in taking Paiute land without Paiute consent was an overt attack on the peace policy as were her repeated scornful references to Christianity and Christian reformers. Reformers retaliated by attacking her to defend the peace policy.[7]

Both Winnemucca's *Life Among the Piutes* and her portrait are interventions into American politics that need to be placed together to make sense. Both were meant to give her standing as both a Paiute and a Victorian woman. She, with the help of her editor, addressed her presumed largely female audience as "dear readers." The book was a defense of female virtue, an exercise in the power of domesticity, and the extension of the women's realm into public politics.[8]

Like many white women in her audience, Sarah Winnemucca had an expansive view of female domesticity. She

moved back and forth between emphasizing her status as "the chieftain's weary daughter" and emphasizing her status as a woman who moved into male realms. The book as well as the portrait emphasized her femininity, her vulnerability, and her toughness. She was often crying, but she also rode alone or in the company of other women across dangerous terrain in war. She cared for children; she faced down men. This resonated with white female readers.[9]

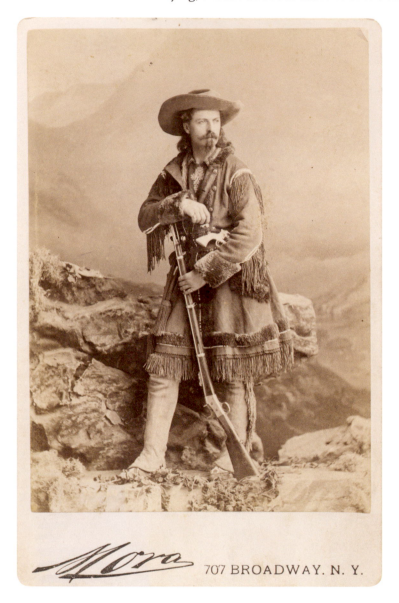

707 BROADWAY. N. Y.

Fig. 2.6
WILLIAM F. CODY
(1846–1917) by José Maria Mora (1849–1926), albumen silver print, c. 1875. *National Portrait Gallery, Smithsonian Institution, Washington, D.C.*

In the nineteenth century Winnemucca's narrative would have been read against the narrative of another figure, William F. "Buffalo Bill" Cody (fig. 2.6). Buffalo Bill Cody became the most famous American of his age by endless self-promotion and by blurring the boundaries between his personal story and larger iconic stories of the Pony Express rider, the army scout, and the Indian fighter. His portrait captured the ambiguity. It is both identifiably Cody and indistinguishable from the iconic image of the scout.[10] Cody attached the scout to a narrative of domesticity. His Wild West show was about the extension of the home—the white domestic space—into a wild interior. Buffalo Bill actually got along well with Indian peoples and enjoyed their company, but when he enlisted them to perform in his show, the narrative pitted brave white men waging wars in protection of white homes and families against remorseless and bloodthirsty savages.[11]

Winnemucca reversed that narrative by putting not just herself but women at the center of her story. Whereas Cody featured Indian attacks and the white man's defense and made his hero the white man, Winnemucca made her story one of white rape and pillaging and made her hero the Indian woman. The domestic space was now an Indian space, and it was Indian women who were in constant danger from white men. The supposed defenders of women and children in Buffalo Bill's narrative were, in Winnemucca's telling, dangerous sexual predators. Cody's scouts, cowboys, and settlers were rapists and cowards; none of them could be trusted. The white men who could be trusted were either soldiers whom Winnemucca cleverly detached from the Cody narrative, and who made friends of the Indians, or men who married Indian women and entered Indian domestic circles. She did all this in Victorian prose appealing to the sympathies of a largely white, feminine, Victorian audience that was predisposed to accept versions of predatory male behavior. It is impossible to boil Winnemucca's photographs and the writing that explained them into any simple conflict between "tradition" and "modernity."[12]

Both Buffalo Bill and Sarah Winnemucca were exceptional people, yet what they accomplished might seem to be literary or theatrical sideshows while the federal government

and corporations occupied the center ring. The processes at work in the sideshows, however, were the same as in the main ring. Outside of the federal government, the most powerful institutions shaping the West were railroad corporations. Stephen J. Field was a Supreme Court justice who was both a friend of the Southern Pacific Railroad and a recipient of that corporation's favors. In 1893 he wrote Collis P. Huntington, then president of the Southern Pacific, asking for his portrait to put in a gallery of pictures of railroad men that he was assembling because, he believed, "the great railroad builders of the age . . . have done as much, if not more than any others to advance the commercial interests of the world, and thereby promote civilization."[13]

Field intended that his gallery commemorate titans, men who were important to him as "a class" rather than as individuals, and their portraits—as much as the portraits of scouts—were at once discrete and indistinguishable: James J. Hill created the Great Northern Railroad; Collis P. Huntington was one of four "Associates" who controlled the Central Pacific and Southern Pacific railroads;[14] and Henry Villard twice led the Northern Pacific Railroad. They were among the richest and most prominent men of their time, but their portraits were literally dark. In Huntington and Hill's case these stocky, stolid, Victorian men formed a gloomy mass at the center of the frame (plates 16 and 18). They posed like locomotives—large and looming—but they seem less distinctive than the locomotives that they owned. They convey the stolid respectability that the portraits were meant to convey.

Such portraits were as artful in their stolidity as those of Sarah Winnemucca and Buffalo Bill Cody were in their calculated flamboyance. Railroad men such as Huntington and Hill needed portraits to create images of trust and reliability because the people who knew them best were not inclined to trust them. Huntington shocked even world-weary Charles Francis Adams, who was president of the Union Pacific. When the "old scoundrel," as Adams referred to Huntington, sought $50,000 to pass legislation in Congress, he was more "cynical, coarser-fibred and openly canting in his talk than ever before."[15] The same year that Field wrote Huntington asking for his portrait, Thomas Oakes of the Northern Pacific wrote that Wall Street regarded James J. Hill as being "out of his mind. Even his friends are disturbed about his mental condition,"[16] Oakes wrote. But Oakes's superior, Henry Villard, chairman of the board of the Northern Pacific, was no more highly thought of in 1893. E. L. Godkin, editor of *The Nation* and the *New York Post*, reported to James Bryce that "our friend Villard" was "universally denounced as a visionary, if not worse, who has made money at the expense of other people. . . . The unfortunate truth is that of six companies of which he was at the forefront, everyone has either gone to smash or depreciated enormously in value, and the losers naturally ask how it is that he has so much money? How vain is human greatness."[17] The portraits communicated the respectability and trust that was in short supply for subjects who were regularly corrupt and sporadically incompetent.

Field's praise of leading railroad men and their scorn for each other were two sides of the same coin, and both indicated that in the affairs of large enterprises individuals mattered. That corruption was not punished did not surprise Gilded Age Americans any more than the fact that virtue was not rewarded. However, many Americans expected that incompetence would not yield wealth. The question that Godkin's "losers" asked—"how it is that he has so much money?"—revolved around relationships between individuals.

Gilded Age corruption and wealth in the West and elsewhere were artifacts of friendship. Personal relations between individuals mattered a great deal. The Gilded Age did not invent

friendship, but it perfected it. "Friend" was how the Associates of the Central Pacific Railroad often addressed each other: Friend Huntington, Friend Stanford, Friend Crocker, Friend Hopkins. Their correspondence reads like a Quaker meeting. The men who ran the railroads had journalists who were friends, executives in other corporations who were friends, and bankers who were friends. Above all, though, they had politicians who were friends. Friend was, perhaps, the key word in Gilded Age governance and in Gilded Age corporations. On "being asked the secret of political success," John Morrissey—"prize fighter, professional gambler and member of Congress . . . replied, 'Stick to your friends, and be free with your money.'" As a lawmaker told reporter George Alfred Townsend, "measures lived or died on friendship." It was not only good to have friends; it was essential.[18]

What was often missing from Gilded Age friendship was what seems to us its defining and necessary element: affection. It is not that these men never liked each other. When Mark Hopkins died, Huntington wrote: "I liked him so much and his death has hurt me more than I can tell. If I had not so much to do for the living I would stop for a time and think only of the dead."[19] But the writings of Huntington and his other Associates about Friend Stanford comprise a chronicle of amazement, dismay, and irritation at his greed, laziness, ignorance, and ineptitude. Huntington once wrote Stanford himself, saying, "I wish you would tell me whom to correspond with in Cal. when I want anything done; for I have become thoroughly convinced that there is no use in writing to you."[20] Mark Hopkins thought Stanford's key quality was his intellectual torpor. "He could do it," Hopkins told Huntington of some necessary task, "but not without more mental effort than is agreeable to him."[21] And it was not just the Associates who recorded their disgust. Ex-Senator John Conness of California railed against Stanford as "this immensely stupid man" who had forgotten that "I had helped make his fortune."[22] In this rage against Stanford was the conviction that individuals mattered.

The elimination of affection from corporate and political friendships in the Gilded Age was its genius. Friendship was a code—a network of social bonds between individuals that could organize political activity. Affection was not necessary.[23] Friendship was where the kind of men found in an Edith Wharton novel obtained their footing. In a Wharton novel both sex and money were at stake; in railroad friendship, only money was involved. In the novels of Wharton, Henry James, and even William Dean Howells, the businessmen husbands or fathers—who were so necessarily present but as necessarily alien to the love affairs and friendships, as well as to the flirtations and conversations around which these works revolved—only blundered and did damage. The female characters created inchoate networks too insubstantial to support the ponderous men whom they accidentally ensnared. But this is too simple a take on both the novels and the Gilded Age. The material networks—the bands of steel that girded the continent—also depended on other inchoate networks that mirrored the secrets, courtships, and friendships of the drawing room and dining room. The cultural connections of business and politics central to the railroads were the domain of friends.[24]

Precisely because corporations such as those that Hill and Huntington headed were complicated and opaque to outsiders, and because investors neither understood the financial instruments they were offered nor believed the claims made in official reports and newspapers, people often put their trust in individuals rather than corporations. The fact that this trust was often misplaced did not change the importance of individuals to the enterprise.

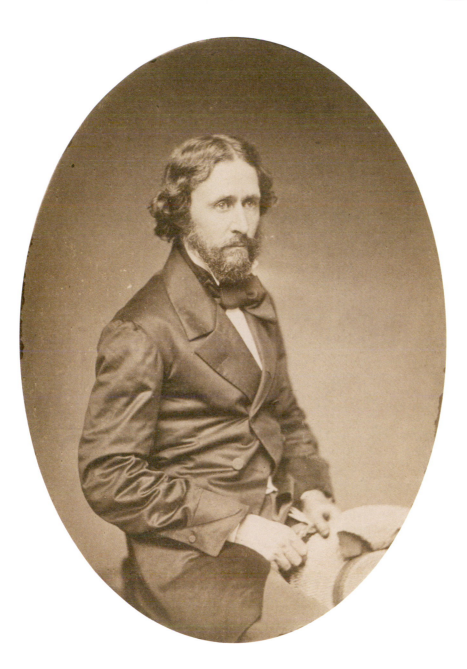

FIG. 2.7
JOHN C. FRÉMONT
(1813–1890) by Samuel Root
(1819–1889), salted-paper
print, c. 1856. *National
Portrait Gallery, Smithsonian
Institution, Washington, D.C.*

In the early 1870s Jay Cooke was the banker behind the Northern Pacific Railroad. Self-made, patriotic, well-connected, and deeply religious, Cooke was a man whose word was trusted because of his success in marketing the U.S. government bonds that financed the Civil War.[25] As he wrote the president of the Northern Pacific, "You must remember, that my responsibility is greater than that of all the rest put together, as the money thus to be expended comes in 90 cases out of a hundred from those who purchase simply on my word, not on the word of Jay Cooke & Co. in this case so much as my personal reputation."[26] Yet Cooke deceived, lied to, and manipulated these investors, making his deceptions all the more serious and his fall all the harder.

The corrupt themselves made distinctions based on character. It was not just the impressive string of failures that John C. Frémont (fig. 2.7) had strung together by the end of the Civil War that alienated him from the benefits of trust and friendship. It was also what men like Cooke regarded as his character. Frémont had gained fame as the pathfinder exploring the West and helping bring California into the Union. He had been the darling of the nation. However, his California activities ended in his court-martial, and on his later

expeditions what had earlier seemed daring now seemed only reckless and ignorant. Men straggled out of the mountains bearing tales of cannibalism. In 1856 Frémont had been the Republican candidate for the president of the United States. He lost. He became a Civil War general and nearly lost Missouri before Lincoln sacked him. Ulysses S. Grant served under him. Grant found him a man of mystery: "You left without the least idea of what he meant or what he wanted you to do." By the early 1870s Frémont was a man so expert at transmuting opportunity into spectacular disaster that he was not only capable of squandering a gold mine, he actually did squander a gold mine.[27]

Frémont became president of the Memphis, El Paso, and Pacific Railroad. Many fledgling transcontinentals never reached the Pacific, but few raised as much money and built as little track as Frémont's road. In Paris during the summer of 1869, where he remained while his wife, Jessie, and his family toured Europe, his agents solicited French investments and he spent his time trying to seduce the much younger Vinnie Ream. She was the "young lady artist" who later "petrified," as Mark Twain put it in *The Gilded Age*, Abraham Lincoln into a statue with an expression that indicated he was "finding fault with the washing." This is the statue that now stands in the Capitol rotunda.[28]

By 1871 the man who had aspired to be president of the United States was a railroad president and a criminal.[29] French courts tried him in abstentia and convicted him of fraud. His agents had forged documents, given false information, and swindled roughly $6 million from investors of limited means. Few who knew Frémont were surprised that his railroad crumbled. "Frémont is entirely unreliable in money matters," Jay Cooke wrote his brother Harry in 1871," and it injures any one to have any connection with him."[30]

The politics of friendship and the solicitations of trust—all of them based on personal networks—indicated that the corporations were not simply bureaucracies filled with faceless but efficient drones. When Charles Francis Adams of the Union Pacific spoke to the undergraduates of Harvard University in 1886, he filled his talk with homilies about the modern corporation in which "the individual withers, and the whole is more and more."[31] In practice, however, the corporation was closer to the army of Adams's Civil War experience, where "the constitutionally unqualified were to instruct the uninformed,"[32] and "the regimental quarrels were incessant; the spirit of insubordination was rife and in the air."[33]

The Union Pacific and other railroads were full of men intent on demonstrating their manhood, giving full rein to their anger, and allowing their individual resentments to throw the whole machine off the tracks. "Pride, prejudice and anger," Adams wrote, "should have nothing whatever to do with business," but Adams's managers were aggressive and testy. They were, in his terms, "boys" who "lost their temper . . . so that they go in for it regardless of the degree to which their clothes will be torn." They had "no regard whatever for the interests entrusted to their care."[34] Far from being throwbacks, they anticipated a new ideal of masculinity. Pride, prejudice, and anger were part of their makeup and they were proud of it. They would not be pushed around.[35] Adams protested this, proclaiming railroad men "disposed to be altogether too 'smart'" and vowing "to jump very hard on any of our young men who resort to trickery, chicanery, smartness, or underhand dealing."[36]

Adams's subordinates were not men eager to have their individuality wither; they were not prototypes for a clichéd nineteenth-century bourgeoisie. They were more than the sum of their material interests and not reducible to a set of unitary bourgeois values.[37] Historians have often portrayed the discipline and the conventions of business and corporations as

stifling manliness and forcing it to find an outlet in leisure, but Adams placed it at the heart of his particular corporate culture.

The people Adams denounced do not appear in the portraits of the nineteenth-century West displayed here, but they are a reminder that the insistent and complicated subjectivity of the people of the West demands attention. This is not a retreat back to the clichés of individualism. I do not think that most people in the nineteenth-century West were individualists in the classic Tocquevillian sense of thinking their fate was in their hands. They knew better than that; they solicited favors so assiduously because they knew their fate depended on others. They knew what these portraits reveal—the tensions between a collective identity, a modern role, and the individual desire to bend these things to individual purposes. It is necessary to concentrate on what these portraits disguise and the words necessary to reveal their art, artifice, and context, but it is also necessary to come back to the distinct and individual people who stood or sat before the camera. Individualist was a role they could play, but it was a role. The role and the person were both real. The history of the West is neither the sum of individual lives nor the cultural roles that people played, but it includes both of these things. Neither were the simple products of institutions or large historical processes.

Notes

1. Alfred Doten, *The Journals of Alfred Doten, 1849–1903*, ed. Walter Van Tilburg Clark (3 vols.; Reno: University of Nevada Press, 1973), entry of Aug. 23, 1858, book no. 18, vol. 1: 433.

2. Ibid., entry of Oct. 17, 1856, book no. 4, vol. 1: 313; entry of July 6, 1858, book no. 18, vol. 1: 421; entry of Nov. 28, 1858, book no. 19, vol. 1: 456; and entry of Nov. 7, 1859, book no. 21, vol. 1: 515.

3. Ibid., entry of May 26, 1863, book no. 27, vol. 1: 704.

4. Ibid., entries of May 26, May 29, and June 2, 1863, book no. 27, vol. 1: 704–706.

5. Ibid., Dec. 1, 1864, book no. 30, vol. 2: 816.

6. Mick Gidley, *Edward S. Curtis and the North American Indian, Incorporated* (New York: Cambridge University Press, 1998).

7. Sarah Winnemucca Hopkins, *Life Among the Piutes: Their Wrongs and Claims* (Boston: G. P. Putnam and Sons and by the Author, 1883), 52, 87, 90, 209–10, 239, 267.

8. Ibid., 70, 77, 82, 86.

9. Ibid., 12, 34, 22, 23, 24, 26, 29, 85, 101, 104, 120, 151, 168–69.

10. Louis Warren, *Buffalo Bill's America: William Cody and the Wild West Show* (New York, Knopf, 2005), ix–xiv; and Richard White, "Frederick Jackson Turner and Buffalo Bill," in James Grossman, ed., *The Frontier in American Culture* (Berkeley: University of California Press, 1994), 39–40.

11. Warren, *Buffalo Bill's America*, 177, 195, 238, 254.

12. Winnemucca, *Life Among the Piutes*, 84, 92, 98, 102, 139.

13. Stephen J. Field to Collis P. Huntington [hereafter CPH], March 13, 1893, CPH Papers, 1856–1901 (Sanford, N.C.: Microfilming Corporation of America, 1978–1979), series 1, reel 51.

14. The three other Associates were Leland Stanford, Mark Hopkins, and Charles Crocker. E. B. Crocker was also an original Associate but suffered a stroke. David Colton was an Associate for several years before his death.

15. Adams Journal, Dec. 23, 1888, Adams Memorabilia, Charles Francis Adams II Papers, 1861–1933, Massachusetts Historical Society, microform.

16. Thomas Oakes to Charles Mellen, June 30, 1893, Letters Sent, 137.H.11.3 (B), letterpress book 34, vols. 58, 341, Minnesota Historical Society.

17. E. L. Godkin to James Bryce, Nov. 19, 1893, in William M. Armstrong, ed., *The Gilded Age Letters of E. L. Godkin* (Albany: State University of New York Press, 1974), 452.

18. The Morrissey quotation is from *Union Pacific Employees' Magazine*, Sept. 1886, 1. The second quotation is from Mark Wahlgren Summers, *The Era of Good Stealings* (New York: Oxford University Press, 1993), 109. See also John Conness to Isaac E. Gates, March 13, 1872, CPH Papers, series 1, reel 5; and Richard Franchot to CPH, Dec. 2, 1873, box 22, vol. 6: 5, Mark Hopkins Correspondence, Timothy Hopkins Transportation Collection, 1816–1942, M 97, Special Collections, Stanford University. For political friendship, see Glenn C. Altschuler and Stuart Blumin, *Rude Republic: Americans and Their Politics in the Nineteenth Century* (Princeton: Princeton University Press, 2000), 117–18.

19. CPH to Charles Crocker, April 12, 1878, CPH Papers, series 2, reel 6.

20. CPH to Leland Stanford, Oct. 25, 1871, and to Charles Crocker, May 17, 1871, in *Letters from Collis P. Huntington to Mark Hopkins, Leland Stanford, Charles E. Crocker, and E. B. Crocker* (privately printed), vol. 2: 275; and Mark Hopkins to CPH, Oct. 10, 1872, CPH Papers, series 1, reel 5.

21. Hopkins to CPH, Dec. 8, 1872, CPH Papers, series 1, reel 5.

22. Conness to CPH, Nov. 9, Nov. 17, 1875, CPH Papers, series 1, reel 8.

23. The best account of networks of family and friendship in American business is Pamela Walker Laird, *Pull: Networking and Success Since Benjamin Franklin* (Cambridge, Mass: Harvard University Press, 2006), esp. 2, 15, 22–23.

24. Paula Baker makes similar points in her book *The Moral Frameworks of Public Life: Gender, Politics, and the State in Rural New York* (New York: Oxford University Press, 1991), 27–32.

25. Henrietta M. Larson, *Jay Cooke, Private Banker* (Cambridge, Mass.: Harvard University Press, 1936), 254, 273–95.

26. Ibid., 351.

27. Tom Chaffin, *Pathfinder: John Charles Frémont and the Course of American Empire* (New York: Hill and Wang, 2002), 469.

28. Speech of Hon. Jacob M. Howard in the Senate of the United States, June 22–23, 1870, Graff 1979, Newberry Library, Chicago, 7; Howard Lamar, *The Far Southwest, 1846–1912: A Territorial History*, rev. ed. (Albuquerque: University of New Mexico Press, 2000), 392; H. Craig Miner, *The Corporation and the Indian: Tribal Sovereignty and Industrial Civilization in Indian Territory, 1865–1907* (Columbia: University of Missouri Press, 1976), 44–46; Chaffin, *Pathfinder*, 490–93; and Mark Twain and Charles Dudley Warner, *Gilded Age: A Tale of To-Day* (1874; repr. New York: Harper & Brothers Publishers, 1915), 236.

29. For accusations of Frémont's complicity in the fraud, see Speech of Hon. Jacob M. Howard in the Senate of the United States; "Memphis, El Paso & Pacific Rail Road Co. (Explanation of Wm. Aufermann)," Corporation of Foreign Bondholders Council, the Newspaper Cuttings Files of the Council of Foreign Bondholders in the Guildhall Library, 2nd series, London, microform; and *American Railways, 1874–1893*, vol. 2, reel 219.

30. Jay Cooke to Brother Harry, March 20, 1870, Northern Pacific, Letters No. 1 (letterbook), Jan. 19, 1870–Sept. 27, 1871, Private Letters, Jay Cooke, Cooke Collection, Historical Society of Pennsylvania; and Speech of Hon. Jacob M. Howard in the Senate of the United States, 11.

31. "Railroad Management: A Lecture to Harvard Students by Charles Francis Adams, Jr.," *New York Times*, March 17, 1886, p. 5.

32. Charles Francis Adams, *An Autobiography*, with a memorial address delivered Nov. 17, 1915, by Henry Cabot Lodge (Boston: Houghton Mifflin Co., 1920), 131.

33. Ibid., 147.

34. Adams to Hugh Riddle, Nov. 8, 1884, and Adams to Callaway, Dec. 4, 1884, Union Pacific, President's Office, Outgoing Correspondence, series 2, vol. 24, reel 21, Nebraska State Historical Society, Lincoln, microform.

35. Gail Bederman, *Manliness & Civilization: A Cultural History of Gender and Race in the United States, 1880–1917* (Chicago: University of Chicago Press, 1995), 18–19.

36. Adams to Charles E. Perkins, Nov. 2, 1886, series 2, vol. 36, reel 32, and Adams to J. Savage, April 11, 1887, series 2, vol. 41, reel 36, Union Pacific, President's Office, Outgoing Correspondence, Nebraska State Historical Society, Lincoln, microform.

37. As Bederman has argued, manhood and manliness were not synonymous in the late nineteenth century (*Manliness & Civilization*, 5–20). The literature on manhood has grown increasingly sophisticated and nuanced. Thomas Winter, *Making Men, Making Class* (Chicago: University of Chicago Press, 2002), sees the generation born during and just after the war as still embodying the earlier vision of manhood. He, unlike Bederman, sees manhood as remaining dominant over manliness (1–27). Winter also gives a detailed bibliography of this literature on manliness (149–50).

Photographic Portraits
from the American West
1845-1924

Captions by

Frank H. Goodyear III (FHG)

Maya E. Foo (MEF)

Amy L. Baskette (ALB)

LAND

IN THE TRANS-MISSISSIPPIAN WEST, land has long been a source of power, riches, and inspiration. Drawn to what this land held, American settlers headed west in increasing numbers beginning in the 1840s. There they pursued new opportunities, some of which were realized, others not. This westward migration also precipitated frequent conflicts, and throughout the nineteenth century the U.S. military clashed repeatedly with foreign rivals and with tribal nations that saw this land as their own. Many questions surrounded the future of these lands: Who was to control them? How would they be used? What exactly awaited settlers? This section highlights those American politicians, military leaders, industrialists, preservationists, writers, and artists whose interest in and engagement with these lands profoundly shaped how they would be understood by the century's end.

The American claim is by the right of our manifest destiny to overspread and to possess the whole of the continent which Providence has given us for the development of the great experiment of liberty and federative self-government entrusted to us.

⤙ JOHN L. O'SULLIVAN in an editorial in the *New York Morning News*, 1845

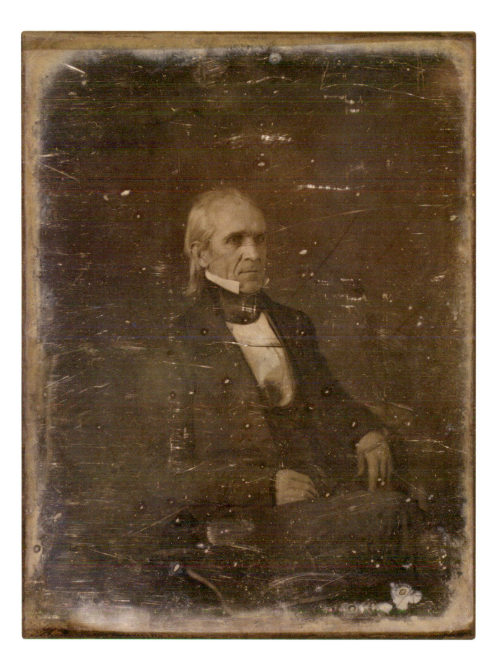

JAMES K. POLK
(1795–1849)
Born Mecklenburg County, North Carolina

James K. Polk, the eleventh president of the United States, spent much of his one term in the White House consumed by conflicts in the West. Despite being a Jacksonian Democrat who favored states' rights over an expanded federal role in political affairs, Polk inherited upon his election in 1844 two crises that demanded a national response. In the Pacific Northwest, questions lingered about the boundary between the United States and Great Britain. After considerable back-and-forth, the two nations agreed upon the forty-ninth parallel, and a crisis was averted. In the Southwest, however, Polk moved the nation toward war. When Mexican authorities refused to acknowledge the annexation of Texas, Polk ordered General Zachary Taylor to advance a military force to the Rio Grande, where in 1846 hostilities broke out. In this conflict, the U.S. Army was victorious, and with the signing of the Treaty of Guadalupe Hidalgo in 1848, Polk fulfilled an earlier campaign promise to acquire California. (FHG)

1.

MATHEW BRADY (1823?–1896)
Whole-plate daguerreotype,
21.3 × 15.9 cm (8 ⅜ × 6 ¼ in.),
1849
*Prints and Photographs Division,
Library of Congress, Washington, D.C.*

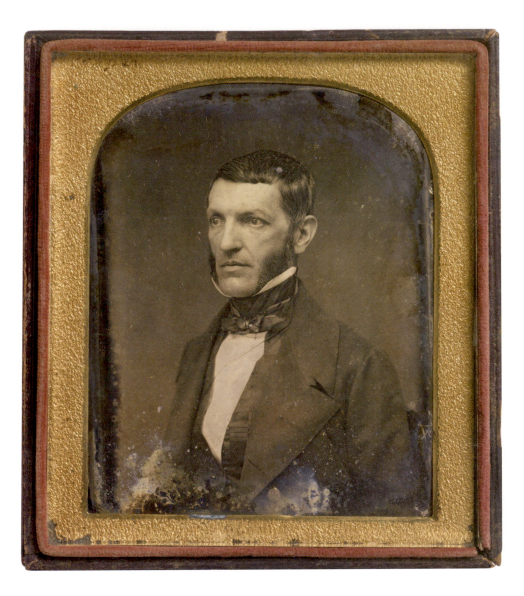

George Bancroft
(1800–1891)
Born Worcester, Massachusetts

2.

John Plumbe, Jr. (1809–1857)

Quarter-plate daguerreotype,
10.7 × 9.3 cm (4 ³⁄₁₆ × 3 ¹¹⁄₁₆), 1846

*National Portrait Gallery,
Smithsonian Institution*

Best remembered for his magisterial ten-volume *History of the United States* (1834–1874)—
one of the first comprehensive histories of America—George Bancroft also played an
active part in Democratic Party politics in the 1840s. Though defeated in the campaign for
governor of Massachusetts in 1844, he was tapped the following year by James K. Polk for
the post of secretary of the navy. In this position Bancroft acted decisively in supporting
the newly elected president's expansionist policies. In the lead-up to the Mexican War, he
directed the Pacific naval squadron to occupy San Francisco Harbor and other key California
ports. Then, having been reassigned as the acting secretary of war, Bancroft ordered General
Zachary Taylor to lead his military force into the contested Texas borderland—an action
that led directly to war with Mexico. Following Taylor's victory in the 1848 presidential
election, Bancroft left public office and returned to his work as a historian. (FHG)

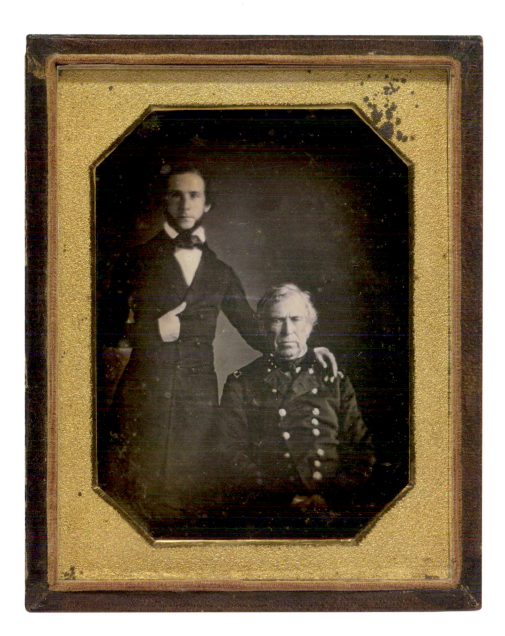

ZACHARY TAYLOR
(1784–1850)
Born Orange County, Virginia

This daguerreotype shows Zachary Taylor—the hero of the Mexican War—seated next to his chief of staff, William Bliss. A career military officer, Taylor served more than three decades on the western frontier, where he earned the nickname "Old Rough and Ready" for his unpolished demeanor and courage under fire. In 1846 Taylor was ordered to the Rio Grande, the southern boundary claimed controversially by Texas. This action upset Mexican authorities, who ordered a large force to drive Taylor's army out. In a series of battles that followed—most famously at Palo Alto, Monterrey, and Buena Vista—Taylor distinguished himself as a military commander. After the war, Taylor reluctantly agreed to run for president and went on to win the 1848 campaign. Desirous of unifying the nation, he contributed instead to sectional tensions by adamantly refusing to extend slavery into the territories. Taylor died unexpectedly in 1850 after only sixteen months in office. (FHG)

3.

UNIDENTIFIED PHOTOGRAPHER

Quarter-plate daguerreotype,
10.8 × 8.2 cm (4 ¼ × 3 ¼ in.),
c. 1848

*National Portrait Gallery,
Smithsonian Institution; acquired
in part through the generosity of the
Quaker Oats Company*

ANDRÉS PICO
(1810–1876)
Born San Diego, California

4.

UNIDENTIFIED PHOTOGRAPHER

Quarter-plate daguerreotype,
14 × 10.8 cm (5 ½ × 4 ¼ in.),
c. 1850

*Seaver Center for Western History
Research, Los Angeles County Museum
of Natural History, California*

This daguerreotype pictures Andrés Pico, the commander of the Californio military during the Mexican War. His older brother was Pio Pico, the last Mexican governor of Alta California prior to the U.S. annexation of the territory. With the outbreak of war in May 1846, both men led an effort to repulse the Americans. At the Battle of San Pasqual—fought in December outside of San Diego—Andrés Pico was victorious in the bloodiest battle of the California campaign. However, the following month he was defeated by a force under the command of John C. Frémont and compelled to sign an armistice. Pico remained in southern California after the war, becoming involved for a short time in a gold mining venture. He later moved into politics and was elected a state senator in 1860. A large ranch owner, Pico supported the growing railroad network in California and in 1864 actively promoted President Abraham Lincoln's reelection. (FHG)

WINFIELD SCOTT

(1786–1866)

Born near Petersburg, Virginia

Winfield Scott served as the commanding general of the U.S. Army during the Mexican War. Known as "Old Fuss and Feathers" for his insistence on military discipline, he directed the 1847 campaign that captured the coastal city of Veracruz. From there he led U.S. forces west to Mexico City, where he again defeated the Mexican army and occupied the city. Although President James K. Polk urged him to continue the military campaign, the American diplomat Nicholas Trist proceeded to negotiate and sign the Treaty of Guadalupe Hidalgo, which ended the war and ultimately ceded to the United States 525,000 square miles of territory in the present-day Southwest. Scott set his sights on the White House on several occasions but was never elected. When he retired from the military in 1861—roughly the year this photograph was taken—he had compiled more than fifty years of service in the military. (FHG)

5.

MATHEW BRADY STUDIO
(active 1844–1894)

Salted-paper print, 47 × 39.8 cm (18 ½ × 15 ¹¹⁄₁₆ in.), c. 1861

National Portrait Gallery, Smithsonian Institution

6.

James McClees (1821–1887)
and Julian Vannerson
(c. 1827–1875)

Salted-paper print,
18.8 × 13.4 cm (7 ⅜ × 5 ¼ in.),
c. 1859

*National Portrait Gallery,
Smithsonian Institution; gift of
Roger F. Shultis, 1986*

Sam Houston

(1793–1863)
Born Rockbridge County, Virginia

As commander in chief of the Texas army during the Texas Revolution in 1835–1836, Sam Houston led the forces that secured Texas independence from Mexico. Wounded at the climactic Battle of San Jacinto, he was elected shortly thereafter to be the first president of the new Republic of Texas. In this position Houston encouraged the annexation of Texas to the United States, a decision that legislators ultimately agreed upon in 1845. The following year he was elected to the first of three terms in the U.S. Senate. This signed photograph shows Houston at the end of his Senate career, a period when he worked hard to preserve the Union during the fractious lead-up to the Civil War. Elected governor of Texas in 1859, he was removed from office two years later when—Texas authorities having voted to secede—he refused to take an oath of allegiance to the Confederacy. (FHG)

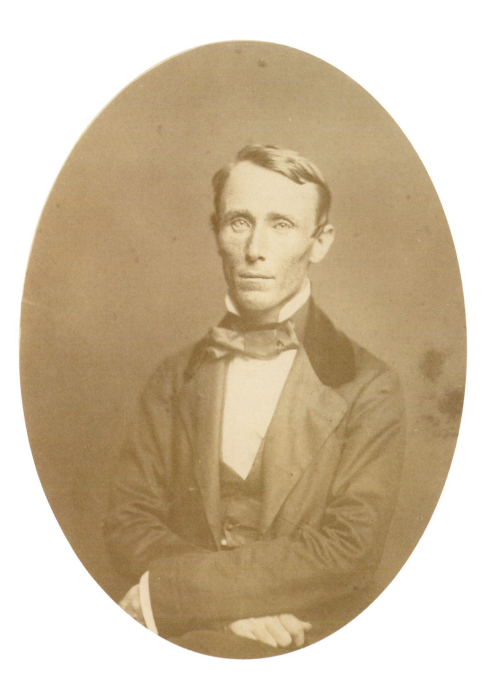

William Walker
(1824–1860)
Born Nashville, Tennessee

Described by one obituarist as a "mischievous man," William Walker was intent on establishing an American colony in Latin America in the years before the Civil War. Having failed at medicine and law, Walker left in 1850 for California, where he found work at a San Francisco newspaper. In 1853 he initiated his first "filibustering" expedition, leading a group of followers to Baja California and proclaiming it the Republic of Lower California. Mexican authorities were not pleased and promptly dispatched a force to drive Walker out. After escaping across the border, Walker was arrested by U.S. Army officials but was later acquitted in court. Many Americans at the time sympathized with Walker's goals, an attitude that emboldened him to organize a new colonizing expedition. On this occasion Walker chose Nicaragua. Once again, though, his venture failed. Walker was ultimately executed by a firing squad in Honduras. (FHG)

7.

Webster Brothers
(active 1850s)

Salted-paper print,
18.3 × 13.3 cm
(7 3/16 × 5 1/4 in.), c. 1857

*National Portrait Gallery,
Smithsonian Institution*

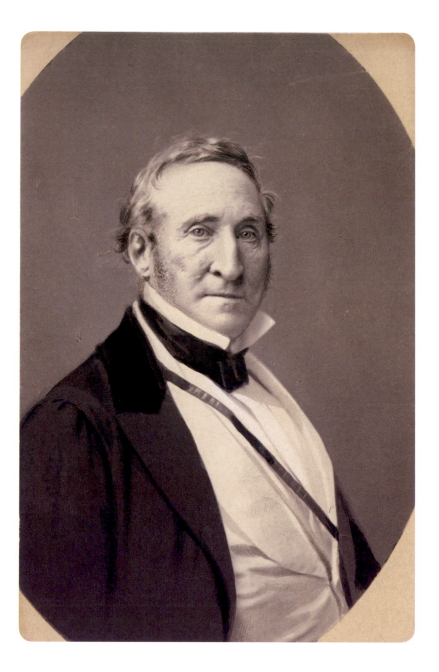

Thomas Hart Benton
1782–1858
Born near Hillsboro (now Hillsborough), North Carolina

8.

Unidentified photographer

Salted-paper print,
16.5 × 10.8 cm (6 ½ × 4 ¼ in.),
c. 1857

George R. Rinhart Collection

Elected to the U.S. Senate from Missouri in 1820, Thomas Hart Benton held this office for thirty years. During his tenure he became well known for his advocacy of westward expansion and for his opposition to slavery's extension into the West. Though a slaveholder himself, Benton looked down on the institution, believing that it would tear apart the nation. His declaration against slavery in the West put him increasingly at odds with his own Democratic Party and with popular opinion in his own state, and in 1850 he failed to win reelection. While he expressed genuine affection for his son-in-law John C. Frémont, he was unwilling to support his presidential campaign in 1856 out of fear that the newly created Republican Party would lead the South to secede. A fervent supporter of Manifest Destiny, Benton consistently proposed or endorsed legislation that furthered the West's exploration and settlement. (FHG)

JOHN C. BRECKINRIDGE
(1821–1875)
Born Lexington, Kentucky

This daguerreotype shows Kentucky congressman John C. Breckinridge around the time of the passage of the Kansas-Nebraska Act of 1854. Having served as a major during the Mexican War, Breckinridge rose rapidly through the political ranks after being first elected to Congress in 1851. In the debate about slavery's future in the West, he and Illinois senator Stephen Douglas took a lead role in pressing for legislation that would allow settlers to decide for themselves whether to permit slavery in the new territories. Rendering the Missouri Compromise of 1820 "inoperative and void," the Kansas-Nebraska Act was hailed as a victory for states' rights and the pro-slavery South. Its passage upset many Northerners and helped to give birth to the Republican Party, which opposed slavery's extension in the West. Thereafter, Breckinridge continued his political ascension, becoming James Buchanan's vice president in 1856 and then running unsuccessfully for president in 1860. (FHG)

9.

WILLIAM R. PHIPPS
(active 1849–c. 1867)

Sixth-plate daguerreotype,
7.1 × 6 cm (2 ¹³⁄₁₆ × 2 ⅜ in.), c. 1855

*National Portrait Gallery,
Smithsonian Institution*

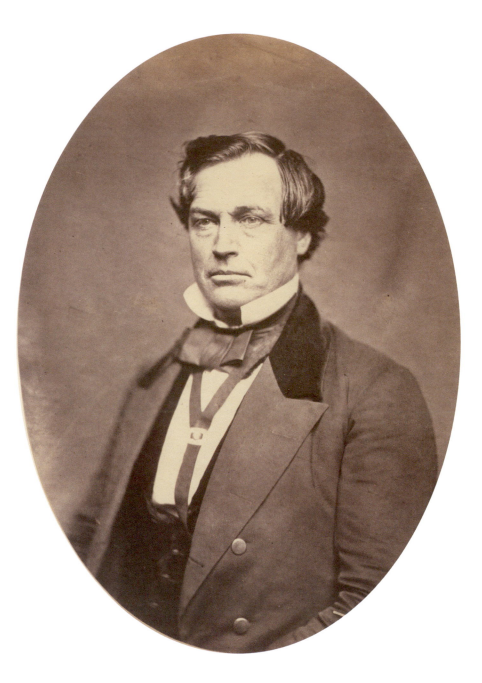

JAMES DENVER
(1817–1892)
Born Winchester, Virginia

10.

WHITEHURST STUDIO
(active 1849–1860)

Salted-paper print, 18.4 × 3.3 cm
(7 ¼ × 5 ¼ in.), c. 1856

*National Portrait Gallery,
Smithsonian Institution; gift of
Charles Isaacs and Carol Nigro*

On the day in 1857 that President James Buchanan appointed James Denver the governor of Kansas Territory, Kansas citizens voted to accept the Lecompton Constitution, which permitted slavery in the territory. A former captain under Winfield Scott during the Mexican War and a one-term congressman from California, Denver was immediately thrown into what became a protracted struggle over the question of slavery in the western territories. Violent skirmishes between settlers broke out throughout the region, and Denver—a staunch Unionist—was forced to acknowledge that all his powers would be required to "prevent them from cutting each other's throats." He was ultimately successful in squelching the turmoil, and in 1861 Kansas was admitted to the Union as a free state. A gold-hunting party sent out into western Kansas Territory by Denver in 1858 named in his honor the town that would later become the capital of Colorado. (FHG)

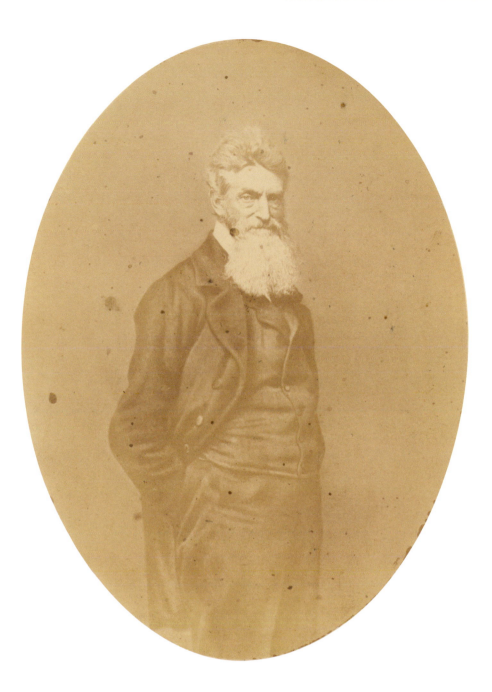

JOHN BROWN
(1800–1859)
Born Torrington, Connecticut

Prior to leading his famous assault in 1859 on the federal arsenal at Harpers Ferry, John Brown made national headlines for his abolitionist activities in Kansas and Missouri. Having worked as a tanner and later a wool merchant in the East, Brown decided in 1855 to travel to Kansas, where five of his sons had taken up homesteads. Pro-slavery "border ruffians" from Missouri increasingly threatened free-state supporters in Kansas, and the sons hoped their father would bring weapons to protect them. Following an attack on the town of Lawrence, Kansas, by pro-slavery forces, Brown joined a guerrilla band that ultimately killed five men in Pottawatomie County, an act that further escalated regional tensions and led to the burning of the town of Osawatomie by pro-slavery forces. These events served as a prelude to Brown's eventual plan to lead a mass slave uprising—a goal that fell short when he was captured and hung at Harpers Ferry. (FHG)

11.

JAMES WALLACE BLACK (1825–1896), after an 1859 daguerreotype by Martin M. Lawrence

Salted-paper print, 18.7 × 3.5 cm (7 ⅜ × 5 ⁵⁄₁₆ in.), 1859

National Portrait Gallery, Smithsonian Institution

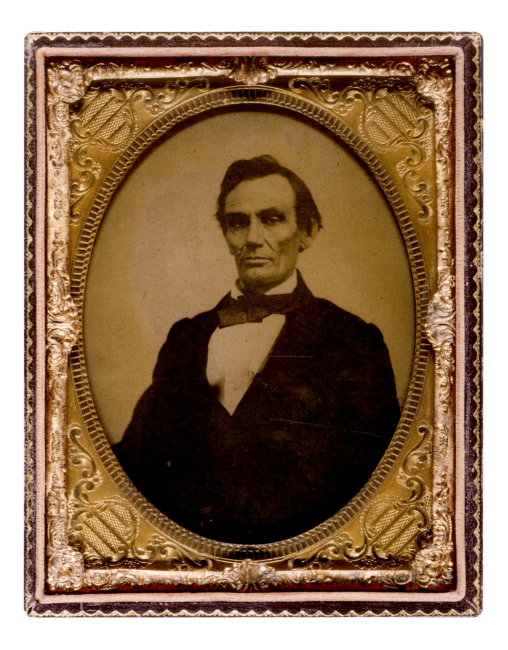

ABRAHAM LINCOLN
(1809–1865)
Born Hardin County, Kentucky

12.

Wɪʟʟɪᴀᴍ Jᴜᴅᴋɪɴs Tʜᴏᴍsᴏɴ

(lifedates unknown)

Ambrotype, 12.7 × 9.5 cm

(5 × 3 ¾ in.), 1858

*National Portrait Gallery,
Smithsonian Institution*

The first president born west of the Appalachian Mountains, Abraham Lincoln actively supported America's westward expansion. In a series of legislative acts—all passed in 1862 during a period of the Civil War when the Confederacy stood poised to succeed in its campaign to secede from the Union—Lincoln dramatically enlarged the federal role in promoting settlement in the West. In addition to creating the Department of Agriculture, he signed the landmark Homestead Act, thereby opening millions of acres of public land for farming and ranching. He also passed the bill that established the land grant college system and signed legislation that authorized the creation of the first transcontinental railroad, insisting on it having a northern rather than a southern route. Opposed to slavery's expansion, Lincoln worked to limit the Confederacy's influence in the West. In doing so, he transformed the relationship between the East and the West. (FHG)

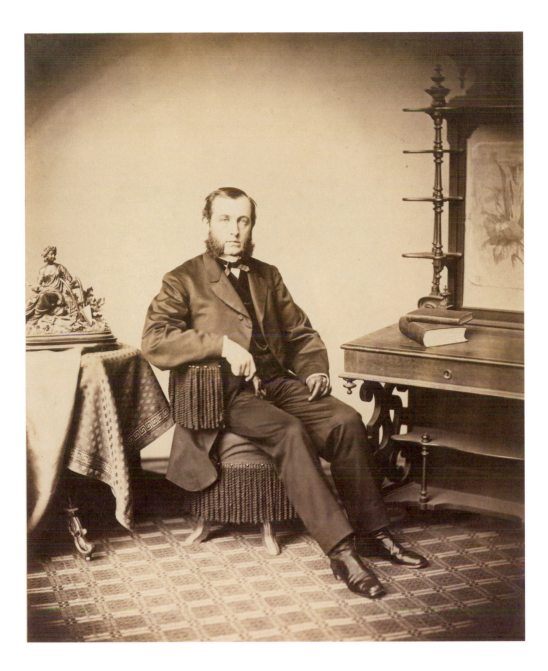

JOSEPH GLIDDEN
(1813–1906)
Born Charlestown, New Hampshire

As a cattle rancher in Illinois, Joseph Glidden was familiar with the difficulties of containing livestock on land that was largely empty of traditional fencing materials such as timber and stone. In 1873, at a local county fair, he was inspired by an exhibit of armored wire fencing made of wood and metal points. Glidden revised the idea and improved the design by twisting short pieces of wire into sharp points, which were then fastened around a wire. Although he did not invent barbed wire, Glidden received a patent for it in 1874 and sold half of his interest to an investor for $60,000. This portrait shows Glidden prior to his financial success. He sits beside a table on which rests a sculpture of a woman and a plow—a symbol of agrarian prosperity. Glidden's barbed wire proved very popular and further accelerated the establishment of ranches and farms throughout the West. (MEF)

13.

UNIDENTIFIED PHOTOGRAPHER

Salted-paper print, 49.4 × 40.5 cm (19 7/16 × 15 15/16 in.), c. 1858

National Portrait Gallery, Smithsonian Institution

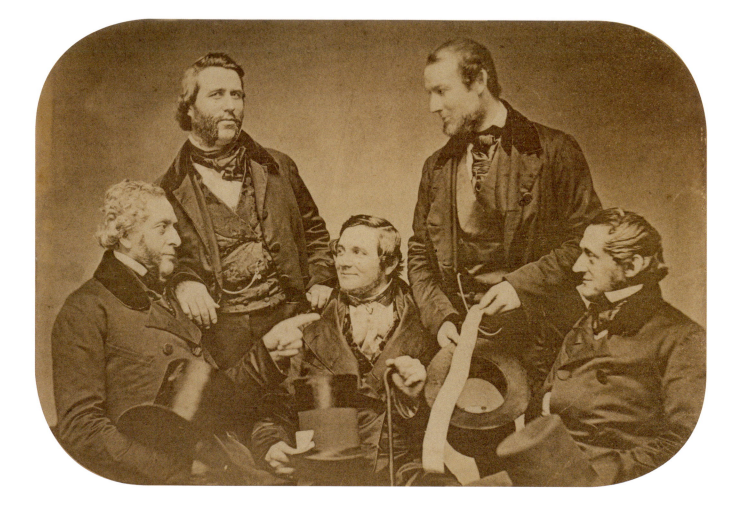

14.

ALEXANDER HESLER (1823–1895)

Albumenized salted-paper print,
13.7 × 19.7 cm (5 ⅜ × 7 ¾ in.),
c. 1857

*National Portrait Gallery,
Smithsonian Institution*

WILLIAM BUTLER OGDEN
(1805–1877)
Born Walton, New York

Seated at the center in this group portrait is William Butler Ogden, the first mayor of Chicago and later the first president of the Union Pacific Railroad. Arriving in Chicago in 1835, Ogden was skeptical about the new town's future. Yet he soon came to believe that Chicago was well situated to grow into the industrial and transportation hub of the Midwest. To achieve this goal required significant investment in the regional infrastructure, and Ogden was aggressive in helping to build roads, railways, canals, and bridges. Having made a fortune in real estate, he invested in various new businesses and inventions, including Cyrus McCormick's reaper—a piece of machinery that would revolutionize agricultural production in the Midwest and on the plains. Given his experience with railroads, his political connections, and his enthusiasm for a transcontinental line, he was named the first head of the Union Pacific after its incorporation in 1862. (FHG)

LELAND STANFORD
(1824–1893)
Born Watervliet, New York

Leland Stanford immigrated to California during the gold rush and initially operated a series of stores near Sacramento. A supporter of the new Republican Party, Stanford was elected governor of California in 1861 and used this office to advance his dream of building a railroad east across the Sierras. While other partners oversaw the financial and engineering challenges, Stanford worked to ensure political support for the Central Pacific Railroad. His gubernatorial term lasted only two years, but he continued to play a lead role in managing the railroad's construction until its completion in 1869. Stanford was an aggressive businessman and over time built an extensive transportation network throughout California. The "Octopus"—as it was named by detractors—made him rich, yet led many to question such an extraordinary concentration of power and wealth. In 1884 Stanford's only child died at age fifteen. Grief-stricken, he gave the land and money to establish a university in his son's memory. (FHG)

15.

CHARLES M. BELL (1848–1893)

Albumen silver print,
14.3 × 10.2 cm (5 ⅝ × 4 in.),
c. 1880

George R. Rinhart Collection

Collis P. Huntington

(1821–1900)

Born Harwinton, Connecticut

16.

William Keith (1838–1911)

Gelatin silver print,
34.9 × 27.1 cm (13 ¾ × 10 ¹¹/₁₆ in.),
c. 1900

*National Portrait Gallery,
Smithsonian Institution*

"Buckle on your armor for the fight, for the ground once lost is lost forever." It was this sentiment that guided financier Collis P. Huntington, one of the "Big Four" (also known as the "Associates") who oversaw the construction of the western portion of the transcontinental railroad. Having joined the gold rush in 1849, Huntington had limited success operating trading posts in and around Sacramento. Eventually partnering with Mark Hopkins, Charles Crocker, and Leland Stanford, he helped to incorporate the Central Pacific Railroad in 1861. After President Abraham Lincoln signed the Pacific Railway Act the following year, the Central Pacific began to lay tracks eastward from California. At the same time, the Union Pacific Railroad moved westward from midcontinent. Sensitive to this rivalry, Huntington pushed crews working on the Central Pacific—including two thousand Chinese laborers—to complete as much track as possible. In May 1869 the two lines met at Promontory Point, Utah, where a great celebration was held. (MEF)

HENRY VILLARD
(1835–1900)
Born Speyer, Rhenish Bavaria

In 1883 the Northwest celebrated the completion of the Northern Pacific Railroad, America's second transcontinental railroad. To mark the achievement, company officials— led by Northern Pacific's president, Henry Villard—organized an elaborate ceremony at the location in Montana where the rail lines from the East met those from the West. This photograph shows a group who attended the festivities. Villard is seated at the center with a hat on his knee. A German immigrant who worked as a journalist during the Civil War, Villard became interested in the transportation industry after studying railroad bonds for a group of German investors. In 1881, hoping to build a rail and steamship empire in the Northwest, Villard assumed control of the Northern Pacific, which had struggled financially since it was first chartered in 1864, and led the effort to complete the line's construction. (FHG)

17.

FRANK JAY HAYNES (1853–1921)

Albumen silver print,
12.5 × 20.8 cm (4 15/16 × 8 3/16 in.),
1883

National Portrait Gallery, Smithsonian Institution; gift of Henry Villard

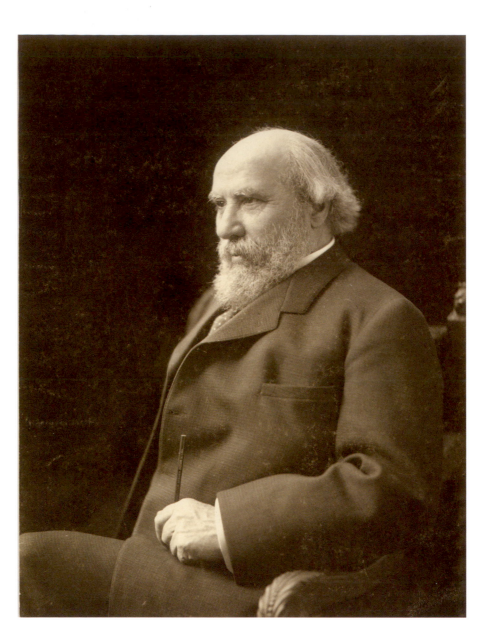

JAMES J. HILL
(1838–1916)
Born near Rockwood, Ontario, Canada

18.

PACH BROTHERS STUDIO
(active 1867–1993)

Gelatin silver print,
32.4 × 24.9 cm (12 ¾ × 9 ¹³⁄₁₆ in.),
1902

*National Portrait Gallery,
Smithsonian Institution; gift of the
Old Print Shop*

Often referred to as the "empire builder," James J. Hill rose from humble beginnings to command one of the largest railroad networks in the West. He acquired his first line in 1878 and over the course of the next four decades bought or built more than six thousand miles of railroad lines, principally on the northern plains and in the Pacific Northwest. The founder of the Great Northern Railway, Hill competed aggressively with the Union Pacific and the Northern Pacific railroads for control of the transcontinental freight business. Although he could be ruthless in his transactions, he was regarded by many as a relatively benevolent developer. In 1904 he was found in violation of the Sherman Antitrust Act and was forced to dissolve the holding company that controlled his various enterprises. Nevertheless, he and the Great Northern Railway continued to play a dominant role in the nation's transportation industry. (FHG)

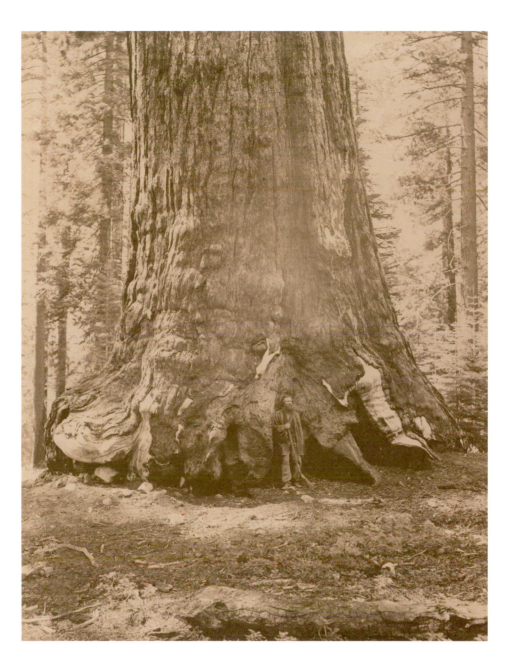

GALEN CLARK
(1814–1910)
Born Dublin, New Hampshire

Drawn to California by the gold rush, Galen Clark instead fell in love with the beauty of the Yosemite Valley and its surrounding forests. He built a cabin there in 1857, hoping to recover from a recent bout of tuberculosis. While hunting he discovered nearby a large grove of sequoia trees and named it after Mariposa County. In 1864, partially in response to Clark's promotional efforts to preserve this land, President Abraham Lincoln signed legislation granting to California the Yosemite Valley and the Mariposa Grove as park land. Clark became known at the time as the "Guardian of Yosemite." In this role he acted as a guide and a protector of the valley. San Francisco photographer Carleton Watkins met Clark on one of his many trips to Yosemite and created this mammoth plate image of Clark standing next to the "Grizzly Giant," one of the famous redwoods in the Mariposa Grove. (ALB)

19.

CARLETON WATKINS (1829–1916)

Albumen silver print,
52.1 × 39.8 cm (20 ½ × 15 ¹¹⁄₁₆ in.),
c. 1865–66

National Portrait Gallery, Smithsonian Institution

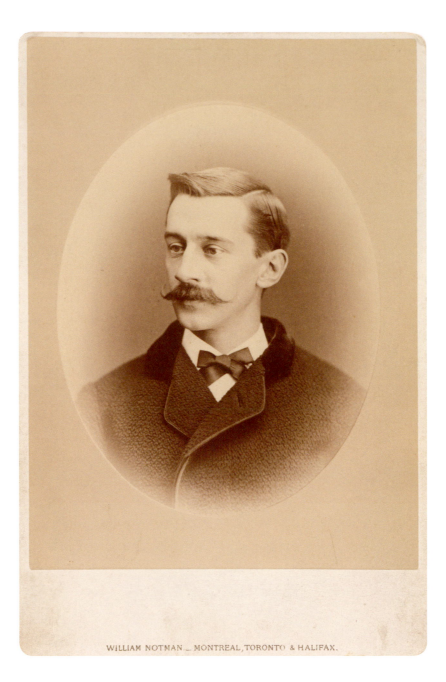

WILLIAM NOTMAN — MONTREAL, TORONTO & HALIFAX.

GEORGE BIRD GRINNELL
(1849–1938)
Born Brooklyn, New York

20.

WILLIAM NOTMAN (1826–1891)

Albumen silver print,
11 × 8.5 cm (4 ⁵⁄₁₆ × 3 ⅜ in.),
c. 1880

*National Portrait Gallery,
Smithsonian Institution*

Often called the "father of American conservation," George Bird Grinnell was instrumental in convincing others about the importance of using natural resources wisely. He lived in New York City but directed great attention to western lands and the region's Native peoples. Beginning in 1870, when he accompanied Yale paleontologist Othniel Marsh on a "bone-hunting" trip onto the plains, Grinnell tried to devote a portion of every year to travel and study in the West. Becoming editor in chief of *Forest and Stream* in 1881, he transformed this sportsmen's weekly into the nation's leading voice for conservation. In addition to helping to found several organizations devoted to this cause—including the Audubon Society, the Boone and Crockett Club, and the American Game Association—Grinnell also counseled his friend Theodore Roosevelt about the subject. One of his final achievements was leading the successful decade-long campaign to establish Glacier National Park. (FHG)

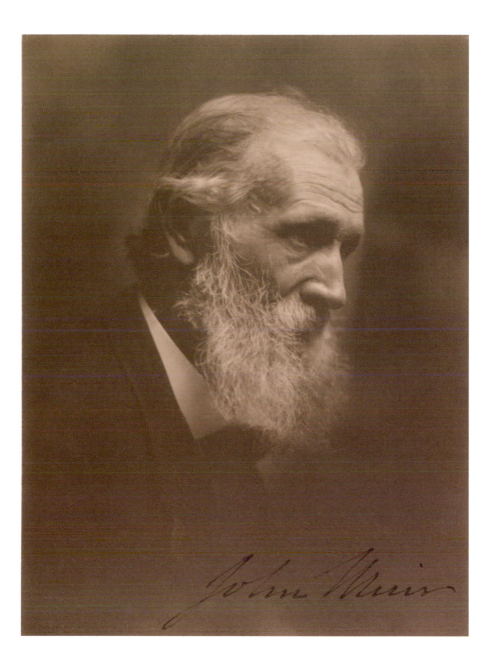

JOHN MUIR
(1838–1914)
Born Dunbar, Scotland

In describing Yosemite Valley's importance to modern society in 1912, naturalist John Muir explained, "Everybody needs beauty as well as bread, places to play in and pray in, where nature may heal and give strength to body and soul alike." Few individuals at the turn of the twentieth century were more eloquent in describing nature's beauty or in popularizing the idea of wilderness as a restorative. Settling in northern California in 1868, Muir enjoyed walking great distances. Though he hiked throughout the West, he found the Sierras most appealing. There he devoted much attention to studying and writing about the natural environment. He helped to set aside Yosemite as a national park in 1890 and two years later founded the Sierra Club to foster a wider appreciation for land preservation. In his role as Sierra Club president, he worked with several U.S. presidents to establish federally protected forest reserves. (FHG)

21.

WILLIAM DASSONVILLE
(1879–1957)
Platinum print, 20.5 × 15.3 cm
(8 ¹⁄₁₆ × 6 in.), c. 1910

National Portrait Gallery,
Smithsonian Institution

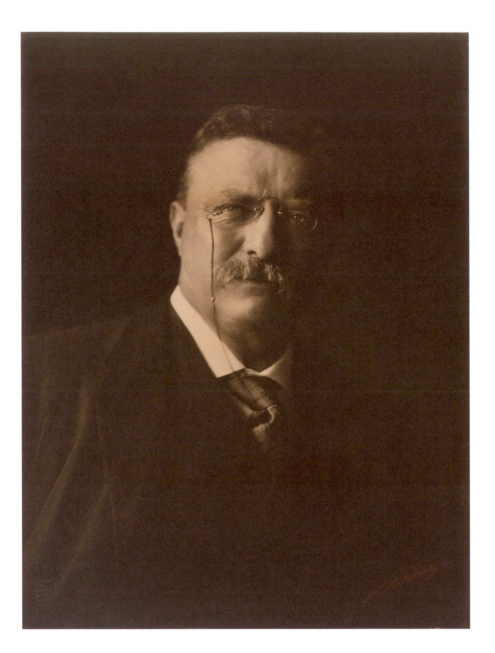

Theodore Roosevelt
(1858–1919)
Born New York City

22.

Edward S. Curtis (1868–1952)

Platinum print, 40 × 30.2 cm
(15 ¾ × 11 ⅞ in.), 1904

*National Portrait Gallery,
Smithsonian Institution*

Although he lived in the East, Theodore Roosevelt had a lifelong interest in the American West. After his first wife died during childbirth in 1884, the young New York assemblyman relocated to a ranch in western Dakota Territory, where he contemplated leaving politics for a career as a rancher and a writer. During this period he authored several books, including a biography of Missouri senator Thomas Hart Benton and a four-volume epic, *The Winning of the West*. This interest in the American West continued during his presidency. Believing that America needed to utilize its natural resources more rationally, he made conservation a national issue. In a series of legislative acts, he laid the foundation for twentieth-century land use policy. Native American history and culture also fascinated Roosevelt, and in 1907 he wrote the foreword to the first volume of Edward S. Curtis's photographic study, *The North American Indian*. Curtis created this portrait of the twenty-sixth president in 1904. (FHG)

GIFFORD PINCHOT
(1865–1946)
Born Simsbury, Connecticut

The first chief of the U.S. Forest Service, Gifford Pinchot was a significant voice at the turn of the twentieth century in debates about federal land management policy. Steering between the stance of preservationists who wanted lands set aside and that of business leaders who wanted unfettered access to extract timber and minerals, Pinchot believed that the guiding hand of government was required to efficiently manage the nation's public lands. President Theodore Roosevelt shared his ideas about conservation, and the two men worked together to empower the newly created Forest Service and to expand the number of national forest reserves. Although Pinchot upset preservationists by supporting the damming of the Tuolumne River in Yosemite's Hetch Hetchy Valley, he was instrumental in implementing policies that greatly reduced the wholesale exploitation of the nation's natural resources. An advocate of planned use and renewal, Pinchot was one of the founders of the modern conservation movement. (FHG)

23.

FRANCES BENJAMIN JOHNSTON
(1864–1952)

Platinum print, 18.9 × 23.8 cm
(7 ⁷⁄₁₆ × 9 ⅜ in.), c. 1901

*Prints and Photographs Division,
Library of Congress, Washington, D.C.*

WILLIAM MULHOLLAND
(1855–1935)
Born Belfast, Ireland

24.

JAMES W. BLEDSOE
(lifedates unknown)

Gelatin silver print,
20.3 × 25.4 cm (8 × 10 in.),
c. 1910

University of Southern California, on behalf of USC Special Collections

When engineer William Mulholland first arrived in Los Angeles in 1877, the town's population was fewer than ten thousand people. Thirty years later it had grown to more than two hundred thousand. Mulholland found work initially as a ditch tender for a privately owned water company. Given southern California's arid climate and its periodic droughts, the city's growth depended on a reliable water supply, and Mulholland's expertise in water management was increasingly in demand. In 1904 the city appointed him the superintendent and chief engineer of the public waterworks, and Mulholland and city leaders immediately went to work on a long-range water plan. The proposed solution was a 250-mile aqueduct from the Owens River Valley to Los Angeles. Despite vocal opposition from farmers and others, Mulholland led the massive construction effort, and by 1913 the aqueduct was complete. Over the next twenty years Mulholland remained at the center of the often-heated debate regarding the management of water in the West. (FHG)

FRANCIS PARKMAN
(1823–1893)
Born Boston, Massachusetts

Before the Civil War, few books rivaled Francis Parkman's *The Oregon Trail* in popularizing travel in the West. Published in 1849 during the height of the excitement surrounding the discovery of gold in California, *The Oregon Trail* chronicled an eight-month trip from St. Louis to Wyoming Territory that Parkman and his cousin Quincy Adams Shaw made in 1846. To Parkman, the son of a Unitarian minister, the West represented freedom and adventure. The book's romantic descriptions of their time chasing buffalo, interacting with frontiersmen, and meeting with members of the Lakota tribe promoted the idea that the West was a beautiful, yet untamed natural paradise. Parkman's family initially disapproved of his desire to become a historian, but the success of *The Oregon Trail* encouraged him to pursue this interest. His most substantial achievement—the seven-volume *France and England in North America* (1865–1892)—owed much to this earlier experience traveling in the West. (FHG)

25.

Attributed to ALBERT SOUTHWORTH (1811–1894) and JOSIAH HAWES (1808–1901)

Quarter-plate daguerreotype, 10.8 × 8.3 cm (4 ¼ × 3 ¼ in.), c. 1852

National Portrait Gallery, Smithsonian Institution

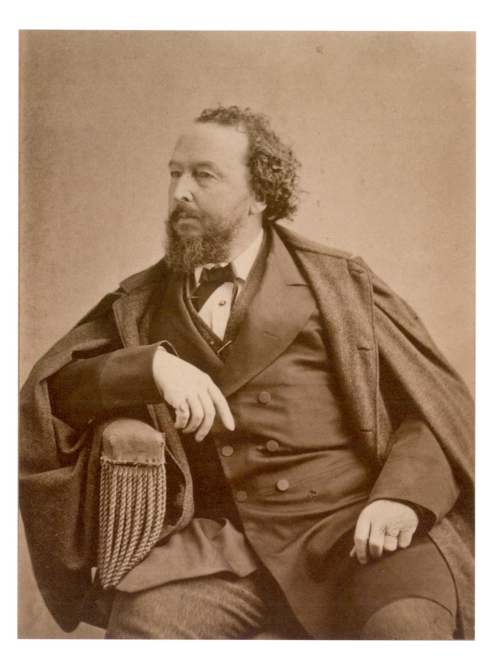

BAYARD TAYLOR
(1825–1878)
Born Kennett Square, Pennsylvania

26.

NAPOLEON SARONY (1821–1896)

Albumen silver print, 14 × 9.8 cm
(5 ½ × 3 ⅞ in.), c. 1870

*National Portrait Gallery,
Smithsonian Institution*

Published in 1850, Bayard Taylor's *Eldorado, or Adventures in the Path of Empire* provided a lively eyewitness account of California during the first year of the gold rush. Taylor wrote eloquently about the dramatic social and political changes then occurring in California—an area that the United States had recently acquired in the aftermath of the Mexican War. Taylor traveled to California in 1849 under the auspices of Horace Greeley's *New York Tribune*. Greeley hoped that Taylor might provide a series of short sketches for publication, but Taylor found so much to write about during his four months in California that he decided to publish a book as well. To readers who wondered about the West's impact on newcomers from the East, Taylor wrote, "A man, on coming to California, could no more expect to retain his old nature unchanged, than he could retain in his lungs the air he had inhaled on the Atlantic shore." (FHG)

SAMUEL CLEMENS
(1835–1910)
Born Florida, Missouri

Boston photographer George M. Baker completed this group portrait in 1869. It shows the writer Samuel Clemens standing between David Ross Locke ("Petroleum V. Nasby") on the left and Henry Wheeler Shaw ("Josh Billings"), two humorists who accompanied Clemens on a national lecture tour that year. Having published the satire *The Innocents Abroad* earlier that summer, the thirty-four-year-old Clemens was beginning to emerge as the preeminent American author of his generation. Until 1869 he had spent most of his life in the West. Growing up alongside the Mississippi River and then settling in Nevada and California during the Civil War, Clemens pursued various professions—river pilot, prospector, and journalist—before adopting the pen name "Mark Twain" and dedicating himself to a writing career. Though he would settle permanently in the Northeast at the end of this tour, it was in the West where he found his unique literary voice and many of the subjects of his later novels. (FHG)

27.

GEORGE M. BAKER
(lifedates unknown)

Albumen silver print,
22.1 × 15.8 cm (8 ¹¹⁄₁₆ × 6 ¼ in.),
1869

*National Portrait Gallery,
Smithsonian Institution*

Bret Harte
(1836–1902)
Born Albany, New York

28.

Jeremiah Gurney (1812–1895)

Albumen silver print, 8.3 × 7.3 cm
(3 ¼ × 2 ⅞ in.), c. 1870

*National Portrait Gallery,
Smithsonian Institution*

Through his short stories and essays Bret Harte presented many Americans with their first taste of the society that the California Gold Rush had produced. In stories such as "The Luck of Roaring Camp" and "The Outcasts of Poker Flat," Harte brought to life a colorful assortment of gamblers, miners, and other adventurers who, like him, had settled in California. Returning to the East in 1871, he found himself lionized as the West's signature writer. But Harte never felt any real kinship with the crude world he portrayed, and his later western stories paled in comparison to the crisply narrated tales that had made him a celebrity. By 1878 Harte was sailing for Europe, where even his lesser works continued to find an appreciative audience. There he remained for the rest of his life, grinding out hackneyed variations of his original themes and settings. (FHG)

FREDERICK JACKSON TURNER
(1861–1932)
Born Portage, Wisconsin

This portrait of Frederick Jackson Turner pictures the young historian in his office at the Wisconsin Historical Society. As the head of the history department at the University of Wisconsin, Turner believed that the history of the American West merited greater attention. In a 1893 essay, "The Significance of the Frontier in American History," he wrote that the "true point of view in the history of this nation is not the Atlantic coast, it is the great West." Turner argued that the nation's unique character and its vigor were a direct byproduct of the continual movement of Americans westward. However, reflecting on data from the 1890 census indicating that Americans had now settled every section of the continent, he feared that the nation's pioneering spirit might be lost. Turner's writings were highly influential during his lifetime and continue to provoke lively discussion today. (FHG)

29.

REUBEN GOLD THWAITES
(1853–1913)
Gelatin silver print, 11.4 × 9.5 cm
(4 ½ × 3 ¾ in.), c. 1892
Wisconsin Historical Society, Madison

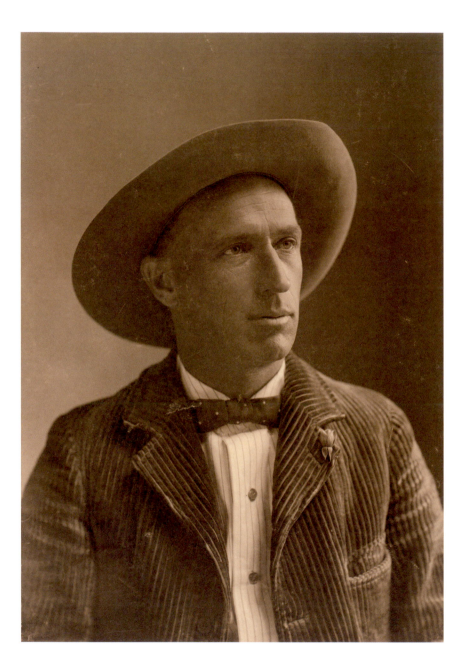

Charles Lummis
(1859–1928)
Born Lynn, Massachusetts

30.

Aurelian Scholl
(lifedates unknown)

Gelatin silver print,
19.8 × 13.8 cm (7 ¹³⁄₁₆ × 5 ⁷⁄₁₆ in.),
c. 1897

*Prints and Photographs Division,
Library of Congress, Washington, D.C.*

As an editor and a writer, Charles Lummis was influential in calling attention to the rich heritage of southwestern culture. Lummis was raised in the East, but after accepting a newspaper job in Los Angeles in 1885, he relocated there, walking more than three thousand miles in less than five months, a trip he recounted in his popular book, *A Tramp Across the Continent*. Following a paralyzing stroke in 1887, he recovered on a friend's New Mexico ranch for several years, in the process becoming an authority on the history and culture of the region. In addition to collecting native folklore and songs, he sought to preserve several of the old Spanish missions that were increasingly threatened. In 1894 he became the editor of *Land of Sunshine* and transformed it into one of the leading literary magazines in the West. Lummis is shown here in his typical everyday garb: a Spanish-style corduroy jacket and wide-brimmed hat. (MEF)

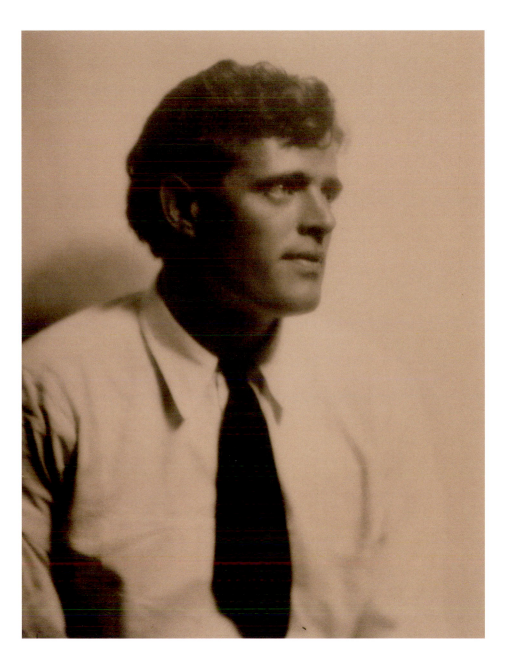

JACK LONDON
(1876–1916)
Born San Francisco, California

"The greatest story Jack London ever wrote was the story he lived," wrote the literary critic Alfred Kazin. Destitute as a young man in San Francisco, London was forced to work a grueling factory job to make ends meet. He was jailed for vagrancy at age eighteen, an experience that compelled him to turn his life around. London had long wanted to become a writer, but it was not until the publication of *The Call of the Wild* in 1903—based on his experience in Alaska during the 1897 Klondike Gold Rush—that he began to achieve wide acclaim. In this and other writings, he presented the wilderness as a cold, often savage place. A prolific author and one-time member of the Socialist Labor Party, London had become a self-made millionaire by the time of his death at age forty. (ALB)

31.

Arnold Genthe (1869–1942)

Gelatin silver print,
23.8 × 18.1 cm (9 ⅜ × 7 ⅛ in.),
c. 1900

*National Portrait Gallery,
Smithsonian Institution*

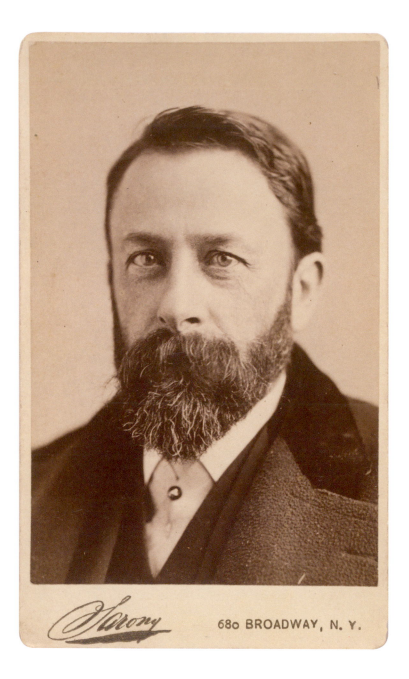

Albert Bierstadt
(1830–1902)
Born Solingen, Germany

32.

Napoleon Sarony (1821–1896)

Albumen silver print,
9.2 × 5.9 cm (3 ⅝ × 2 ⁵⁄₁₆ in.),
c. 1870

*National Portrait Gallery,
Smithsonian Institution; gift of
Larry J. West*

Known for his visually poetic views of the often forbidding western landscape, Albert Bierstadt was one of the first academically trained painters to travel in the West. Having first gone west with a surveying expedition in 1859, Bierstadt returned to his New York studio and began painting panoramic landscapes that won him wide acclaim. His paintings rendered the West as a largely uninhabited landscape infused with a spirituality that enraptured viewers. This carte-de-visite photograph of the artist is dated from around the period when Bierstadt returned to northern California in 1871. On that visit he found that the once pristine and open wilderness he had depicted a decade earlier had been discovered by tourists and affected by rapid industrialization. Undiscouraged, Bierstadt traveled to more remote locations in the Sierra Nevada range and continued to paint. (MEF)

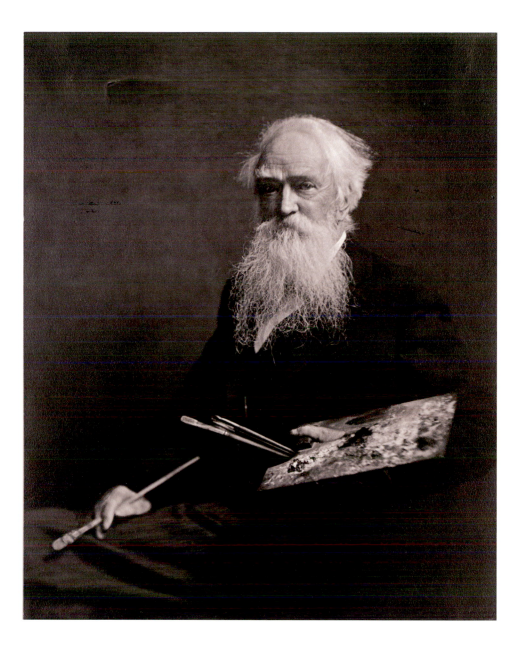

THOMAS MORAN

(1837–1926)

Born Bolton, Lancashire, England

"I place no value upon literal transcripts from Nature," wrote the artist Thomas Moran in 1879. "My general scope is not realistic; all my tendencies are towards idealization." Inspired by romantic literature, Moran painted canvases that transformed the West into an Edenic paradise. As a member of several government expeditions to the West, Moran had firsthand experience with the awe-inspiring vistas he later interpreted in his work. He traveled to Yellowstone in 1871, before it became a national park, and the work that resulted from this trip helped to popularize it as a tourist destination. Curiously, however, when westward expansion encroached upon the pristine wilderness, Moran did not include the telltale signs of civilization's progress. Even in his old age, Moran continued to paint with fervor. As one reporter observed in 1922, "He was a picture of intensity and energy." (MEF)

33.

WILLIAM EDWIN GLEDHILL
(1888–1976)

Gelatin silver print,
28.7 × 22.9 cm (11 ⁵⁄₁₆ × 9 in.),
1921

*National Portrait Gallery,
Smithsonian Institution*

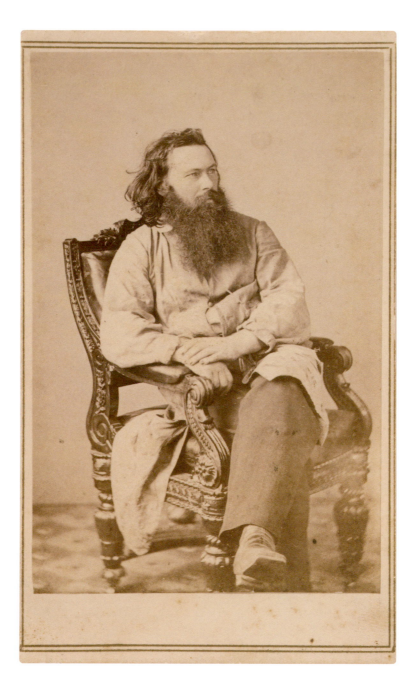

ALEXANDER GARDNER
(1821–1882)
Born Paisley, Scotland

34.

JAMES GARDNER (1829–?)

Albumen silver print, 8.6 × 5.5 cm
(3 ⅜ × 2 ³⁄₁₆ in.), 1863

*National Portrait Gallery,
Smithsonian Institution; gift of
Larry J. West*

As a young man in Scotland, Alexander Gardner dreamed of establishing a cooperative settlement in the United States. He and others purchased land in Iowa for this purpose, but Gardner never relocated there himself. Instead, he settled first in New York and later in Washington, D.C., where he found employment with photographer Mathew Brady. In 1863 he left Brady to open his own studio, specializing in portraiture and in the photographic documentation of the Civil War. Well known for his battlefield landscapes and his portraits of President Abraham Lincoln, Gardner was commissioned by the Kansas Pacific Railroad in 1867 to create a series of photographs that would publicize the construction of this second transcontinental line. Gardner's work on the southern plains represents some of the earliest photographic views of this region. A year later he was in Wyoming photographing the signing of the Fort Laramie Treaty with the Lakotas. (FHG)

B 3542. PRIMITIVE MINING; THE ROCKER CALAVERAS CO., CAL.
WATKINS' NEW BOUDOIR SERIES YO SEMITE AND PACIFIC COAST, 427 Montgomery Street, San Francisco.

CARLETON WATKINS

(1829–1916)
Born Oneonta, New York

In this playful self-portrait, Carleton Watkins portrays himself as a miner working in a fashion favored by the early California argonauts. Watkins went west during the gold rush, eventually settling in San Francisco. Although he learned photography in a local portrait studio, Watkins made his reputation as a landscape photographer. In 1861 he ventured for the first time to Yosemite Valley, a place that his photographs would help to make famous. During this period he also worked on commission for railroads, mining companies, and other industrial projects, creating images that publicized these ventures. Widely exhibited and often praised, his photographs shaped how people came to understand the West. Watkins was not a good businessman, however, and in 1874 he was forced to declare bankruptcy and to sell his negatives to a rival photographer. While he was able to reconstitute his practice, he often struggled to support himself during the latter half of his career. (FHG)

35.

SELF-PORTRAIT

Albumen silver print,
11.2 × 17.6 cm (4 ⁷⁄₁₆ × 6 ¹⁵⁄₁₆ in.),
c. 1883

*National Portrait Gallery,
Smithsonian Institution*

Eadweard Muybridge
(1830–1904)
Born Kingston-on-Thames, England

36.

Self-portrait

Albumen silver print,
51.5 × 39.1 cm (20 ¼ × 15 ⅜ in.),
1872

*National Portrait Gallery,
Smithsonian Institution; gift of
Larry J. West*

In this self-portrait Eadweard Muybridge is seated at the base of the famous "General Grant" sequoia tree. Having obtained a mammoth plate camera in 1872, Muybridge spent the summer creating a series of photographs of Yosemite Valley and the Mariposa Grove that might rival those by Carleton Watkins. Like his photographic colleague, Muybridge immigrated to California during the gold rush. There he took up photography as a profession and earned a reputation first for his panoramic cityscapes and for his views of the California landscape. In 1872, railroad magnate Leland Stanford approached Muybridge for help in settling a $25,000 wager about whether a trotting horse ever had all four feet off the ground. The challenge of photographing a horse in motion fascinated Muybridge and inspired him to conduct further experiments photographing individuals and animals in motion. These studies—and the different machines he devised—are recognized as forerunners of modern motion picture technology. (FHG)

EXPLORATION

A NEW CHAPTER IN THE HISTORY OF AMERICAN EXPLORATION
began in the 1840s. Buoyed by recent advances in the sciences,
a new generation traveled west, desirous of studying this
region's lands and its Native peoples. The
addition of vast new territories resulting from
treaties with Mexico and Britain provided
the impetus for much of this work. To better
understand what the United States had recently
acquired, federal and state governments
sponsored a series of surveying expeditions to
map and inventory these lands. In addition to
surveyors, these parties included geologists,
naturalists, and at times anthropologists. Artists
and photographers also played a vital role in
assisting this work and in publicizing the surveys themselves.
The individuals shown in this section made discoveries that
greatly enhanced scientific knowledge during this period.
They also had the additional effect of preparing the frontier
for American settlement.

*We have an unknown distance
yet to run, an unknown river
to explore. What falls there
are, we know not; what rocks
beset the channel, we know not;
what walls ride over the river,
we know not. Ah well, we may
conjecture many things.*

➤ JOHN WESLEY POWELL on e-xploring
 the Colorado River, 1869

John C. Frémont
(1813–1890)
Born Savannah, Georgia

37.

Mathew Brady (1823?–1896)

Ambrotype, 14.1 × 10.9 cm
(5 9/16 × 4 5/16 in.), c. 1856

*National Portrait Gallery,
Smithsonian Institution*

During a series of four expeditions into the West in the 1840s, John C. Frémont created detailed maps and reports that opened this region to American expansion. Having gained experience conducting survey work while growing up in the Southeast, Frémont joined the U.S. Army Corps of Topographical Engineers in 1838. Several years later he led his first western expedition to map the territory through which the Oregon Trail would pass. Accompanied by the mountain man Kit Carson, Frémont became a national hero for identifying a route through the Rocky Mountains. Yet his reputation was sullied in 1847, when in the midst of the Mexican War he was court-martialed and dismissed from the army for rashly disobeying an order. Entering the political arena, Frémont was elected the first senator from California two years later. This ambrotype by Mathew Brady pictures him in about 1856, the year he ran unsuccessfully as the first Republican candidate for president. (ALB)

JESSIE BENTON FRÉMONT
(1824–1902)
Born Rockbridge County, Virginia

The daughter of the influential Missouri senator Thomas Hart Benton, Jessie Benton Frémont inherited her father's political acumen and his interest in the West. In 1841, the seventeen-year-old Jessie defied her family and eloped with the young military officer John C. Frémont. When he returned from expeditions into the West, she helped him draft the official reports that soon became vital guides for emigrants headed west. Throughout their nearly fifty-year marriage, Jessie was a powerful advocate for her husband, defending his career when necessary and actively supporting his rise in politics. In 1856, while he was campaigning for president, she appeared in public alongside him, a first among candidates' wives. She spent her life in the shadows of great men, yet she was effective in making herself heard. After her husband's retirement, she supported the family as an author, selling short stories and sketches to popular periodicals. (ALB)

38.

EDWARD AND HENRY T. ANTHONY (active 1860–1901), after the Mathew Brady Studio

Albumen silver print, 8.3 x 5.3 cm (3 ¼ × 2 ¹⁄₁₆ in.), c. 1865

National Portrait Gallery, Smithsonian Institution

James Duncan Graham
(1799–1865)
Born Prince William County, Virginia

39.

Attributed to John Plumbe, Jr.
(1809–1857)

Three-quarter plate
daguerreotype, 16.5 × 13.5 cm
(6 ½ × 5 ⁵⁄₁₆ in.), c. 1845

*National Portrait Gallery,
Smithsonian Institution*

This daguerreotype pictures the army officer James Duncan Graham seated next to a map that shows a section of the St. Lawrence River. Educated at West Point, Graham became a central figure in the effort to better determine the location of and territory abutting the nation's borders. Having first traveled west in 1819 with Major Stephen Long's expedition to the Rocky Mountains, Graham embarked in 1839 on a series of surveying expeditions under the auspices of the newly created Corps of Topographical Engineers. He and his team of assistants produced highly detailed maps, first along the boundary line between Texas and Mexico and later between the United States and the British provinces. After the Mexican War, Graham returned to the Southwest to survey the new border. (FHG)

CLARENCE KING
(1842–1901)
Born Newport, Rhode Island

Clarence King—standing at right alongside three members of Josiah Whitney's Geological Survey of California—was a key figure in the scientific exploration of the West. A Yale-trained geologist, King crossed the continent on horseback in 1863, ending up in San Francisco, where he volunteered for the Whitney Survey. After three years mapping California's topography, King returned east and convinced Congress to sponsor an ambitious survey of the lands between the Sierra Nevada range and the Great Plains through which the transcontinental railroad was meant to pass. The resulting six-year project elicited vital information that encouraged the expansion of mining and industrial development in the West. King also made national headlines during this period for exposing the "Great Diamond Hoax," a fraudulent diamond-salting scheme perpetrated by two Wyoming land speculators. King later championed the creation of the U.S. Geological Survey and in 1879 became its first director. (FHG)

40.

SILAS SELLECK
(active c. 1851–1876)

Albumen silver print,
20.5 × 15.5 cm (8 ¹⁄₁₆ × 6 ⅛ in.),
1864

*National Portrait Gallery,
Smithsonian Institution*

Ferdinand V. Hayden
(1828?–1887)
Born Westfield, Massachusetts

41.

Unidentified photographer

Albumen silver print, 9 × 5.6 cm
(3 ⁹⁄₁₆ × 2 ³⁄₁₆ in.), c. 1875

*National Portrait Gallery,
Smithsonian Institution*

One of the great field geologists of his time, Ferdinand V. Hayden played a key role in the scientific exploration of the West. Although he trained for a medical career, Hayden became fascinated by the study of natural history while at Oberlin College. In the decade before the Civil War, he made several trips into the West to study the region's unique geology and to collect specimens. He did this work with the support of different sponsors, including the Smithsonian and the Corps of Topographical Engineers. The expeditions that earned him a national reputation occurred under the auspices of the Department of the Interior during a twelve-year period beginning in 1867. Hayden traveled widely but was especially well known for his work in Yellowstone. A prolific author who wrote for scholars and the general public alike, Hayden did much to encourage the founding of Yellowstone National Park in 1872. (FHG)

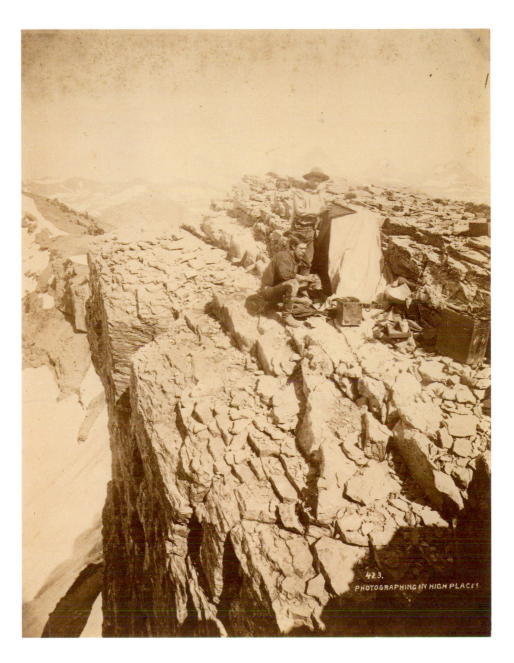

WILLIAM HENRY JACKSON
(1843–1942)
Born Keeseville, New York

This photograph shows William Henry Jackson squatting next to his photographic equipment on a rock outcropping in Wyoming's Teton Range. His assistant, Charley Campbell, stands beside him. At the time, Jackson was traveling with and creating views for Ferdinand Hayden's survey expedition into the territory surrounding Yellowstone. He had participated in the first comprehensive survey of Yellowstone the previous summer, and his photographs from that trip played a role in Congress's decision to designate it a national park in the spring of 1872. Over a lengthy career, Jackson traveled widely throughout the West, creating photographs for scientific reports, railroad companies, and later the burgeoning tourist trade. Having spent time with painters Sanford Gifford and Thomas Moran, he was well versed in the tradition of landscape art, and his photographs often conveyed a similar wonderment regarding the majestic beauty of the western landscape. (FHG)

42.

SELF-PORTRAIT

Albumen silver print,
21.9 × 16.8 cm (8 ⅝ × 6 ⅝ in.),
1872

*National Portrait Gallery,
Smithsonian Institution; gift of
Larry J. West*

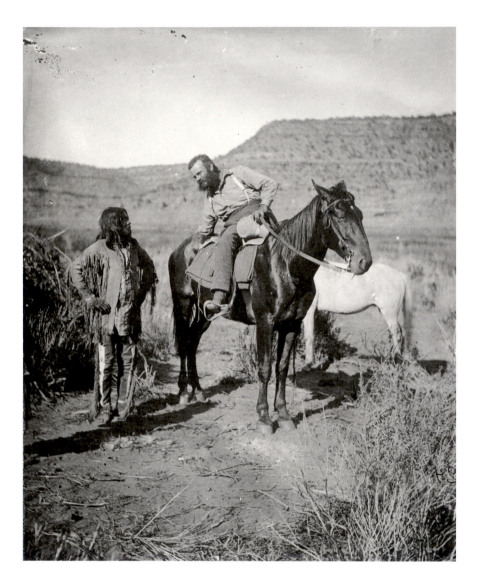

JOHN WESLEY POWELL
(1834–1902)
Born Mount Morris, New York

43.

WILLIAM HENRY HOLMES
(1846–1933)

Albumen silver prints,
11 × 8.9 cm (4 ⁵⁄₁₆ × 3 ½ in.) and
11 × 8.6 cm (4 ⅜ × 3 ⅜ in.), 1873

Smithsonian Institution Archives

John Wesley Powell's work as an explorer, a geologist, and an anthropologist in the West helped to shape national policies regarding the development of public lands and the welfare of Native American tribes. Celebrated in 1869 for leading the first American expedition through the Grand Canyon of the Colorado River, Powell's greater contribution came in the form of scientific reports—many of which went against long-held beliefs—on western lands and the peoples living there. Powell's advocacy of communal or government control of water for irrigation in the West was derided at the time, yet his studies served as the foundation for twentieth-century water-use policies. As director of both the U.S. Geological Survey and the Bureau of Ethnology, he saw science as a vital force in promoting the common good. These photographs picture Powell and two different Paiute men during his 1873 expedition into the Southwest. (FHG)

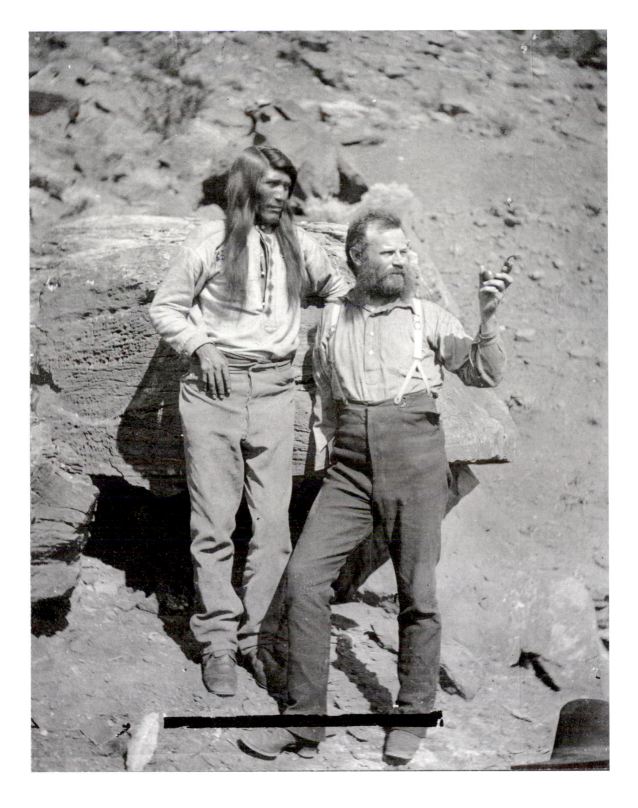

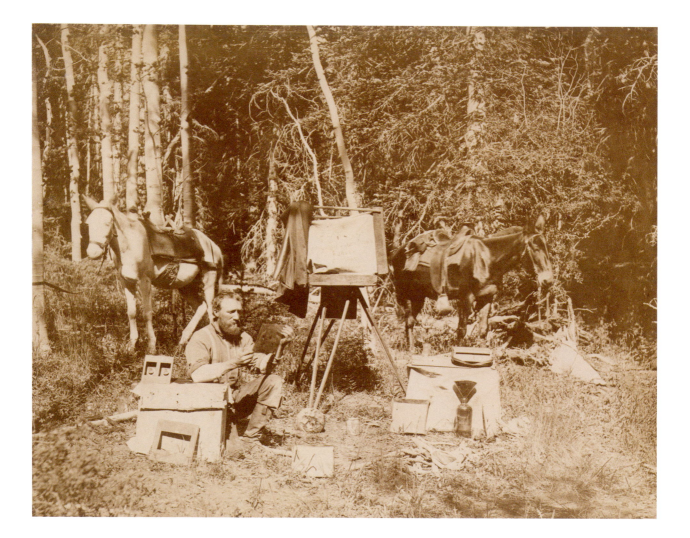

JOHN K. HILLERS
(1843–1925)
Born Hanover, Germany

44.

Attributed to ALMON HARRIS
THOMPSON (1839–1906) or
GROVE KARL GILBERT
(1843–1918)

Albumen silver print,
18.5 × 23.5 cm (7 ⁵⁄₁₆ × 9 ¼ in.),
1875

*National Portrait Gallery,
Smithsonian Institution; gift of
Larry J. West*

The photographic equipment that John K. Hillers used during John Wesley Powell's
western surveys included cameras, a portable darkroom, and glass-plate negatives that
together weighed more than a thousand pounds. This photograph shows Hillers inspecting
a photographic plate in Utah while surrounded by such equipment. A German immigrant
who was a Union sergeant during the Civil War, Hillers joined Powell's survey in 1871 when
Powell needed a boatman for his expedition down the Colorado River. Hillers was hired at
first as a laborer, but when he expressed an interest in photography, the survey's official
photographer taught him the wet-plate process. Hillers continued to work for Powell when
he became head of the Bureau of Ethnology in 1879 and devoted six years documenting
Native American communities in the Southwest. Like other photographers associated with
western expeditions, Hillers made important contributions to the scientific understanding
of the lands and Native peoples of the West. (MEF)

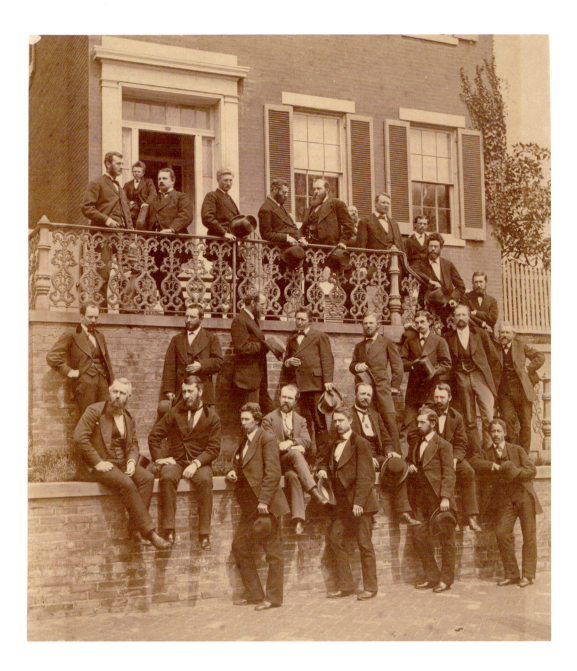

GEORGE M. WHEELER
(1842–1905)
Born Hopkinton, Massachusetts

Standing in the top row, sixth from the left with a long beard and thinning hair, is George M. Wheeler, the West Point graduate who in 1871 developed a comprehensive plan for surveying the territory west of the hundredth meridian. For the next eight years Wheeler led a group of soldiers and civilians that surveyed nearly 360,000 square miles, roughly one-third of the mountainous West. The Wheeler Survey accumulated a vast quantity of information regarding the region's geology, botany, and ethnography. Most significantly, the survey published maps—164 in all—that covered nearly all the land through which the party had traveled. The creation of the U.S. Geological Survey in 1879 effectively ended Wheeler's work in the West. This photograph, taken outside of Wheeler's Washington, D.C., office, depicts many of the men who served with him. The photographer Timothy O'Sullivan—who accompanied Wheeler for three seasons—stands in the bottom row at the left. (FHG)

45.

TIMOTHY O'SULLIVAN
(1840–1882)

Albumen silver print, 26 × 22.5 cm
(10 ¼ × 8 ⅞ in.), c. 1874

*National Portrait Gallery,
Smithsonian Institution*

Timothy O'Sullivan
(1840–1882)
Born Ireland

46.

Philp & Solomons
(active 1870s)

Albumen silver print,
8.8 × 5.5 cm (3 ⁷⁄₁₆ × 2 ³⁄₁₆ in.),
c. 1870

National Portrait Gallery,
Smithsonian Institution; gift of
Larry J. West

Celebrated for his candid photographs of the western landscape, Timothy O'Sullivan began his career as an assistant to Alexander Gardner in Mathew Brady's Washington, D.C., studio. During the Civil War, O'Sullivan traveled with the Union army throughout the mid-Atlantic states, creating memorable photographs of the death and destruction visited upon this region. In 1867 he traveled West for the first time under the auspices of Clarence King's Fortieth Parallel Survey. Though he made Washington, D.C., home, O'Sullivan spent a part of each of the next seven years working in the West for King and later George Wheeler's Hundredth Meridian Survey. Like most landscape photographers of this period, O'Sullivan created many compositions that glorified the natural beauty of the land. Yet more often he represented the western landscape as a desolate, arid terrain that seemed incapable of supporting settlement. O'Sullivan died of tuberculosis at age forty-two. (FHG)

ALICE FLETCHER
(1838–1923)
Born Havana, Cuba

A pioneer in the field of anthropology, Alice Fletcher believed that differing views between Native peoples and non-Natives could be reconciled. She devoted much of her fieldwork to studying the Omahas, a Nebraska tribe that in the early 1880s was threatened by the prospect of being relocated. Politically active, Fletcher petitioned Congress to grant individual land titles to the Omahas. When the act passed in 1882, officials at the Bureau of Indian Affairs appointed her to divide reservation land among tribal members. For the next year, she lived on the Omaha reservation, where she carried out this work and continued her studies. Given her opposition to the reservation system, Fletcher lent her support to helping draft the controversial Dawes Act of 1887, legislation meant to improve the welfare of Native peoples through property ownership and education. (MEF)

47.

MARCUS ORMSBEE
(active 1863–1868)

Tintype, 7.6 × 4.4 cm
(3 × 1 ¾ in.), 1868

National Anthropological Archives,
Smithsonian Institution

Matilda Coxe Stevenson
(1849–1915)
Born San Augustine, Texas

48.

Charles M. Bell (1848–1893)

Albumen silver print,
8.3 × 4.8 cm (3 ¼ × 1 ⅞ in.),
c. 1875

*National Anthropological Archives,
Smithsonian Institution*

Raised in an era when women were largely barred from the sciences, Matilda Coxe Stevenson defied expectations and studied to become a mineralogist. Her marriage in 1872 to noted geologist James Stevenson provided her with an opportunity to do more than simply read scientific literature. Often traveling with him throughout the West, she assisted at first in the effort to collect specimens, but in time she became an equal partner in gathering information and authoring scholarly articles. The Stevensons concentrated much of their work in the Southwest, residing for a part of each year with a different Native American community. Following her husband's death in 1888, Matilda Stevenson continued this work under the auspices of the Bureau of American Ethnology, in the process becoming the first professionally employed woman in the field of anthropology. A vocal advocate for women's rights, Stevenson, along with Alice Fletcher, was also responsible for introducing the first federal legislation to preserve archaeological sites. (FHG)

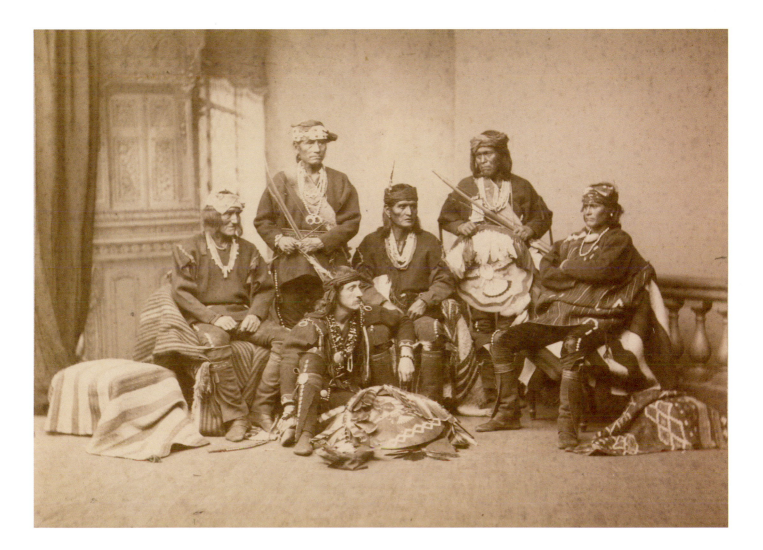

FRANK HAMILTON CUSHING
(1857–1900)
Born North East, Pennsylvania

Seated on the floor together with five men from Zuni Pueblo, anthropologist Frank Hamilton Cushing wears a costume typical of that southwestern tribe. In his five-year sojourn with the Zunis beginning in 1879, Cushing became famous for taking an active part in nearly every element of the tribe's secular and sacred life. In doing so, he pioneered the participant method of field observation, an important albeit controversial contribution to the field of ethnology. The Zunis welcomed Cushing and eventually admitted him to the Priesthood of the Bow, a prestigious tribal society. Cushing conducted his work under the auspices of the Bureau of American Ethnology. In part to repay the hospitality showed him, Cushing arranged for a Zuni delegation to travel east in 1882 to meet with President Chester Arthur and other government and scientific officials. This photograph was taken during a side trip to Boston. (FHG)

49.

JAMES WALLACE BLACK
(1825–1896)

Albumen silver print,
16 × 22.3 cm (6 5/16 × 8 3/4 in.), 1882

*National Portrait Gallery,
Smithsonian Institution*

Othniel Marsh
(1831–1899)
Born Lockport, New York

50.

Frank A. Bowman
(lifedates unknown)

Albumen silver print,
21.9 × 16.7 cm (8⅝ × 6⁹⁄₁₆ in.),
1883

*National Portrait Gallery,
Smithsonian Institution*

This photograph commemorates the meeting between the paleontologist Othniel Marsh and the Lakota chief Red Cloud in New Haven in 1883. While digging for fossils in Dakota Territory nine years earlier, Marsh observed and later reported to government officials and newspapers in the East the deplorable conditions and widespread corruption on several Native American reservations. Marsh had met Red Cloud on this trip and later invited him to visit his Connecticut home. The first professor of vertebrate paleontology in the United States, Marsh was a frequent member of western expeditions sponsored by the U.S. Geological Survey. The fossils he and his team of assistants collected helped to build important collections at the Smithsonian and at Yale University's Peabody Museum. During an era when Charles Darwin's theory of natural selection was hotly contested in the United States and abroad, Marsh was one of Darwin's earliest supporters. (FHG)

FRANK JAY HAYNES
(1853–1921)
Born Saline, Michigan

This self-portrait of Frank Jay Haynes shows the photographer at Norris Geyser Basin during the first American expedition into Yellowstone National Park during the winter. With ice on his beard, Haynes holds a notebook in front of him and looks into the cold wilderness. Haynes was the official photographer for both the Northern Pacific Railroad and Yellowstone National Park. Over the course of forty years, he documented the development of the park and also offered photographic services to visitors. While Haynes captured the drama of the park's natural features by emphasizing its unique geological formations and grand vistas, his photographs also transformed the landscape into a tourist destination. Later, from a specially outfitted railroad car, he sold views of Yellowstone and created portraits of individuals in communities along the Northern Pacific's lines. (MEF)

51.

SELF-PORTRAIT

Albumen silver print,
12.6 × 19.8 cm (4 15/16 × 7 13/16 in.),
1887

*National Portrait Gallery,
Smithsonian Institution*

Franz Boas
(1858–1942)
Born Minden, Westphalia, Germany

52.

Wilhelm Fechner
(lifedates unknown)

Collodion print, 15 × 10.5 cm
(5 ⅞ × 4 ⅛ in.), 1901

*American Philosophical Society,
Philadelphia, Pennsylvania*

Having made his first trip to the Pacific Northwest in 1888, Franz Boas returned throughout his life to collect objects and compile information pertaining to the Native peoples of this region. His fieldwork there formed the foundation of his thinking about the discipline of anthropology. Whereas many in his day subscribed to an evolutionary theory of society—whereby humans progressed in well-defined stages—Boas insisted that each society needed to be understood on its own terms. His book *The Mind of Primitive Man,* published in 1911, was influential in helping to establish the notion of cultural relativism and in challenging the prevailing belief in racial hierarchies. As a professor at Columbia University for more than forty years, Boas was one of the key voices in anthropological research and served as the mentor to many aspiring practitioners, including Margaret Mead and Ruth Benedict. (FHG)

Stereographic Portraits

A STEREOGRAPH INCLUDES TWO nearly identical photographs
affixed side by side. When seen through a stereoscope, the two
photographs appear to the eye as a single three-dimensional
image. During the latter half of the nineteenth century, viewing
stereographs was a commonplace pastime for middle-class
households and was regarded as having both educational and
entertainment value. Photographers created thousands of views
of historic landmarks, natural wonders, and people from many
backgrounds. As the vogue for stereographs coincided with the
exploration and settlement of the West, the western region became
a popular subject for stereograph manufacturers. The seven images
published here demonstrate that noteworthy individuals often
figured as characters within the narrative dramas enacted in these
views. Not surprisingly, stereographic portraits had the effect of
enhancing one's public notoriety. Before the introduction of the
moving picture in the early twentieth century, stereographs were
the dominant visual entertainment of the era.

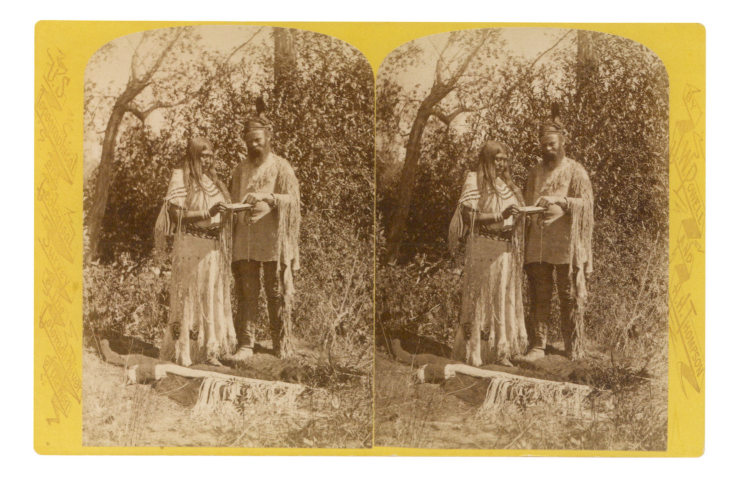

JOHN WESLEY POWELL AND TAU-RUV, A UTE WOMAN

53.

JOHN K. HILLERS (1843–1925)

Albumen silver print,

11.1 × 15.5 cm (4 ⅜ × 6 ⅛ in.),

1874

National Portrait Gallery,
Smithsonian Institution

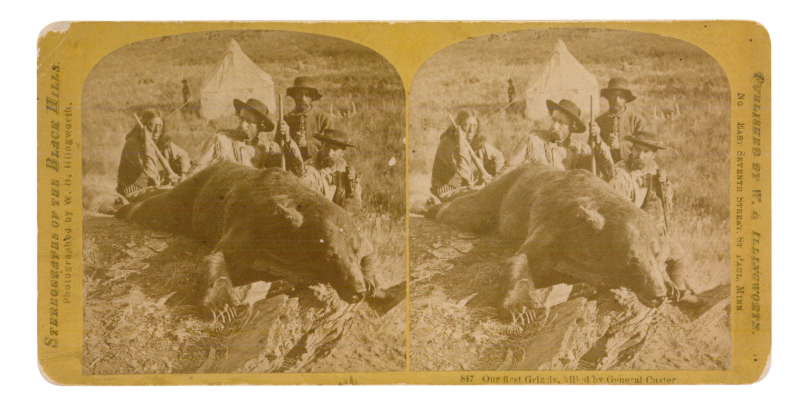

847 Our first Grizzly, killed by General Custer.

GEORGE A. CUSTER AND THE GRIZZLY BEAR HE SHOT

54.

WILLIAM H. ILLINGWORTH
(1844–1893)

Albumen silver print,
8.1 × 15.4 cm (3 ³⁄₁₆ × 6 ⅛ in.),
1874

National Portrait Gallery,
Smithsonian Institution

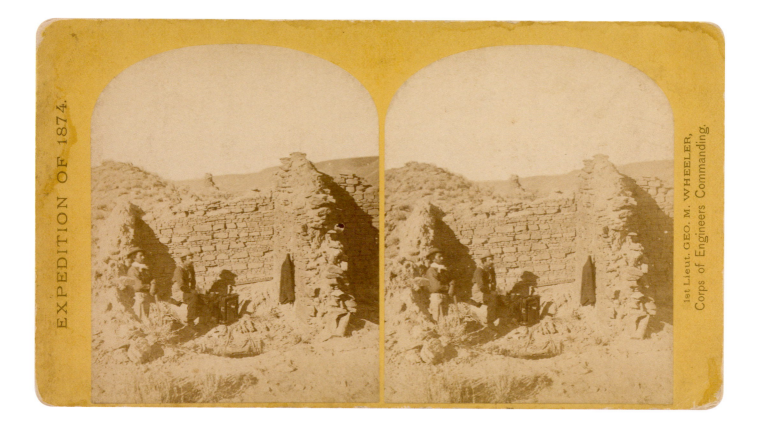

EXPEDITION OF 1874.

1st Lieut. GEO. M. WHEELER,
Corps of Engineers Commanding.

Timothy O'Sullivan (right) in an adobe ruin

55.

Self-portrait

Albumen silver print, 9.2 × 15 cm
(3 ⅝ × 5 ⅞ in.), 1874

National Portrait Gallery,
Smithsonian Institution; gift of
Larry J. West

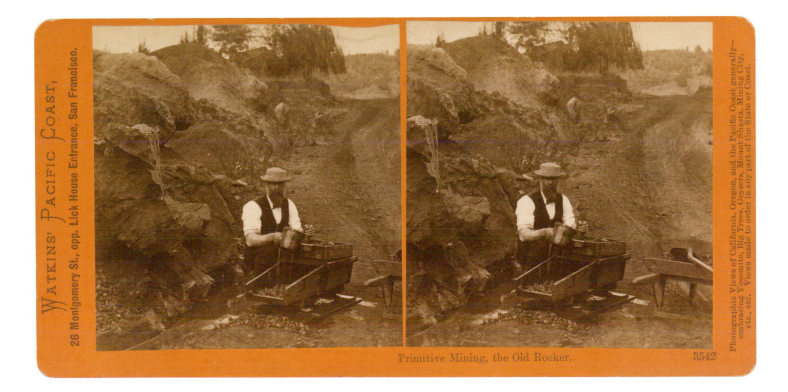

Carleton Watkins in a mining pose

56.

Self-portrait

Albumen silver print, 7.8 × 15 cm
(3 ¹⁄₁₆ × 5 ⁷⁄₈ in.), c. 1883

*National Portrait Gallery,
Smithsonian Institution; gift of
Larry J. West*

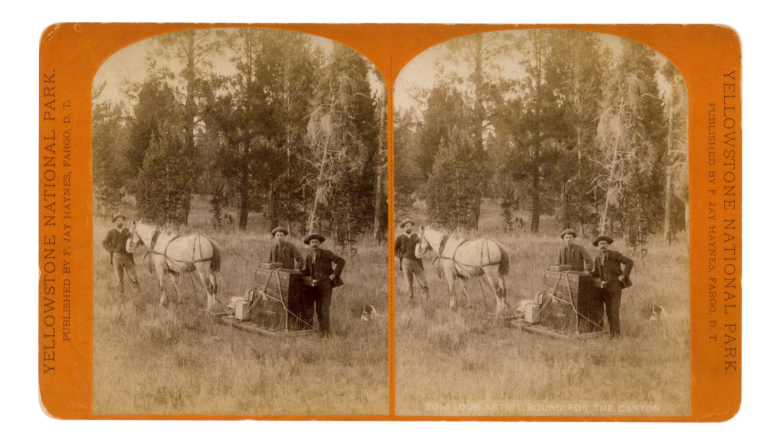

FRANK J. HAYNES WITH HORSE AND ASSISTANTS

57.

Self-portrait

Albumen silver print, 9.7 × 15 cm
(3 ¹³⁄₁₆ × 5 ⅞ in.), 1887

National Portrait Gallery,
Smithsonian Institution; gift of
Larry J. West

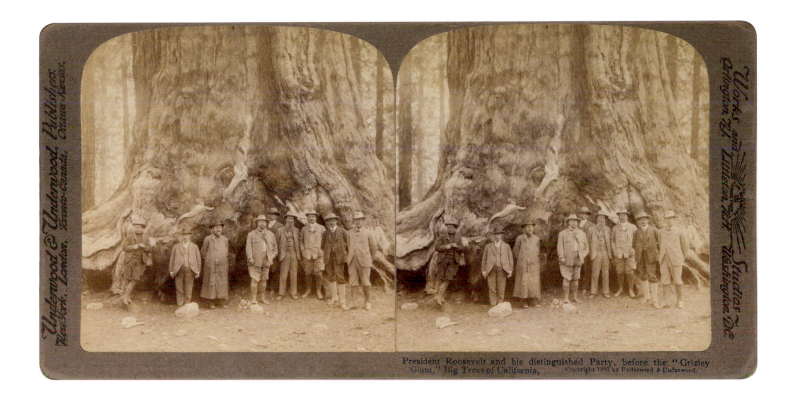

President Roosevelt and his distinguished Party, before the "Grizley Giant," Big Trees of California, Copyright 1903 by Underwood & Underwood.

THEODORE ROOSEVELT AND HIS PARTY BEFORE THE "GRIZZLY GIANT" REDWOOD

58.

UNDERWOOD & UNDERWOOD
(active 1880–c. 1950)

Gelatin silver print,
8.1 × 15.4 cm (3 ³⁄₁₆ × 6 ¹⁄₁₆ in.),
1903

National Portrait Gallery,
Smithsonian Institution

THOMAS MORAN AT THE GRAND CANYON

59.

UNDERWOOD & UNDERWOOD
(active 1880–c. 1950)

Gelatin silver print, 8.1 × 15.5 cm
(3 3/16 × 6 1/8 in.), c. 1903

National Portrait Gallery,
Smithsonian Institution

DISCORD

THE OPENING UP OF THE WEST to American settlement led to frequent conflicts with the region's Native peoples. Tribal leaders embraced contact at times, for such exchanges made possible trade and political alliances. However, with an ever growing number of settlers moving west, these relationships increasingly fell apart. Throughout the latter half of the nineteenth century, Native warriors and the U.S. Army clashed in a series of often well-publicized military engagements. Officials tried at times to reach a diplomatic solution, yet repeatedly U.S. authorities either ignored treaties or imposed their own answer to the "Indian problem." By the century's end, most tribes in the West had ostensibly been subjugated and forced onto federally controlled reservations. Non-Native writers, artists, and photographers found this conflict a compelling subject, for many believed—incorrectly—that they were documenting the final hours of a "vanishing race."

Is there blood in the veins of your young men? Rise up against the bloodless conquest that is turning your people into slaves! The red man was made by our Great Spirit to hunt and to fight, to be free as the prairie wind.

➤ SITTING BULL to a Crow delegation, 1887

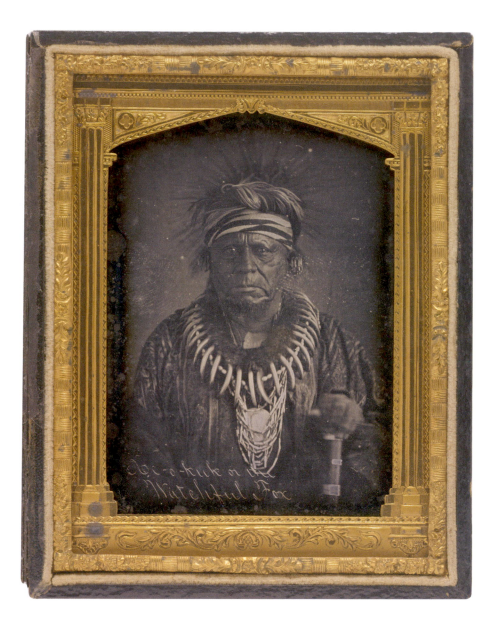

KEOKUK
(c. 1790–1848)
Born Saukenuk, in present-day Illinois

60.

Thomas Easterly (1809–1882)

Sixth-plate daguerreotype, 8.3 × 5.7 cm (3 ¼ × 2 ¼ in.) sight, 1847

Smithsonian Institution, National Museum of American History, Behring Center

Regarded as one of the earliest known photographic portraits of a Native American, this daguerreotype pictures the Sauk chief Keokuk. The pioneering photographer Thomas Easterly created it during Keokuk's visit to St. Louis in the spring of 1847. On this occasion the chief wears a bear claw necklace and a peace medal, and holds a silver-tipped cane. Known as the Watchful Fox (the name is inscribed on the image in the lower left corner), Keokuk rose to prominence during a series of diplomatic exchanges with U.S. authorities in the 1830s. Whereas his Sauk colleague Black Hawk favored armed resistance, Keokuk sought a negotiated settlement with government officials. His willingness to sell tribal lands in Iowa and to relocate west of the Mississippi River to a reservation in Kansas caused great political divisions among his tribe. Many refused to leave, and some who made the journey to Kansas in 1845 returned to Iowa shortly thereafter. (FHG)

OLIVE OATMAN
(1838–1903)
Born Whiteside County, Illinois

In the spring of 1851, a band of Apaches in present-day Arizona captured thirteen-year-old Olive Oatman and her younger sister. They killed or seriously injured the rest of the family during the attack. At the time, the Oatman family—originally from Illinois—was headed west to California to start their lives anew. Shortly thereafter the Apaches sold the two sisters to a Mohave family. While living with this family, Oatman was tattooed on the chin, a custom common among members of the tribe. In 1856, after enduring five years in captivity and the death of her sister, Oatman's freedom was negotiated, and she was given over to authorities at Fort Yuma. Accounts of her release were published widely, and her biography became a best seller. Though Oatman claimed that her Mojave family treated her well, stories such as hers reinforced commonly held assumptions that Native Americans were violent savages. (ALB)

61.

BENJAMIN F. POWELSON
(1823–1885)
Albumen silver print,
9.5 × 5.7 cm (3 ¾ × 2 ¼ in.),
c. 1863
*National Portrait Gallery,
Smithsonian Institution*

WHITNEY, **LITTLE CROW,** ST. PAUL.
A Sioux Chief and Leader of the *Indian Massacre of*
1862, in Minnesota.

Entered according to Act of Congress, by J. E. Whitney, in the year 1862,
in the Clerk's Office of the U. S. District Court for Minnesota.

LITTLE CROW
(1812?–1863)
Born near present-day St. Paul, Minnesota

62.

Joel Emmons Whitney
(1822–1886)

Albumen silver print,
8.6 × 5.7 cm (3 ⅜ × 2 ¼ in.), 1862

*National Portrait Gallery,
Smithsonian Institution*

A Mdewakanton Dakota chief, Little Crow played a pivotal role in diplomatic interactions between the eastern Dakota tribes and U.S. authorities during the 1850s and early 1860s. While he opposed the government's proposed acculturation program, Little Crow and others agreed in 1851 to a treaty that ceded almost all of the tribe's traditional landholdings in Minnesota. Tensions grew worse after the Dakotas settled on a nearby reservation. Despite Little Crow's concern about militarily opposing the American settlers in the region, warfare broke out in the summer of 1862. Little Crow led successful attacks on an army fort and several settlements, but he and his followers were ultimately defeated six weeks later when President Abraham Lincoln directed reinforcements to quell the violence. Later that winter thirty-eight Dakota were executed in a mass hanging for their involvement in this conflict. Little Crow was killed the following summer in a skirmish with a local farmer. (FHG)

Henry B. Whipple
(1822–1901)
Born Adams, New York

Appointed the first Episcopal bishop of Minnesota in 1859, Henry B. Whipple was recognized regionally for his missionary work among the state's Native tribes. During his travels he learned about the government's repeated failure to honor treaty obligations and was witness to many abusive practices directed toward Native communities. He wrote President James Buchanan about what he observed and for the next three decades campaigned vigorously for Native American rights. In the aftermath of Little Crow's War of 1862, Whipple garnered national attention for defending many of the Dakotas who were then being held captive. Though thirty-eight were ultimately executed, Whipple was instrumental in having the death sentence commuted for nearly three hundred prisoners. Given the nickname "Straight Tongue" for his commitment to truth, Whipple traveled often to Washington to urge lawmakers to pass legislation aimed at improving the status of Native Americans. (FHG)

63.

Abraham F. Burnham
(lifedates unknown)

Albumen silver print,
8.9 × 5.4 cm (3 ½ × 2 ⅛ in.),
c. 1863

George R. Rinhart Collection

Christopher "Kit" Carson
(1809–1868)
Born Madison County, Kentucky

64.

Charles DeForest
Fredricks (1823–1894),
after daguerreotype by an
unidentified photographer

Albumen silver print,
8.3 × 5.6 cm (3 ¼ × 2 ³⁄₁₆ in.),
c. 1863

*National Portrait Gallery,
Smithsonian Institution*

Christopher "Kit" Carson was a legendary yet controversial figure whose career as a mountain man and an army officer in the Southwest earned him national acclaim. Carson first gained notoriety working under explorer John C. Frémont. Serving on three Frémont-led expeditions during the 1840s, he distinguished himself for his skills as a hunter and a guide. Despite being illiterate, he was fluent in several languages and was able to communicate with many Native American tribes in the region. During the Civil War, Carson commanded a Union regiment, successfully defending New Mexico from Confederate invaders. Also at this time he was called upon to lead a campaign to subdue and relocate the Navajos to a reservation three hundred miles away on the Pecos River. The 1864 "Long Walk" to Bosque Redondo—during which more than two hundred Navajos died—represented one of the largest forced relocations in U.S. history. (ALB)

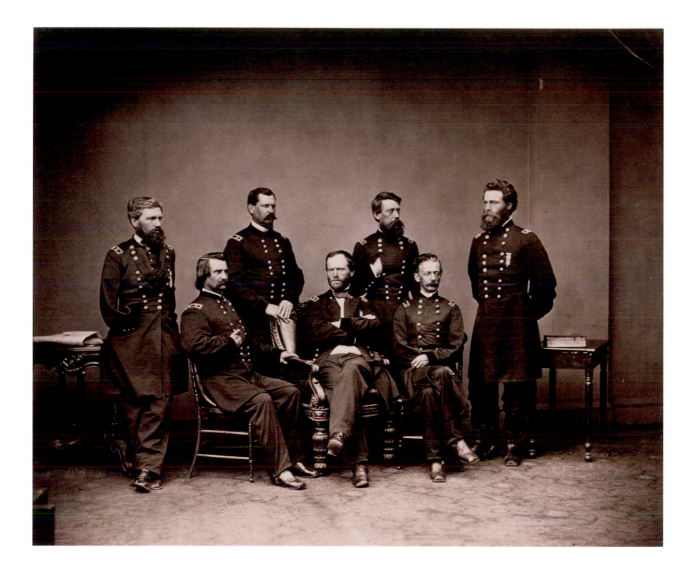

WILLIAM T. SHERMAN

(1820–1891)

Born Lancaster, Ohio

Appointed in 1865 as the U.S. Army's commanding general for the territories west of the Mississippi River, William T. Sherman applied in his confrontation with Native Americans the same scorched-earth tactics he had utilized against the Confederates during the Civil War. For the four years he held this post Sherman was principally responsible for protecting those who were constructing the transcontinental railroad. Toward this end he established a network of military outposts throughout the West and negotiated peace treaties with several Native tribes. Yet when some groups refused to accept a new life on reservations, Sherman was ruthless in subjugating them. Remarking that all Native Americans not on reservations "are hostile and will remain so until killed off," he led the effort to decimate the buffalo population, a vital food source for many. In this group photograph from 1865, Sherman is seated at the center with his arms and legs crossed. (FHG)

65.

MATHEW BRADY STUDIO
(active 1844–1894)

Albumen silver print, 36.7 × 45.5 cm
(14 ⁷⁄₁₆ × 17 ¹⁵⁄₁₆ in.), 1865

National Portrait Gallery,
Smithsonian Institution

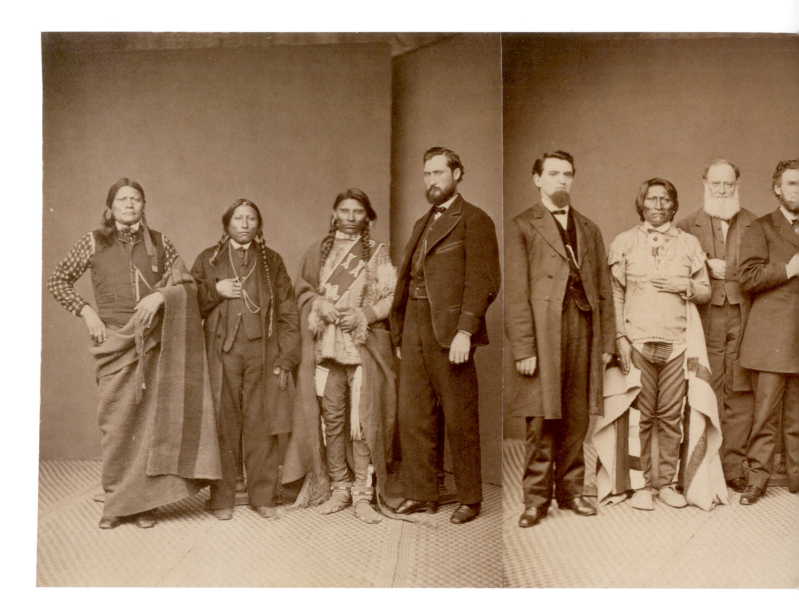

OURAY

(c. 1830–1880)

Born Taos, New Mexico

66.

MATHEW BRADY STUDIO
(active 1844–1894)

Albumen silver print,
17.8 × 49.8 cm (7 × 19 ⅝ in.),
1868

*National Portrait Gallery,
Smithsonian Institution*

This three-part photograph shows eight members of the 1868 Ute delegation to Washington, D.C., standing alongside nine government officials. Because of growing complaints about settlers trespassing on traditional Ute lands, this group came together ostensibly to establish a definable Ute reservation in Colorado. Fourth from the right is Ouray, the individual whom U.S. authorities regarded as the tribe's principal spokesman. Being fluent in English and Spanish, Ouray was best able to communicate with federal officials. His close association with Kit Carson—who traveled with the delegation but is not pictured here—and his reputation for being cooperative also made him the person with whom negotiators most wanted to deal. While he was an important leader, Ouray had no such negotiating authority. Nevertheless, a treaty was signed during the Utes' visit that secured a relatively generous land apportionment. For the remainder of his life, Ouray struggled, often unsuccessfully, to have U.S. authorities honor the terms of this treaty. (FHG)

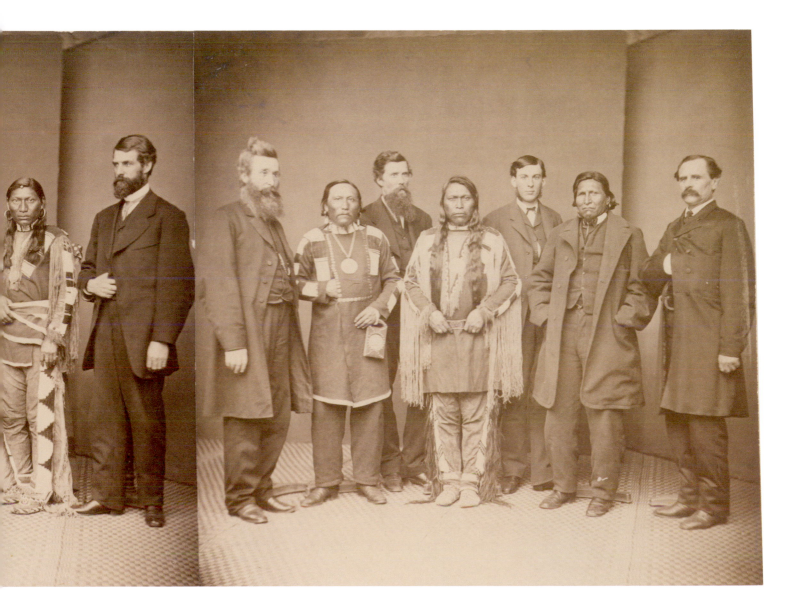

WINEMA
(1836–1920)
Born northern California

67.

CHARLES M. BELL (1848–1893)

Albumen silver print,
18.7 × 13.3 cm (7 ⅜ × 5 ¼ in.),
c. 1875

National Portrait Gallery,
Smithsonian Institution

Winema earned her adult name—which means "strong-hearted woman"—for an act of bravery at age fourteen. In addition to displaying great courage, she also defied expectations throughout her life. Refusing to marry a Modoc man chosen for her, Winema instead wed a Kentucky miner who had come west with the gold rush. In this relationship, her command of English greatly improved, and when tensions between the Modocs and U.S. authorities escalated during the early 1870s, she stepped forward to serve as an interpreter and later a mediator between the two sides. Although warfare ultimately broke out, she earned widespread recognition for saving the life of a government official who came west to negotiate a peace settlement. Following the conclusion of the Modoc War, Winema traveled to Washington, D.C., where she met President Ulysses S. Grant and attended a parade held in her honor. (FHG)

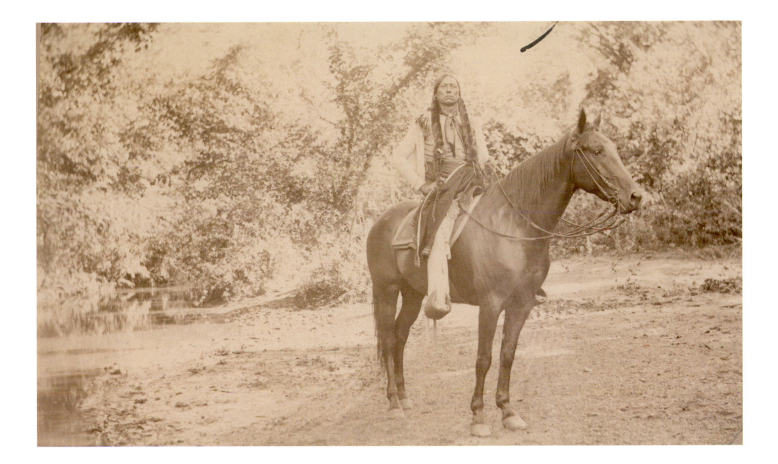

QUANAH PARKER
(c. 1852–1911)
Born northern Texas

Opposed to the increasing wave of American settlement on Comanche lands, Quanah Parker emerged as one of the leaders of the Red River War—fought on the southern plains in 1874–1875. For him the historic encounter between non-Natives and the Comanches shaped many elements of his life. His mother was a white woman who had been captured as a child. His father—an important tribal chief—fought the U.S. military on repeated occasions. Following the surrender of the Comanches to federal authorities in 1875, Parker decided to accept a new life. In time he became a prosperous farmer and rancher with a property of more than forty thousand acres. He was also politically active, rising to become the principal chief of the Comanches and often serving in a diplomatic role with U.S. officials. Yet his decision to wear his hair in braids, to practice polygamy, and to use peyote in ceremonies suggested his continuing desire for an independent life. (FHG)

68.

UNIDENTIFIED PHOTOGRAPHER

Albumen silver print,
11.4 × 19.1 cm (4 ½ × 7 ½ in.),
c. 1897

National Anthropological Archives, Smithsonian Institution

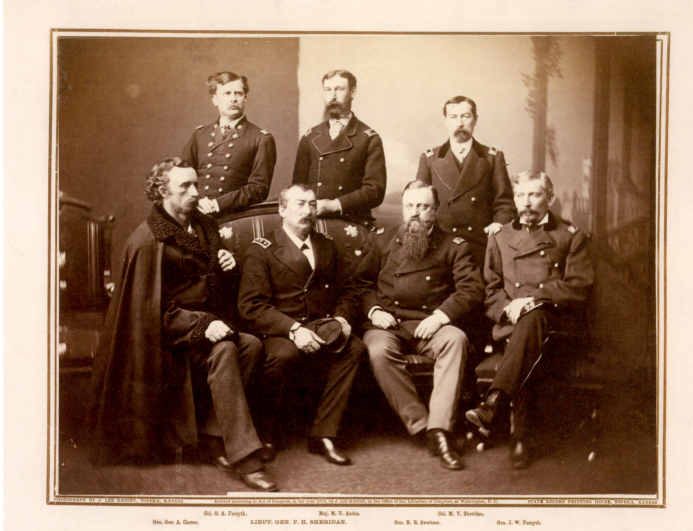

PHOTOGRAPH BY J. LEE KNIGHT, TOPEKA, KANSAS. Entered according to Act of Congress, in the year 1872, by J. Lee Knight, in the Office of the Librarian of Congress, at Washington, D. C. STATE RECORD PRINTING HOUSE, TOPEKA, KANSAS.

Col. G. A. Forsyth. Maj. M. V. Asche. Col. M. V. Sheridan.
Gen. Geo. A. Custer. LIEUT. GEN. P. H. SHERIDAN. Gen. N. B. Sweitzer. Gen. J. W. Forsyth.

Lieutenant General P. H. SHERIDAN, and Staff.

PHILIP SHERIDAN
(1831–1888)
Born en route from Ireland to Somerset, Ohio

69.

J. Lee Knight
(lifedates unknown)

Albumen silver print,
22.1 × 29.2 cm (8 11/16 × 11 1/2 in.),
1872

*National Portrait Gallery,
Smithsonian Institution*

This group photograph was taken in Topeka, Kansas, in 1872. It includes General Philip Sheridan (seated second from the left) alongside members of his staff, including George A. Custer (seated at the far left). At the time, Sheridan was escorting Grand Duke Alexis of Russia on an extended tour of the United States. Sheridan was one of Ulysses S. Grant's most trusted generals during the Civil War and in 1867 was appointed head of the U.S. Army division responsible for pacifying hostile Native American groups on the plains. Reputed to have commented that "the only good Indians I ever saw were dead," he proved to be relentless in fulfilling this assignment, directing numerous military campaigns meant to force tribes to abide by recently enacted U.S. policies. Sheridan also had a keen interest in the Yellowstone region and worked to ensure that the army was assigned the responsibility for managing the new national park. (FHG)

GEORGE A. CUSTER
(1839–1876)
Born New Rumley, Ohio

This ambrotype pictures George A. Custer in his West Point cadet uniform. He graduated in 1861 at the bottom of his class yet rose through the military with extraordinary speed, achieving the rank of major general by the Civil War's conclusion. After the war, the "Boy General" emerged as one of the most visible and controversial military leaders in the West. His victories in battles with the Cheyennes and the Lakotas enhanced his reputation as a daring Indian fighter, even though accounts about the killing of Native women and children also led to accusations of misconduct. Similarly, his 1874 expedition into the Black Hills of Dakota Territory resulted in the discovery of gold but escalated tensions with local tribes. At the Battle of the Little Bighorn in June 1876, Custer met an early death, when he and five companies under his command were soundly defeated by a force of two thousand Native warriors. (FHG)

70.

UNIDENTIFIED PHOTOGRAPHER

Ambrotype, 10.8 × 8.3 cm
(4 ¼ × 3 ¼ in.), c. 1860

*National Portrait Gallery,
Smithsonian Institution*

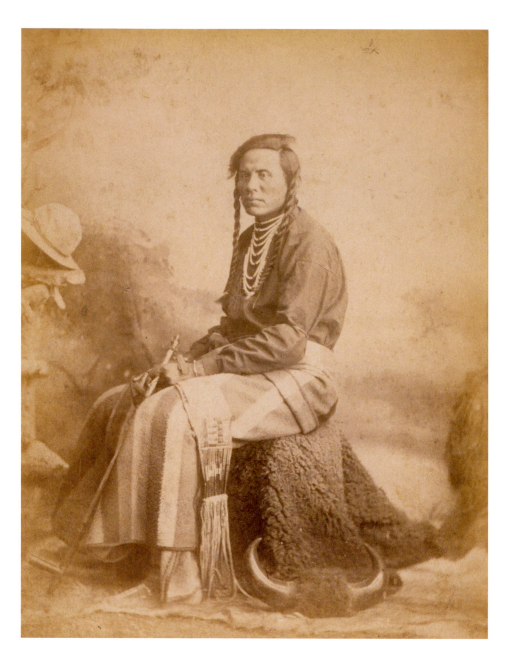

CURLY
(c. 1859–1923)
Born near Rosebud River in present-day Montana

71.

W. B. FINCH (lifedates unknown)

Albumen silver print,
23.1 × 18 cm (9 ⅛ × 7 ¹⁄₁₆ in.),
c. 1880

*National Portrait Gallery,
Smithsonian Institution*

In the spring of 1876 Curly accepted an invitation to scout for George A. Custer and his Seventh Cavalry during their armed engagement with hostile tribes on the northern plains. His own tribe, the Crow, had previously made peace with the United States. In late June—about a week before the United States was to celebrate its centennial—a force of Lakota and Northern Cheyenne warriors soundly defeated Custer and his command at the Battle of the Little Bighorn in Montana. Curly was the only survivor from the main part of that fight. Two days after the battle he reached military authorities and became the first eyewitness to report details about "Custer's last stand." The news shocked the nation and prompted the U.S. Army to redouble its commitment to subduing hostile tribes in the West. In the years that followed, Curly lived on the Crow reservation, serving for a time in the tribal police force. (FHG)

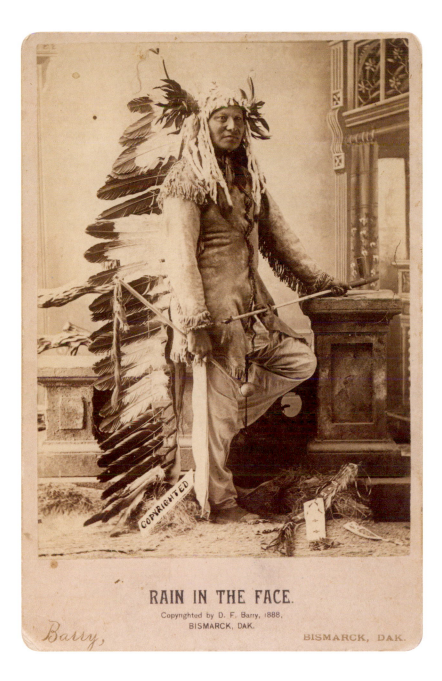

RAIN-IN-THE-FACE
(c. 1835–1905)
Born present-day North Dakota

In the years immediately following the Battle of the Little Bighorn, many Americans believed that Rain-in-the-Face was responsible for killing George A. Custer, the renowned commander of the Seventh Cavalry. Contributing to this story's popularity, poet Henry Wadsworth Longfellow immortalized the Lakota warrior in a poem about Custer's last stand titled "The Revenge of Rain-in-the-Face." Though Rain-in-the-Face did participate in this and other battles, he later distanced himself from this claim, explaining "in that fight the excitement was so great that we scarcely recognized our nearest friends." Deciding to relocate to Canada with Sitting Bull's followers after the battle, Rain-in-the-Face ultimately surrendered to federal authorities in 1880. For the remainder of his life, he lived on the Standing Rock Reservation. The cabinet card shown here is one in a series of portraits of famous Native American warriors assembled by photographer David F. Barry. (FHG)

72.

DAVID F. BARRY (1854–1934)

Albumen silver print,
13.7 × 9.9 cm (5 ⅜ × 3 ⅞ in.), 1888

*National Portrait Gallery,
Smithsonian Institution*

CARL SCHURZ
(1829–1906)
Born Liblar, Germany

73.

NAPOLEON SARONY (1821–1896)

Albumen silver print,
14.1 × 9.7 cm (5 ⁹⁄₁₆ × 3 ¹³⁄₁₆ in.),
c. 1876

*National Portrait Gallery,
Smithsonian Institution*

In 1876 newly elected president Rutherford B. Hayes selected Carl Schurz to head the Department of the Interior. A former reform-minded senator from Missouri, Schurz inherited a position that had been rife with controversy during the previous administration. In particular, corruption was rampant throughout the Bureau of Indian Affairs, and the War Department was then eager to take away oversight of this agency from the Department of the Interior. Schurz resisted and consequently succeeded in changing public perceptions regarding the Indian Bureau. Having immigrated to the United States as a young man, Schurz believed strongly in assimilation, and he used his position to promote the acculturation of Native Americans. He also continued to support their relocation to reservations, a policy that he saw as vital to their "progress" but which drew much criticism. (FHG)

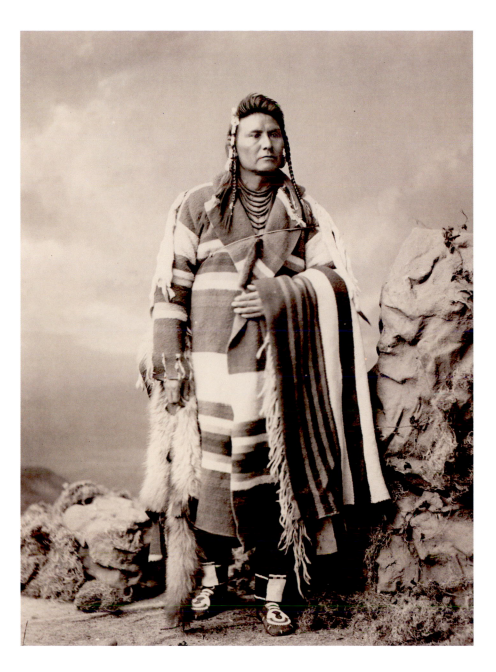

JOSEPH
(1840?–1904)
Born Wallowa Valley, Oregon

Joseph came to embody for many the tragic plight of Native Americans during the second half of the nineteenth century. His resistance to U.S. efforts aimed at moving the Nez Percé community, of which he was a part, to a designated reservation elicited anger from government authorities but also prompted sympathy from many Americans. When troops were called in to expedite the removal process in 1877, Joseph and eight hundred of his followers began a hasty retreat, seeking safety first among allied tribes in Montana and later in Canada. Only thirty miles from the border, a command led by Nelson Miles intercepted this band and forced Joseph to surrender. The photograph shown here was created two years later during a trip to Washington, D.C., where Joseph spoke with President Rutherford B. Hayes and others about his tribe's mistreatment. Despite this visit, Joseph remained imprisoned in Oklahoma until 1885, when he was permitted to resettle on a reservation in Washington State. (FHG)

74.

CHARLES M. BELL (1848–1893)

Albumen silver print,
43.2 × 32.4 cm (17 × 12 ¾ in.),
1879

National Anthropological Archives, Smithsonian Institution

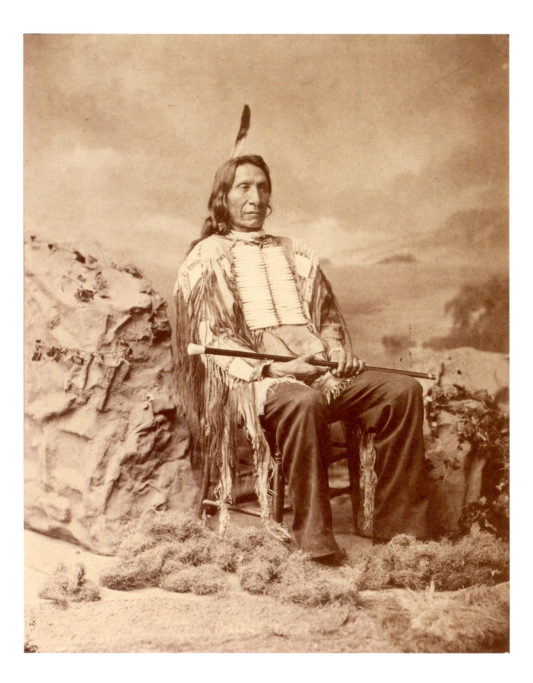

Red Cloud
(1821–1909)
Born western Nebraska

75.

Charles M. Bell (1848–1893)

Albumen silver print,
40.6 × 31.9 cm (16 × 12 9/16 in.),
1880

*National Portrait Gallery,
Smithsonian Institution*

"I have tried to get from my Great Father what is right and just," exclaimed Red Cloud to government officials at the conclusion of his first trip to the East in 1870. Two years earlier the celebrated Lakota leader had forced U.S. authorities to abandon a series of newly constructed forts meant to protect settlers moving across traditional Native lands. Beginning in 1870, however, Red Cloud would choose diplomacy, not warfare, to protect the Lakotas' land base and to ensure the tribe's political and cultural independence. Although the westward migration of American settlers would continue largely unabated, Red Cloud remained dedicated to the future welfare of the Lakotas, meeting with five different U.S. presidents over a period of thirty years. Washington photographer Charles Bell seated Red Cloud next to a papier-mâché rock and a painted seascape backdrop for this portrait taken during one of his many trips to the nation's capital. (FHG)

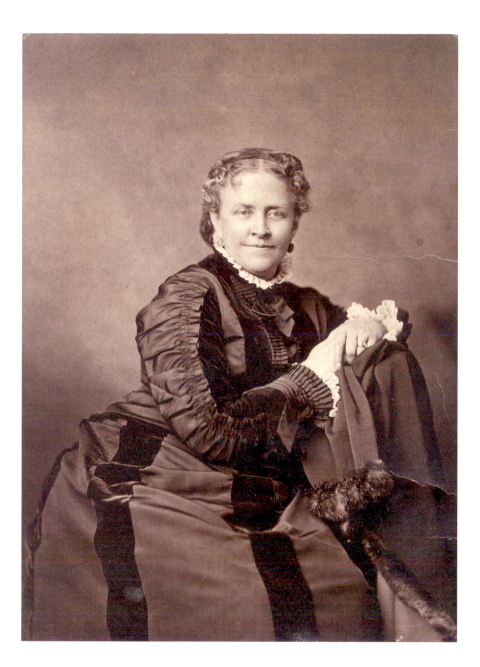

HELEN HUNT JACKSON

(1830–1885)

Born Amherst, Massachusetts

Described in her obituary as a "poet of remarkable sweetness and a novelist of some force," Helen Hunt Jackson wrote about many subjects but became famous for using her pen to call attention to the plight of Native Americans. She first gained awareness of such abuses in 1879 after attending a lecture in Boston that described the forced removal of the Ponca tribe from their Nebraska reservation. Angered by what she heard, Jackson spent the next two years completing *A Century of Dishonor,* a pointed exposé that chronicled the historic mistreatment of tribal peoples in the United States. Resettling in southern California, she was commissioned by the Bureau of Indian Affairs to investigate the condition of the local Mission Indians. This inquiry resulted in a report to Congress outlining their desperate situation as well as publication of the novel *Ramona,* a best-selling romance that Jackson hoped might "move people's hearts" regarding the broader perception of Native Americans. (FHG)

76.

GEORGE H. HASTINGS
(lifedates unknown)

Albumen silver print,
16.5 × 10.2 cm (6 ½ × 4 in.),
c. 1877

*Special Collections, Tutt Library,
Colorado College, Colorado Springs*

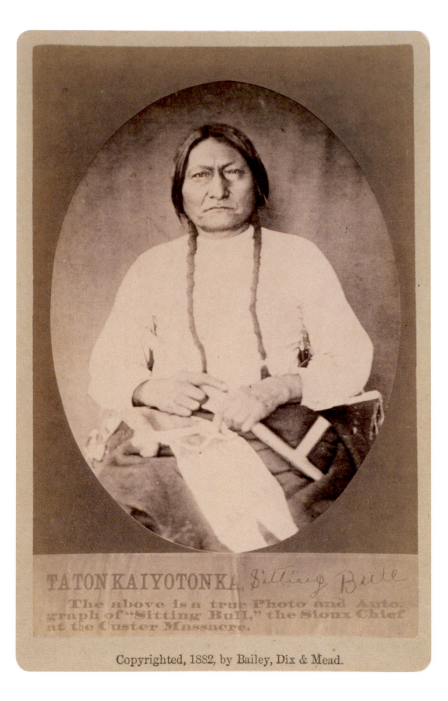

TATON KAIYOTONKA, *Sitting Bull*

The above is a true Photo and Auto-
graph of "Sitting Bull," the Sioux Chief
at the Custer Massacre.

Copyrighted, 1882, by Bailey, Dix & Mead.

SITTING BULL

(c. 1831–1890)

Born near the Grand River in present-day South Dakota

77.

BAILEY, DIX, AND MEAD
(active 1882)

Albumen silver print,
12.2 × 9.1 cm
(4 ¹³⁄₁₆ × 3 ⁹⁄₁₆ in.), 1882

*National Portrait Gallery,
Smithsonian Institution*

Having first battled American soldiers in the 1860s, Sitting Bull gained a reputation as one of the most hostile warriors during the three-decades-long military conflict between the Lakotas and the U.S. Army. On repeated occasions he led campaigns to rid the growing presence of Americans from traditional tribal lands. When officials in 1874 tried to persuade a group of friendly chiefs to cede the Black Hills—where George A. Custer had recently discovered gold—Sitting Bull intervened to stop this transaction. Two years later his forces routed Custer's Seventh Cavalry at the Battle of the Little Bighorn, an event that prompted U.S. officials to expand their military commitment in the West. Sitting Bull and a group of followers eluded U.S. authorities until 1881, when defections and a dwindling food supply compelled him to surrender. This photograph was taken not long afterward, during his imprisonment at Fort Randall. (FHG)

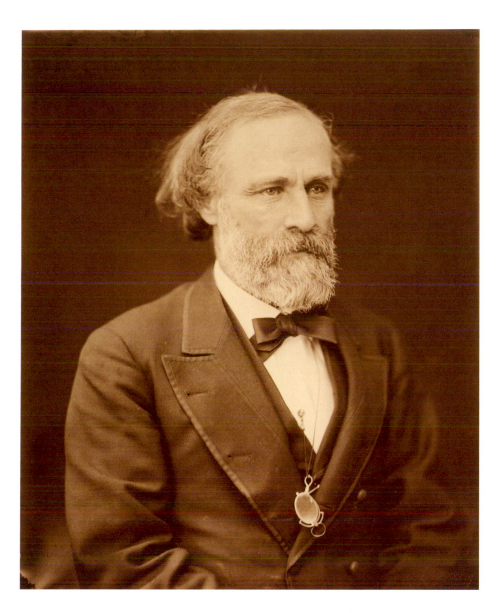

HENRY L. DAWES
(1816–1903)
Born Cummington, Massachusetts

In 1887, when Henry L. Dawes introduced and secured passage of the General Allotment Act (also known as the Dawes Act), the Massachusetts senator believed that he had taken an important step in helping Native Americans toward a better future. Aimed at promoting their assimilation into American society, the bill dissolved the legal standing of tribal nations and divided communally held lands into individual holdings. Dawes had been raised in a farming family and, as chairman of the Senate Committee on Indian Affairs, believed that Native Americans would be more secure as property-owning farmers. Ultimately, the General Allotment Act proved an extraordinary failure. Not only did it disregard the great heterogeneity of tribal communities, but it also resulted in the permanent loss of millions of acres of traditional Native lands. The bill was ultimately overturned in 1934 with the passage of the Indian Reorganization Act. (FHG)

78.

Attributed to SAMUEL M. FASSETT (1825–1910)

Albumen silver print, 24 × 19.6 cm (9 7/16 × 7 11/16 in.), c. 1876

National Portrait Gallery, Smithsonian Institution

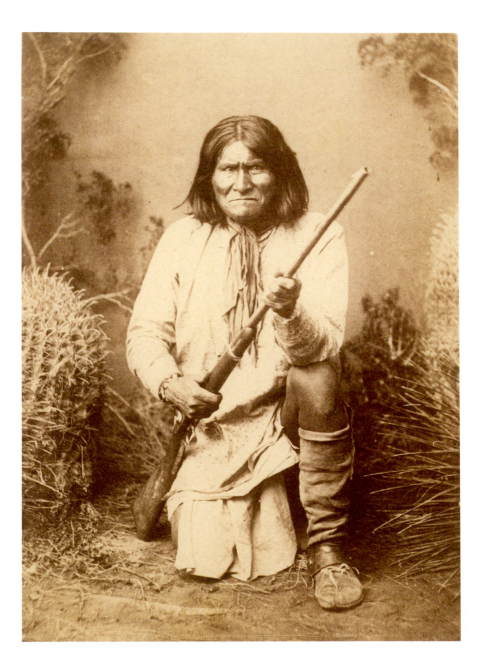

GERONIMO
(c. 1823–1909)
Born near the Gila River in present-day Arizona or New Mexico

79.

A. FRANK RANDALL (1854–1916)

Albumen silver print,
15.7 × 11.2 cm (6 3/16 × 4 7/16 in.),
c. 1887

*National Portrait Gallery,
Smithsonian Institution*

A Bedonkohe Apache war leader, Geronimo earned a reputation as a fierce adversary to Mexican and U.S. authorities alike. After his mother, wife, and three children were killed by Mexican soldiers in 1851, he intensified his opposition to those who were trying to subjugate his tribe. Geronimo did not want to be removed to a reservation, and he fought increasingly to protect his traditional way of life in the Southwest. During this period his daring raids and improbable escapes made him a larger-than-life figure in the American imagination. After more than thirty years of intermittent hostilities, Geronimo decided reluctantly in 1886 to surrender to General Nelson Miles. He and others were subsequently imprisoned in Florida, Alabama, and finally Fort Sill, Oklahoma. Geronimo became a national celebrity late in life, appearing to great fanfare at the St. Louis World's Fair in 1904 and at President Theodore Roosevelt's inaugural parade the following year. (ALB)

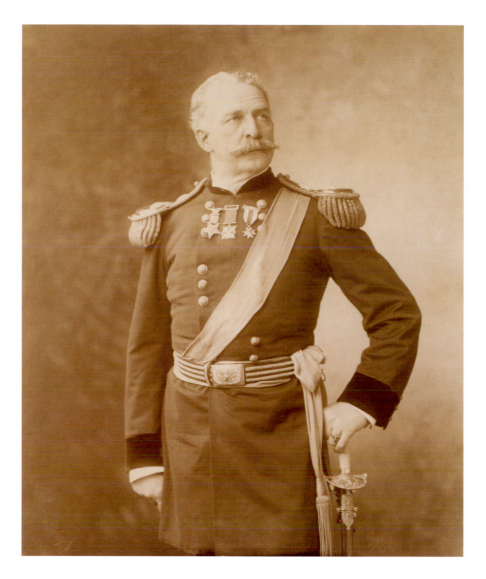

Nelson Miles

(1839–1925)

Born Westminster, Massachusetts

Nelson Miles spent more than four decades in the U.S. military, rising from the rank of first lieutenant during the early years of the Civil War to commander in chief of the army in 1895 and the rarely attained rank of lieutenant general in 1900. Despite having been wounded on several occasions during the Civil War, Miles went on to play a prominent part in military campaigns against tribal nations in the American West. His command was responsible for forcing the surrender of such well-known leaders as Sitting Bull, Joseph, and Geronimo—all front-page news events. In 1894 he also led the troops responsible for quelling the Pullman railroad car strike in Chicago. This photograph, which served as the frontispiece for Miles's autobiography, captures his characteristic formality in dress and bearing. (FHG)

80.

David F. Barry (1854–1934)

Albumen silver print,
48 × 39.8 cm (18 ⅞ × 15 ¹¹⁄₁₆ in.),
c. 1895

*National Portrait Gallery,
Smithsonian Institution*

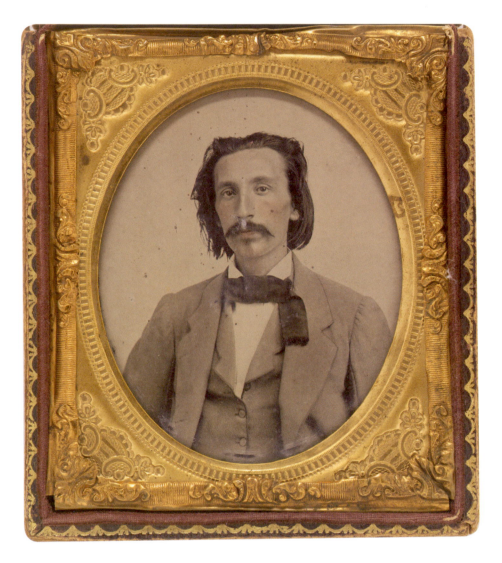

Carl Wimar

(1828–1862)

Born Siegburg, Germany

81.

Unidentified photographer

Ambrotype, 8.6 × 6.7 cm
(3 ⅜ × 2 ⅝ in.), c. 1860

*National Portrait Gallery,
Smithsonian Institution; gift of an
anonymous donor*

Carl Wimar aspired to establish a reputation as the painter of the American West. Immigrating to St. Louis in 1844, Wimar became interested at an early age in the region's history and Native peoples. He apprenticed with a local house and steamboat painter before deciding to pursue academic study in Düsseldorf, Germany, with artist Emanuel Leutze. Returning to St. Louis in 1856, Wimar began to make regular sketching trips out onto the frontier to better understand the subject he longed to paint. His canvases tended to perpetuate mythic ideas about the West and the Native Americans who lived there, yet he was one of the earliest painters to devote himself exclusively to this subject. Wimar's paintings attracted favorable comment, and in 1861 he was commissioned to create four murals to decorate the dome of the new St. Louis Courthouse. Wimar completed the series but died of tuberculosis shortly thereafter at age thirty-four. (FHG)

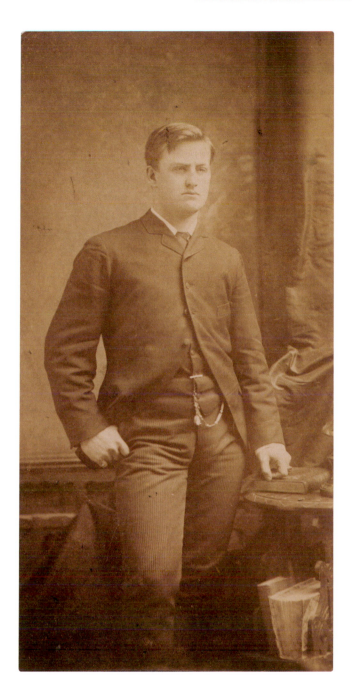

FREDERIC REMINGTON
(1861–1909)
Born Canton, New York

In 1905, artist Frederic Remington pondered the dramatic changes in the West and declared with regret: "I knew the wild riders and the vacant land were about to vanish forever, and the more I considered the subject the bigger the Forever loomed." Having first traveled onto the northern plains in 1881—around the time this portrait was completed—Remington fashioned an artistic career that was centered on the West. He earned his initial acclaim for action-packed drawings of Native Americans and frontiersmen that eastern magazines were eager to publish. Desirous of respect from the art establishment, Remington made the transition to oil painting and, beginning in the mid-1890s, sculpting in clay and bronze. Unlike many artists who pictured the West, Remington was less concerned with landscape. Instead, he strove to create works that captured the principal actors in what he construed as a larger-than-life drama then occurring in the West. (MEF)

82.

WILLIAM NOTMAN (1826–1891)

Albumen silver print,
18.5 × 9.5 cm (7 ¼ × 3 ¾ in.),
c. 1880

Mary Fanton Roberts Papers,
Archives of American Art,
Smithsonian Institution

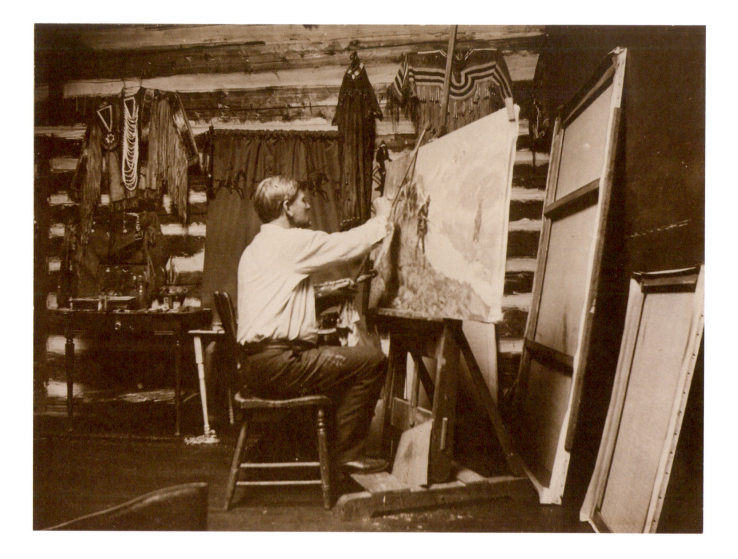

CHARLES M. RUSSELL
(1864–1926)
Born St. Louis, Missouri

83.

UNIDENTIFIED PHOTOGRAPHER

Platinum print, 27 × 36.8 cm
(10 ⅝ × 14 ½ in.), c. 1914

*National Portrait Gallery,
Smithsonian Institution*

Charles M. Russell created paintings and sculptures that romanticized frontier life on the northern plains. Born into a wealthy St. Louis family, Russell eschewed a traditional career and as a teenager became a horse wrangler in Montana. He also pursued his childhood interest in the visual arts by sketching and painting his surroundings. Russell's depictions of life in Montana earned him the nickname "the Cowboy Artist." Even after he stopped going on cattle drives in 1893 to become a full-time artist, he continued to be regarded as an authority on the "Old West," a period before railroads, reservations, and eastern tourists. Though he earned a national reputation, Russell increasingly felt despondent in his later years, once commenting that his wife Nancy "lives for tomorrow, an' I live for yesterday." This portrait shows Russell in his studio, absorbed in his work. (MEF)

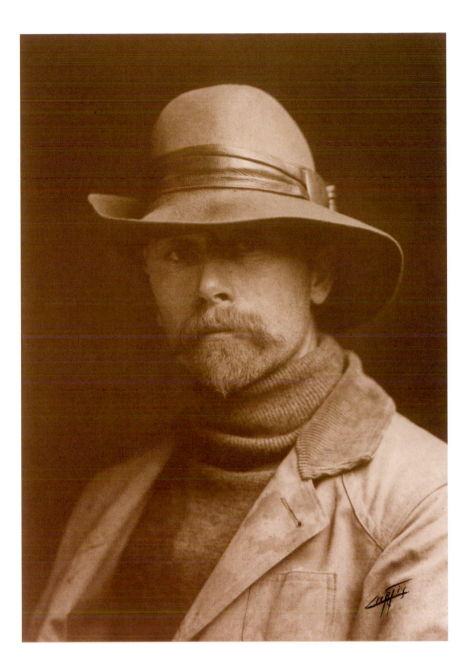

EDWARD S. CURTIS
(1868–1952)
Born Whitewater, Wisconsin

For more than thirty years Edward S. Curtis traveled throughout the West studying and photographing Native American communities. His ambitious goal was to produce a comprehensive documentary record of what he described as "one of the greatest races of mankind" yet one that was destined to "be lost for all time." With encouragement from Theodore Roosevelt and financial support from banker J. P. Morgan, Curtis created more than forty thousand photographs that pictured many aspects of Native American life. Influenced by fine art photography, he emphasized aesthetics as much as ethnographic information. A selection of these images was included in a deluxe twenty-volume series, *The North American Indian* (1907–1930). Curtis also collected cylinder recordings of Native American music and in 1914 released a groundbreaking silent film, *In the Land of the Head Hunters*, about the Kwakiutl of British Columbia. This dashing self-portrait shows the Seattle-based photographer at the outset of his career. (FHG)

84.

SELF-PORTRAIT

Gelatin silver print,
25.4 × 17.9 cm (10 × 7 ¹⁄₁₆ in.),
1899

*National Portrait Gallery,
Smithsonian Institution*

POSSIBILITIES

THE AMERICAN WEST DURING the latter half of the nineteenth century supported a remarkably heterogeneous population. Complementing the region's diverse Native presence, settlers from throughout the United States—and many parts of the world—decided to make the West their home. These new inhabitants came for different reasons, but for many the possibility of achieving economic and religious freedom was most important. In the West it was believed that one could reinvent oneself, and often this dream was realized. Yet the arrival of so many people also caused new frictions that led to dissension, intolerance, and sometimes violence. It also prompted reform; movements such as populism, temperance, women's suffrage, unionism, and Native American rights emerged as significant issues in the West. The individuals in this section played important roles in transforming the West's identity and its relationship with the rest of the nation and the world.

They agreed on one general object—that of bettering their condition, but the particular means by which each proposed to attain his end, were as various as can well be imagined.

❯ JESSE QUINN THORNTON on the settlers who were migrating to Oregon, 1846

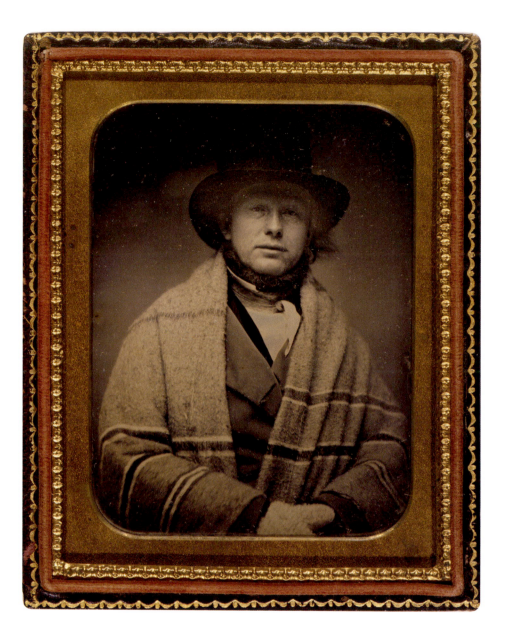

Horace Greeley
(1811–1872)
Born Amherst, New Hampshire

85.

Unidentified photographer

Quarter-plate daguerreotype,
10.7 × 8.2 cm (4 3/16 × 3 1/4 in.),
c. 1850

*National Portrait Gallery,
Smithsonian Institution*

In an 1865 editorial, Horace Greeley, the publisher of the *New York Tribune,* declared, "Go west, young man, go west." Although this statement was probably first uttered by an Indiana journalist in 1851, it succinctly summarized the passion for westward expansion shared by many in the East. Like other journalists of the day, including John O'Sullivan, who prophesied in 1845 that it was America's "manifest destiny" to settle the entire continent, Greeley advocated the exploration and settlement of the West. In 1859 he traveled west by railroad and stagecoach, documenting his journey in a series of articles, one of which called for the construction of a transcontinental railroad. Greeley was famous for his strong opinions on a host of political and cultural issues. Supportive of President Abraham Lincoln, women's rights, and vegetarianism, he also vigorously opposed slavery and the Civil War. (MEF)

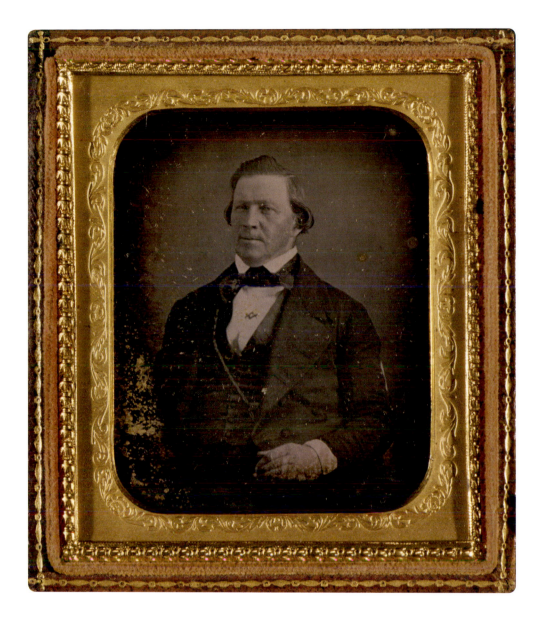

BRIGHAM YOUNG
(1801–1877)
Born Whitingham, Vermont

The second president of the Church of Jesus Christ of Latter-Day Saints, Brigham Young orchestrated the resettlement of the Mormon community in Utah. Fearing further persecution following the murder of founder Joseph Smith in 1844 by an anti-Mormon mob in Illinois, Young and other church leaders decided to start anew in the West. By 1847 the first two thousand settlers had migrated to Salt Lake City. Appointed the territorial governor of Utah by President Millard Fillmore in 1850, Young led the effort to transform the "Promised Valley" into a thriving agricultural community. Relations with the federal government later soured—in part because of the public outcry over the practice of plural marriages—yet Young continued to oversee Mormonism's expansion in the West. By the time of his death, nearly one hundred thousand followers had settled in Salt Lake City and surrounding towns in the Great Basin. (FHG)

86.

Attributed to MARSENA CANNON
(1812–1900)

Sixth-plate daguerreotype,
7.7 × 6.9 cm (3 ⅟₁₆ × 2 ¹¹⁄₁₆ in.),
c. 1850

National Portrait Gallery, Smithsonian Institution; gift of the J. Willard Marriott, Jr., Charitable Annuity Trust

Ann Eliza Young
(1844–after 1908)
Born Nauvoo, Illinois

87.

Thomas Houseworth
(1828–1915)

Albumen silver print,
45.7 × 32.4 cm (18 × 12 ¾ in.),
c. 1875

*Prints and Photographs Division,
Library of Congress, Washington, D.C.*

When Ann Eliza married Brigham Young in 1868, she became the Mormon leader's nineteenth wife. Their marriage was short-lived, however, and five years later Ann Eliza filed for divorce. She claimed that her husband, who had fifty-six children, did not pay enough attention to her two sons from a previous marriage. While the divorce was proceeding in court, Ann Eliza began a multicity lecture tour in which she detailed her life in a polygamous marriage, as well as her opposition more generally to Mormonism. Her lectures coincided with an increasing interest in women's rights, and her outspoken views against her former faith helped influence congressional legislation aimed at outlawing plural marriages. In 1876, she published a popular exposé about Young and Mormonism that chronicled her experiences as "Wife no. 19." After Brigham Young's death the following year, her notoriety waned. (MEF)

JEAN BAPTISTE LAMY
(1814–1888)
Born Lempdes, France

The first archbishop of New Mexico, Jean Baptiste Lamy was an important Roman Catholic leader in the Southwest. Lamy was educated in France and did missionary work in Ohio and Kentucky before being consecrated as a bishop in 1850 and placed in charge of the newly created Vicariate of New Mexico. At first, Lamy was not welcomed by parishioners; however, his determination to reform the New Mexico church, to repair its buildings, and to recruit more clergymen gradually gained him acceptance. Disappointed with the region's low literacy rates, he worked to improve the educational system by staffing it with missionaries. Lamy also supervised much new building for his expanding diocese, including the Cathedral Basilica of Saint Francis of Assisi and the Loretta Chapel, two structures in Santa Fe whose architecture owes more to European designs than the adobe style characteristic of the region. (MEF)

88.

WILLIAM HENRY BROWN
(1844–1886)

Albumen silver print,
16.5 × 11.1 cm (6 ½ × 4 ⅜ in.),
c. 1870

Palace of the Governors, New Mexico History Museum, Santa Fe

JAMES W. MARSHALL
(1810–1885)
Born Mercer County, New Jersey

89.

THOMAS HOUSEWORTH
(1828–1915)

Albumen silver print,
13.3 × 7.6 cm (5 ¼ × 3 in.),
c. 1870

*The Bancroft Library, University of
California, Berkeley*

James W. Marshall's discovery of gold on the South Fork of the American River in January
1848—and President James K. Polk's announcement of the discovery the following
December—precipitated one of the largest and most sudden human migrations in U.S.
history. Over the next several years, more than three hundred thousand people traveled
to California hoping to strike it rich. At the time Marshall—a veteran of the Mexican War
who served under John C. Frémont—was in the midst of constructing a sawmill with his
partner, John Sutter. While the two men initially tried to keep the news quiet, word of
the discovery got out, and the region was soon overrun with miners. Marshall temporarily
abandoned his work as a carpenter to devote attention to his claim and to other prospecting
ventures. Eventually, though, he gave up. Neither he nor Sutter ever profited from the
discovery. (FHG)

JOHN A. SUTTER
(1803–1880)
Born Kandern, Baden

While best known as the person on whose land gold was discovered in 1848, John A. Sutter also made a name for himself as an early pioneer in northern California. Sutter immigrated to the United States as a young man in part to escape financial debts that he had accrued as a store owner in Switzerland. First settling in St. Louis, he traveled to California in 1838 to establish his own colony. In 1841 Mexican governor Juan B. Alvarado granted him nearly fifty thousand acres for this purpose in the previously unsettled Sacramento Valley. Sutter's "New Switzerland" colony attracted numerous settlers and enjoyed a degree of prosperity. The discovery of gold, however, brought a rush of prospectors and ultimately forced him to abandon the community he had founded. A well-respected figure, Sutter was later named the commander of California's militia before retiring to a farm in Pennsylvania. (FHG)

90.

CHARLES M. BELL (1848–1893)

Albumen silver print,
14.6 × 10.5 cm (5 ¾ × 4 ⅛ in.),
c. 1878–1880

George R. Rinhart Collection

LOLA MONTEZ
(1818–1861)
Born Limerick, Ireland

91.

Meade Brothers Studio
(active 1842–1870)

Sixth-plate daguerreotype,
6.4 × 5.1 cm (2 ½ × 2 in.),
c. 1851

*National Portrait Gallery,
Smithsonian Institution; gift of
Mr. and Mrs. Dudley Emerson Lyons*

Lola Montez arrived in New York City from Paris in 1851 with the hope of becoming a famous dancer and actress. However, her notorious reputation as a courtesan and cavorting socialite preceded her. Known for her beauty and her talents in seducing powerful men, Montez attracted audiences who wanted to see the femme fatale in person. After moving to San Francisco in 1853, Montez became famous for her Spider Dance, a performance whose eroticism shocked yet attracted large crowds. During the heyday of the gold rush, Montez performed in mining camp theaters throughout the region. She eventually settled in Grass Valley, California. When she decided several years later to return to San Francisco to begin touring again, her fans gave her a gold nugget as a parting gift. (MEF)

CHINESE MAN

This unidentified Chinese man was photographed during the early years of the California Gold Rush. In this portrait he holds before him his queue, the traditional braid that most Chinese men wore. During the thirty-year period before the passage of the Chinese Exclusion Act in 1882, more than one hundred thousand Chinese people immigrated to the United States. For many, "Gold Mountain"—the Chinese name for California—presented an extraordinary opportunity. Jobs were more plentiful in the West than at home, and some achieved a degree of economic independence. Yet the majority of Chinese endured tremendous hardship and discrimination in their new home. In response to the public outcry regarding "yellow peril," the Chinese were denied basic civil rights, forced into segregated areas, and ultimately, in 1882, denied entry into the United States. Before then, though, the Chinese—recruited to work on the transcontinental railroad's construction or in the mining industry—fulfilled the demand for inexpensive labor. (FHG)

92.

ISAAC WALLACE BAKER
(1810–c. 1862)

Sixth-plate daguerreotype,
8.2 × 6.4 cm (3 ¼ × 2 ¾ in.),
c. 1850

*Oakland Museum of California;
gift of an anonymous donor*

THOMAS STARR KING
(1824–1864)
Born New York City

93.

MATHEW BRADY (1823?–1896)

Half-plate daguerreotype,
14 × 10.6 cm (5 ½ × 4 ³⁄₁₆ in.),
c. 1848

*Prints and Photographs Division,
Library of Congress, Washington, D.C.*

Despite his boyish appearance, Thomas Starr King was a brilliant preacher whose influence went well beyond his congregation. King first established his reputation as a minister in Boston. Although he was courted by churches in several large eastern cities, he decided in 1860 to resettle in San Francisco in part because he viewed the West as a place where his work might have the greatest impact. In a short time he built a large following. Well known for his eloquence about California's natural beauty, King emerged as an important voice in the national political debate for his impassioned words against California's proposed neutrality or possible secession. To rally support and raise money for the Union cause, he traveled widely on a speaking tour throughout the state. President Abraham Lincoln later credited King with saving California from becoming a separate republic. King died at age thirty-nine after contracting diphtheria. (FHG)

DOMINGO GHIRARDELLI
(1817–1894)
Born Rapallo, Italy

A confectioner from Italy, Domingo Ghirardelli established himself as a chocolate merchant in Lima, Peru, before immigrating to California in 1849. Unsuccessful as a miner, Ghirardelli returned to the confectioner's trade shortly thereafter, opening his first shop in Stockton, California. Ghirardelli's business selling chocolate, coffee, and dried fruit proved successful, leading him to open a second store in San Francisco. Although a fire destroyed this establishment in 1851, he rebuilt. Ghirardelli was one of only two chocolate manufacturers in the United States before the Civil War, and his product dominated the western market. By the 1880s he was importing more than 450,000 pounds of cocoa beans a year. The photographer of this carte-de-visite portrait was George H. Johnson, who—like Ghirardelli—relocated to California during the gold rush. He failed also as a prospector, but earned a reputation for opening one of the first photography studios in San Francisco. (ALB)

94.

GEORGE H. JOHNSON (C. 1823–?)

Albumen silver print,

8.9 × 5.5 cm (3 ½ × 2 ³⁄₁₆ in.), 1860

National Portrait Gallery, Smithsonian Institution; gift of Sidney S. Lawrence III, in memory of Polly Ghirardelli Lawrence

LEVI STRAUSS
(1829–1902)
Born Buttenheim, Germany

95.

Attributed to GABRIEL MOULIN
(1872–1945)

Gelatin silver print,
35.6 × 27.9 cm (14 × 11 in.),
c. 1900

*Levi Strauss & Co. Archives,
San Francisco, California*

Levi Strauss's name is synonymous with the iconic jeans he helped to patent in 1873. A German immigrant, Strauss managed his family's dry goods store in San Francisco during the gold rush era. The business provided clothing, fabric, and other merchandise to local stores that supplied provisions to miners. In 1872 a merchant contacted Strauss and described to him the method for reinforcing pants with metal rivets, and the following year the two men received a patent for their innovation. Blue jeans—known then as "waist overalls"—became the preferred clothing for laborers and miners. In addition to being a pioneering entrepreneur in the West, Strauss was also a philanthropist who donated much of his fortune to a variety of San Francisco institutions. This portrait was taken during the period when his popular waist overalls were given the lot number "501," which has become the namesake of his famous jeans. (MEF)

NORTON I.
Emperor of United States and Protector of Mexico.
BRADLEY & RULOFSON. SAN FRANCISCO.

JOSHUA A. NORTON

(c. 1819–1880)

Born London, England

After going bankrupt in 1858 owing to a failed attempt to control a commodities market in San Francisco, Joshua A. Norton proclaimed himself "His Imperial Majesty Norton I, Emperor of the United States and Protector of Mexico." Despite having lost his mental equilibrium, Norton enjoyed a twenty-two-year "reign," during which he used his celebrity status to trumpet San Francisco's virtues and to recommend improvements. Local newspapers published his "decrees," which included a proposal—far-fetched in its day—to build a suspension bridge between Oakland and San Francisco, thus connecting the East Bay to the city. As this photograph shows, Norton often wore a navy commodore's costume and a silk hat with feathers. Period publications described Norton as "the gentlest, most inoffensive, and most agreeable monomaniac that ever lived." It was reported that thirty thousand people attended his funeral, a testament to his extraordinary popularity. (MEF)

96.

HENRY BRADLEY & WILLIAM RULOFSON (active 1863–1878)

Albumen silver print,
16.5 × 11.1 cm (6 ½ × 4 ³⁄₁₆ in.),
c. 1870

The Bancroft Library, University of California, Berkeley

Benjamin Singleton
(1809–1892)
Born Nashville, Tennessee

97.

Unidentified photographer

Albumen silver print,
10.3 × 6 cm (4 ¹⁄₁₆ × 2 ³⁄₈ in.),
c. 1880

Kansas State Historical Society, Topeka

Benjamin Singleton, commonly known as "Pap," believed that the progress of African Americans depended on landownership. Born into slavery, Singleton grew frustrated by the lack of opportunities afforded African Americans after the Civil War. Desirous of starting anew, he and several partners established the Edgefield Real Estate and Homestead Association, and beginning in 1873 they began to scout for parcels of land in the West where an African American community might be born. Over the next several years many freed men began to resettle in Kansas, a location chosen in part because of John Brown's association with the state. With twenty thousand "Exodusters" having emigrated from the South by 1879, Singleton was called before the U.S. Senate to defend this resettlement effort against increasing opposition by white Kansans. In so doing, he became popularly known as "the Moses of the Colored Exodus." While he later proposed establishing a separate black nation in Africa, Singleton spent the remainder of his life in Topeka. (FHG)

JAMES BUTLER HICKOK
(1837–1876)
Born Homer, Illinois

James Butler Hickok received his nickname "Wild Bill" after he shot and killed a man— supposedly in self-defense—during an argument over money in 1861. Seated at the right in this tintype portrait, Hickok served as a scout during the Civil War and later worked in law enforcement in Kansas. Although he accepted William F. Cody's invitation in 1873 to perform together in the play *Scouts of the Plains,* he found the stage was not to his liking and returned to his preferred full-time work as a professional gambler. Back in the West, he earned a wide reputation for his skill as a card player and for his adeptness as a gunfighter. While dime novelists exaggerated many of his feats, he was nonetheless a deadly fighting man. This photograph was taken around 1876, the year Hickok was shot and killed while playing poker in a saloon in Deadwood, Dakota Territory. (MEF)

98.

UNIDENTIFIED PHOTOGRAPHER

Tintype, 20 × 15.2 cm
(7 ⅞ × 6 in.), c. 1876

*National Portrait Gallery,
Smithsonian Institution*

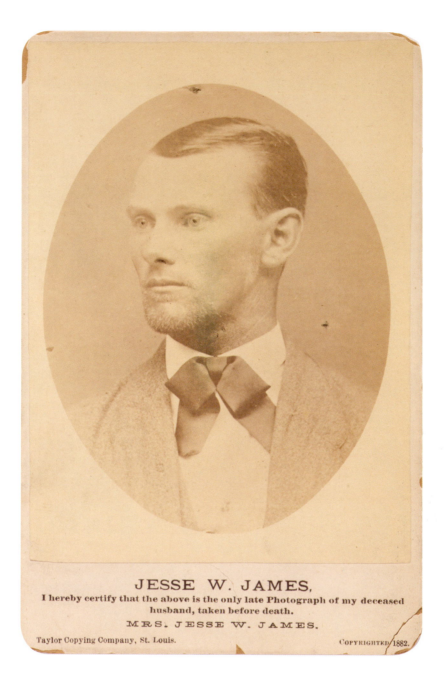

JESSE W. JAMES,
I hereby certify that the above is the only late Photograph of my deceased husband, taken before death.
MRS. JESSE W. JAMES.

Taylor Copying Company, St. Louis. COPYRIGHTED 1882.

JESSE JAMES
(1847–1882)
Born Clay County, Missouri

99.

UNIDENTIFIED PHOTOGRAPHER

Albumen silver print, 13.7 × 10 cm
(5 ⅜ × 3 ¹⁵⁄₁₆), 1882

National Portrait Gallery,
Smithsonian Institution

This portrait of Jesse James was marketed to audiences not long after the famous outlaw's assassination in 1882 at the age of thirty-four. Given James's elusiveness, his wife provided confirmation that it was he who was pictured in this photograph. James's life of violence began when he became a member of a Confederate guerrilla group as a teenager—along with his older brother, Frank—in part to avenge an assault on his family by Union troops during the Civil War. After the war, James failed to return to the life of a law-abiding citizen and instead began robbing banks and trains in Missouri. A Kansas City newspaper editor who supported James's Confederate sympathies transformed his criminal activities into sensationalized fiction and made James appear more as a forgivable Robin Hood figure than the unrepentant bandit that he was. (MEF)

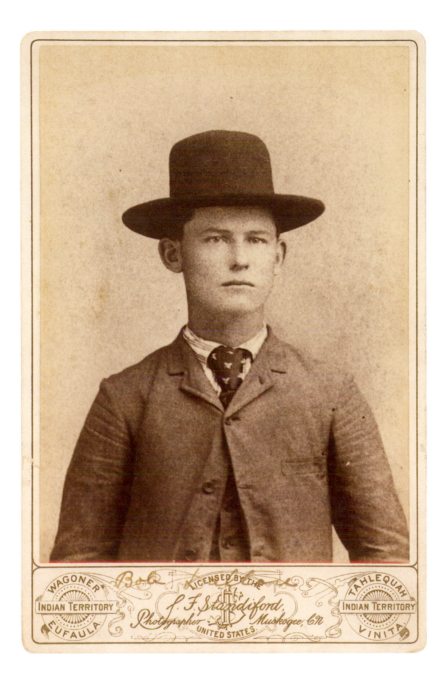

ROBERT DALTON
(1869–1892)
Born Cass County, Missouri

Following his older brothers into law enforcement, Robert Dalton became a deputy U.S. marshal in the so-called Indian Territory in 1889, the year when this portrait is thought to have been taken. However, after a dispute with his superiors, Dalton left this job and entered into a brief yet memorable career as a bank and train robber. He teamed with several brothers, first striking targets in California before returning to the southern plains. The "Dalton Gang" made national headlines for their audacious, often violent crimes and were frequently compared to the earlier band of outlaws led by Jesse and Frank James. Dalton's life as a desperado did not last long. In 1892, he and three other gang members were gunned down by citizens of Coffeyville, Kansas, during a daring double bank robbery. Dalton was twenty-three years old. (FHG)

100.

J. F. STANDIFORD
(lifedates unknown)

Albumen silver print,
13.8 × 9.8 cm (5 $7/16$ × 3 $7/8$ in.),
c. 1889

National Portrait Gallery,
Smithsonian Institution

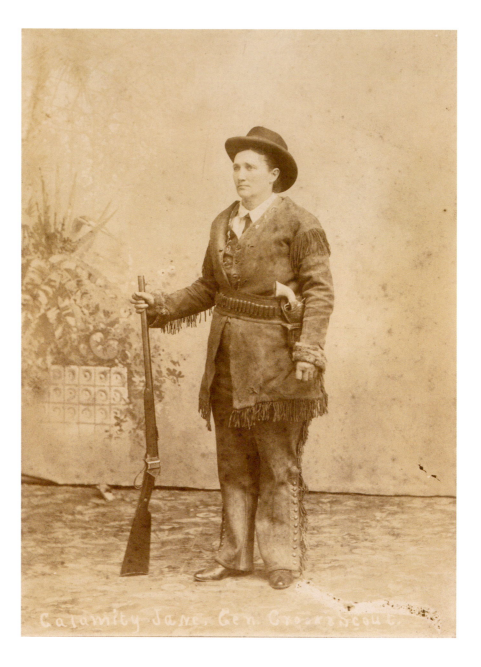

CALAMITY JANE
(1852–1903)
Born Princeton, Missouri

101.

GEORGE W. POTTER
(lifedates unknown)

Printing-out paper print,
13.7 × 9.9 cm (5 ⅜ × 3 ⅞),
c. 1896

*National Portrait Gallery,
Smithsonian Institution*

Born Martha Cannary, Calamity Jane earned her nickname for her riotous behavior and her unladylike appearance. Though much of her life is shrouded in myth, she lived a transient's existence, moving frequently from one small town to another and working in a series of menial jobs. She spent several years in Deadwood, South Dakota, where she was known for her dalliances in brothels, her romantic association with Wild Bill Hickok, and her appetite for alcohol. Yet Calamity Jane also demonstrated genuine concern for the poor and the sick, offering sympathy and relief when others failed to help. At age twenty-five she gained a national profile when she was featured as a sidekick to the character of Deadwood Dick in the first of several dime novels. She died in 1903, most likely of alcoholism, and is buried next to Hickok in a Deadwood cemetery. (MEF)

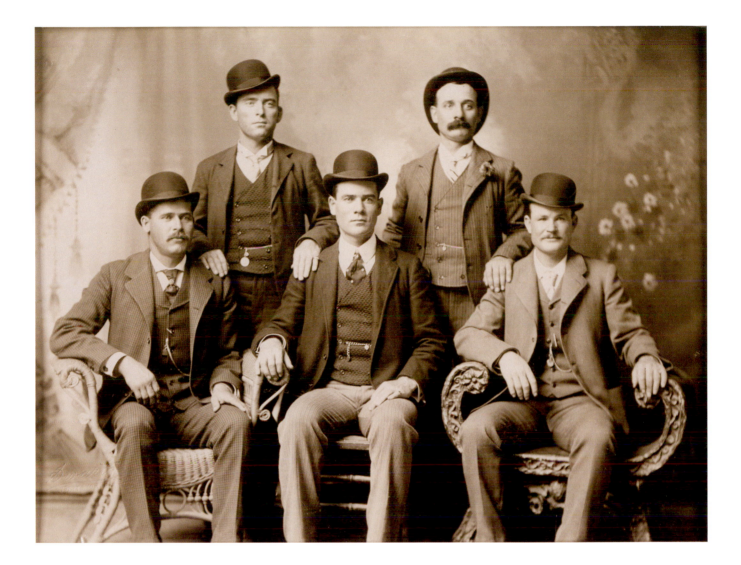

THE WILD BUNCH

Seated, left to right: Harry Longabaugh ("The Sundance Kid"), c. 1870–1909?
Ben Kilpatrick ("The Tall Texan"), ?–1912
Robert LeRoy Parker ("Butch Cassidy"), c. 1866–1909?
Standing, left to right: William Todd Carver, ("Bill") 1866–1901
Harvey Logan ("Kid Curry"), 1865–1903

According to western lore, after robbing a Nevada bank in 1900 and escaping with more than
$30,000, the Wild Bunch outfitted themselves in dapper suits and sat for this group portrait,
copies of which were sent to the bank and the Pinkerton Detective Agency as a joke. The Wild
Bunch, also known as the "Hole in the Wall Gang," had a varied membership; however, the
most notorious members are shown in this group portrait. The heist of the Nevada bank was
one of their most successful robberies and one of their final jaunts as a group. Butch Cassidy
and the Sundance Kid later escaped to South America, where they continued their life of
crime. Their brazen robberies and repeated escapes from law enforcement made the Wild
Bunch famous in their day. Since then, Hollywood has transformed this group of outlaws into
mythic American icons. (MEF)

102.

JOHN SWARTZ
(lifedates unknown)

Gelatin silver print,
16.7 × 21.6 cm (6 %₁₆ × 8 ½ in.),
1900

*National Portrait Gallery,
Smithsonian Institution; gift of
Pinkerton's, Incorporated*

Laura Bullion
(c. 1876–1961)
Born Texas

103.

Unidentified photographer

Gelatin silver print, 10.2 × 6.4 cm
(4 × 2 ½ in.), c. 1901

*National Portrait Gallery,
Smithsonian Institution; gift of
Pinkerton's, Incorporated*

After Laura Bullion's arrest in 1901 for her participation in a Montana train robbery, a St. Louis policeman who was booking her remarked, "I wouldn't think helping to hold up a train was too much for her. She is cool, shows absolutely no fear, and in male attire would readily pass for a boy." Bullion was found with forged banknotes and, after being charged, spent the next two and a half years in prison. She admitted to police that her accomplices in the robbery were Harry Longabaugh (the Sundance Kid) and Ben Kilpatrick (the Tall Texan). Though women do not figure prominently in the history of western crime, Bullion was closely associated with the Wild Bunch and helped the gang in numerous robberies. This mugshot of Bullion was made by the police following her arrest in St. Louis. (MEF)

FORM 100-6-¹10-10M-AH.

P. N. D. A. No:

Name...... *A. E. Miner*

Alias *George Andersen*

Residence...... *Billings, Montana*

Nativity...... *Canada* *White*

Occupation...... *Miner*

Criminal Occupation...... *Train Robber*

Age...... *60 1911 (1.4.0.)* Height...... *5' 10" or 11"*

Weight...... *140* Build...... *Slender*

Complexion...... *Swarthy*

Color of Hair...... *Sandy, gray mixed*

Eyes...... *Long, thin*

Style of Beard...... *Mustache*

Color of Same...... *Sandy, gray mixed*

Date of Arrest...... *February 23, 1911*

Where Arrested...... *Gainesville, Ga.*

Crime Charged...... *Train Robbery*

Peculiarities of Build...... *Stoop Shoulders*

Features, Scars, Marks, Baldness, Etc...... *Upper and lower teeth false. India ink star tattooed on left leg 3" below knee. Dancing girl tattooed left arm.*

WILLIAM MINER

(1847–1913)

Born Bowling Green, Kentucky

This mug shot of the criminal William Miner comes from the archive of the Pinkerton Detective Agency. On the photograph's reverse, it lists Miner's occupation as "train robber," his complexion as "swarthy," and notes that he has a "dancing girl tattooed on his left arm." Despite being jailed on numerous occasions, he always returned to his criminal habits upon being released or escaping from prison. Miner began his career as a prospector and a Pony Express rider but was jailed in 1866 for holding up a stagecoach. When he was not in prison, Miner spent much of the next forty-seven years engaged in some type of robbery scheme. Although he worked principally in the West, this photograph was created in Georgia after his arrest for holding up a Southern Express train. Despite his wide reputation for prison breaks, the sixty-eight-year-old Miner escaped several months later. He was captured shortly thereafter and died in prison in 1913. (FHG)

104.

UNIDENTIFIED PHOTOGRAPHER

Gelatin silver print, 7.6 × 4.8 cm (3 × 1 ⅞ in.), c. 1911

National Portrait Gallery, Smithsonian Institution; gift of Pinkerton's, Incorporated

RICHARD H. PRATT
(1840–1924)
Born Rushford, New York

105.

Job N. Choate (1848–1902)

Albumen silver print,
14.9 × 10 cm (5 ⅞ × 3 ¹⁵⁄₁₆ in.),
1880

*National Portrait Gallery,
Smithsonian Institution*

This group photograph was taken at the Carlisle Indian School in 1880. It includes the school's founder and superintendent, Richard H. Pratt, seated on the steps of a wooden bandstand alongside the Lakota chief Spotted Tail and three unidentified Quaker women from Philadelphia. A soldier who first saw action during the Civil War and later in several campaigns against hostile Native American groups in the West, Pratt believed that formal education was vital to the future welfare of tribal communities. In 1879, while still in the U.S. Army, Pratt established a school in Carlisle, Pennsylvania, where he hoped to transform Native American boys and girls into acculturated and law-abiding citizens. His educational philosophy of forced assimilation owed much to his experiences in the military. As he once explained, he believed it was necessary to "kill the Indian to save the man." (FHG)

SARAH WINNEMUCCA
(1844?–1891)
Born western Nevada

Sarah Winnemucca was one of the ablest and most energetic advocates for Native American rights during the decade of the 1880s, a period replete with crises involving her tribe. The daughter of a prominent Northern Paiute chief, she learned English as a child and used this knowledge to mediate diplomatic exchanges between Paiute leaders and government officials. Concerned about the mistreatment of Native peoples throughout the American West, she delivered more than three hundred public lectures during an 1883 speaking tour in the East. That same year she also authored *Life Among the Piutes: Their Wrongs and Claims*, a book that chronicled the abuses sustained by her tribe from corrupt government agents. Winnemucca used the resulting proceeds to found a school for Paiute children near Lovelock, Nevada. This photograph was created in Baltimore during a stop on her 1883 tour. (FHG)

106.

NORVAL BUSEY
(1845–after 1926)

Albumen silver print,
17.6 × 10.1 cm (6 $^{15}/_{16}$ × 4 in.),
1883

*National Portrait Gallery,
Smithsonian Institution*

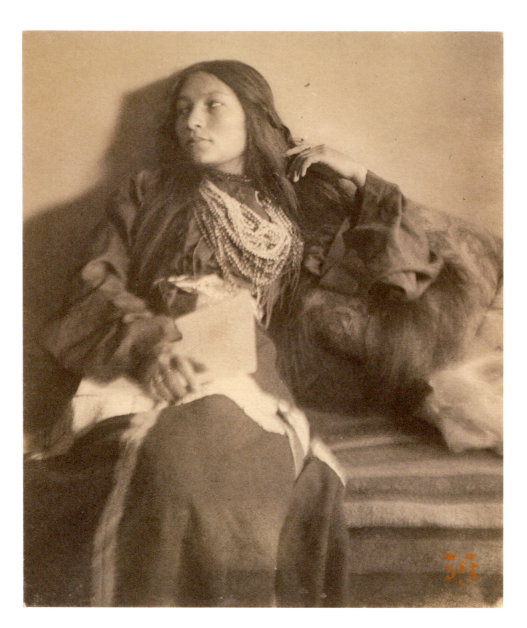

Zitkala-Ša
(1876–1938)
Born on the Yankton reservation, Dakota Territory

107.

Joseph T. Keiley (1869–1914)

Glycerin-developed platinum
print, 12.4 × 10.3 cm
(4 ⅞ × 4 1/16 in.), 1898

*National Portrait Gallery,
Smithsonian Institution*

This portrait pictures Zitkala-Ša—also known as Gertrude Bonnin—at age twenty-two during a period when she taught at the Carlisle Indian School in Pennsylvania. Though she left Carlisle to study violin at the prestigious New England Conservatory of Music, she is best remembered not as a musician but rather as a writer and political activist. In 1900 she began publishing short stories and essays about her childhood and about the issues then affecting Native Americans. Following her marriage in 1902, she resettled in the West, where she worked for the Bureau of Indian Affairs, led community service programs, and taught school again. In 1916, Zitkala-Ša was elected secretary of the Society of American Indians, an appointment that prompted her to move to Washington, D.C. There she worked on various Native American campaigns, including the effort that led to the passage of the Indian Citizenship Act in 1924. (FHG)

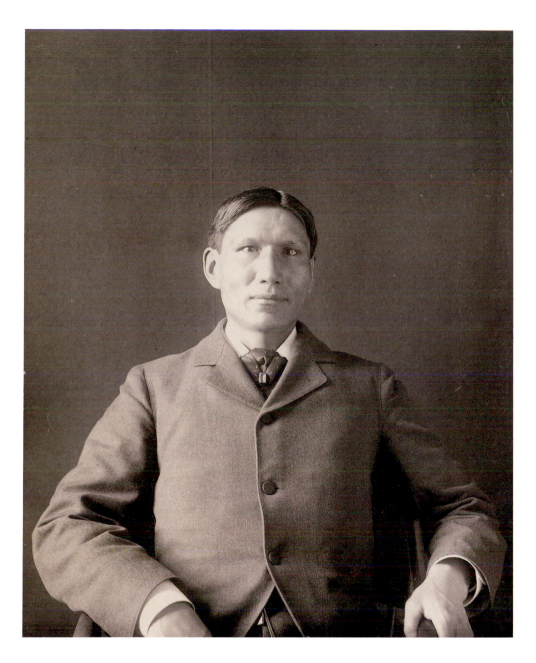

CHARLES EASTMAN
(1858–1939)
Born near Redwood Falls, Minnesota

Charles Eastman was a leading voice for Native peoples at the beginning of the twentieth century. He left home at an early age to attend schools in the Midwest and the East, including Boston University, from which he received a degree in medicine. After graduation, Eastman settled in South Dakota, where he worked as a government doctor on the Pine Ridge Reservation. During this period he became actively involved in national debates about various Native issues. This work prompted Eastman—together with Carlos Montezuma and Arthur Parker—to found in 1911 the Society of American Indians, an organization meant to promote the rights and publicize the achievements of Native Americans. This group was also instrumental in the campaign that led to the passage of the Indian Citizenship Act in 1924. An avid writer, Eastman published several books that offered readers insight into Native history and culture. (MEF)

108.

WELLS MOSES SAWYER
(1863–1960)

Platinum print, 21.9 × 17.8 cm (8 ⅝ × 7 in.), 1897

National Anthropological Archives, Smithsonian Institution

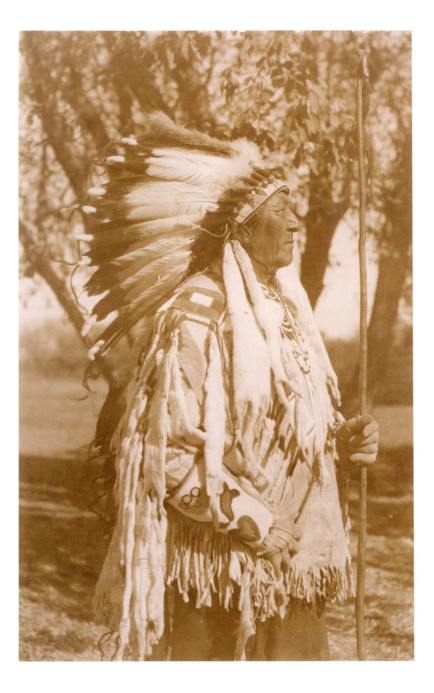

Plenty Coups
(c. 1848–1932)
Born near present-day Billings, Montana

109.

Willem Wildschut
(1883–1955)

Gelatin silver print, 91.4 × 61 cm
(36 × 24 in.), c. 1921

*National Portrait Gallery,
Smithsonian Institution; gift of
Ruth and Vernon Taylor Foundation,
Beatrice and James Taylor*

A celebrated warrior as a young man, Plenty Coups played a crucial role in leading the Crow during the difficult transition to reservation life. As a chief, Plenty Coups stressed the importance of education as a means to maintain tribal integrity and urged his people to become self-sufficient farmers. Although he converted to Catholicism, he revered and sought to carry on the religion and traditional folkways of the Crow. Plenty Coups is thought to have posed for this photograph at the outset of his 1921 trip to Washington, D.C. On that occasion, he served as the Native American representative at the burial of the unknown soldier of World War I at Arlington National Cemetery. Three years later, in part because of the Native contribution to the war effort, the landmark Indian Citizenship Act was passed, thereby granting full U.S. citizenship to all Native Americans. (FHG)

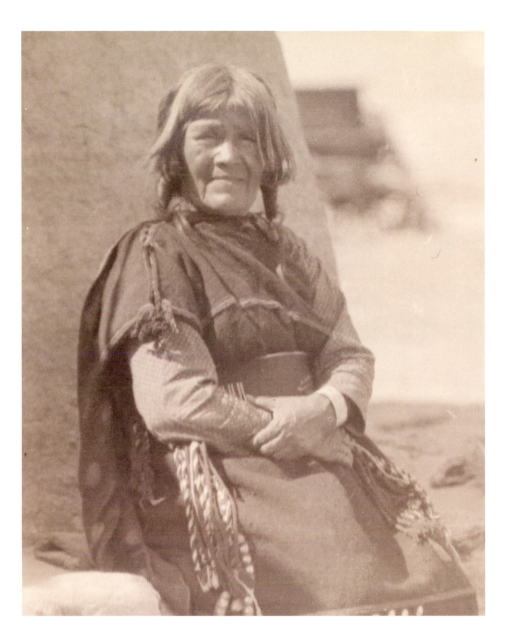

NAMPEYO
(c. 1859–1942)
Born Hano in present-day Arizona

Growing up on the Hopi reservation, Nampeyo was encouraged to pursue the art of ceramics by her grandmother, a well-respected artist. By the century's end she had earned a reputation as one of the finest potters in the Southwest. During this period, archaeological excavations of prehistoric sites in the region were unearthing potsherds from the distant past, and Nampeyo found inspiration in these relics' traditional designs. While she developed a style that honored the past, she also experimented with materials and introduced innovative shapes and decorative elements in her pottery. Her work was widely collected by institutions such as the Smithsonian and also by the growing number of tourists who visited the Southwest. She became so popular that both the Santa Fe Railroad and the Fred Harvey Company—which operated a chain of western hotels and restaurants—incorporated her portrait and her pottery in their advertising. (FHG)

110.

ARNOLD GENTHE (1869–1942)

Gelatin silver print,
24.2 × 19.2 cm (9 ½ × 7 9/16 in.),
1926

*National Portrait Gallery,
Smithsonian Institution*

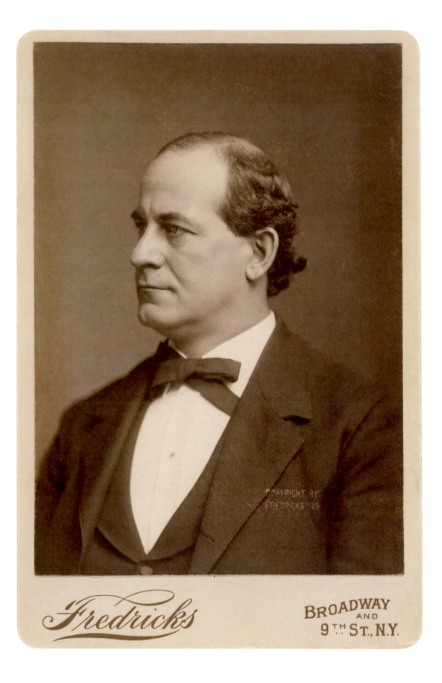

William Jennings Bryan
(1860–1925)
Born Salem, Illinois

111.

Charles DeForest Fredricks
(1823–1894)

Carbon print, 14.1 × 9.8 cm
(5 ⁹⁄₁₆ × 3 ⅞ in.), 1889

*National Portrait Gallery,
Smithsonian Institution*

Nicknamed the "Boy Orator of the Platte," William Jennings Bryan emerged at the nineteenth century's end as the leading political voice for voters in the West. Bryan's rise to fame began with his election to Congress in 1890. A lifelong Democrat, the Nebraska representative also shared much common ground with members of the newly created Populist Party. His support for government ownership of the railroads and limited inflation through coinage of both silver and gold won him wide support in the West. An energetic campaigner whose "Cross of Gold" speech at the 1896 Democratic Convention propelled him to the presidential nomination, Bryan was ultimately defeated that year by Republican William McKinley. He ran unsuccessfully for president on two other occasions. Famous for his devout religious views and his role as a political crusader, Bryan was also known as "the Protestant Pope," a label given him by satirist H. L. Mencken. (FHG)

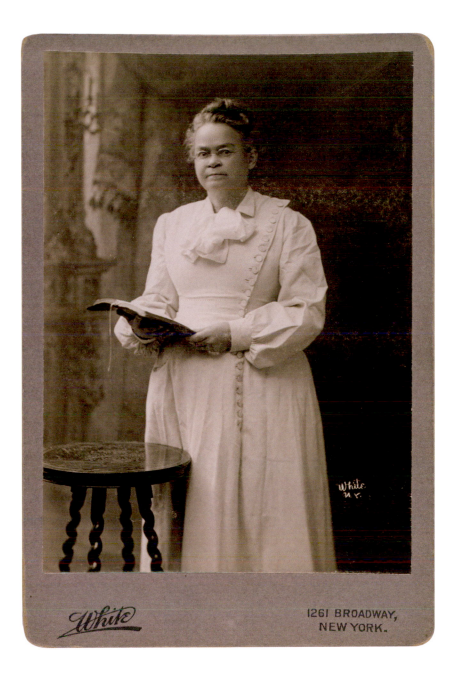

Carrie Nation

(1846–1911)

Born Garrard County, Kentucky

"She fears no man, counts no cost, asks no quarter, and gives none to friend or foe," exclaimed a fellow reformer about Carrie Nation, the temperance leader renowned for using direct action to shut down illegal saloons. After Nation's first marriage broke up on account of her husband's alcoholism, she remarried and settled in Kansas, a state that had banned liquor sales in 1880. Concerned that prohibition was only lightly enforced, she founded a local chapter of the Woman's Christian Temperance Union and began a campaign for more vigorous prosecution of state liquor laws. When moral suasion failed to curb illegal activity, she turned first to public demonstrations and later to outright vandalism against offending saloons. Most famously, Nation stormed into barrooms wielding a hatchet that she used to break bottles and disrupt business. Often arrested and fined, she attracted national attention to the temperance cause. (FHG)

112.

White Studio
(active 1903–1936)

Gelatin silver print, 14.1 × 9.8 cm
(5 9/16 × 3 7/8 in.), c. 1903

National Portrait Gallery,
Smithsonian Institution

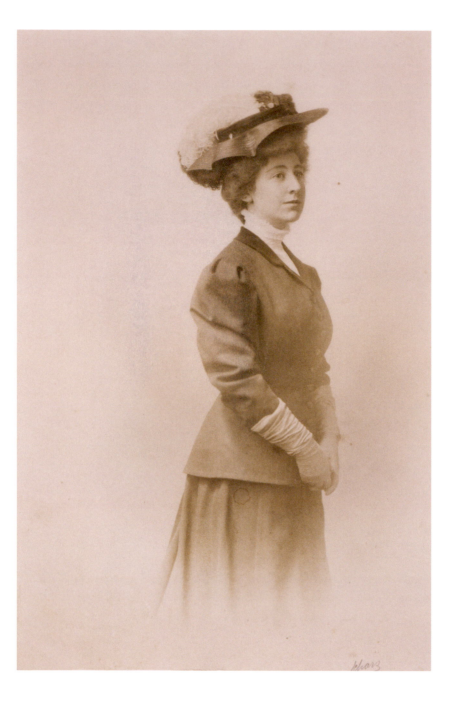

JEANNETTE RANKIN
(1880–1973)
Born near Missoula, Montana

113.

L. CHASE (lifedates unknown)

Gelatin silver print, 17.2 × 11 cm
(6 ¾ × 4 ⁵⁄₁₆ in.), c. 1917

*National Portrait Gallery,
Smithsonian Institution; gift of
Margaret Sterling Brooke*

In 1916 Jeannette Rankin of Montana became the first woman elected to serve in the U.S. Congress. Before her milestone victory, Rankin had gained valuable political experience traveling widely on behalf of the campaign for women's suffrage. During her congressional race, she made support for this issue—together with child protection and national prohibition—the centerpiece of her platform. Rankin served two nonconsecutive terms and was the only member of Congress to vote against the country's entry into World War I and World War II. In 1918 she lost her bid for election to the Senate in part because of her unpopular stance on the war. A lifelong pacifist, Rankin opposed all war "because we've never settled any dispute by fighting." Her political success owed much to the opportunities afforded many women in the West during this period. (ALB)

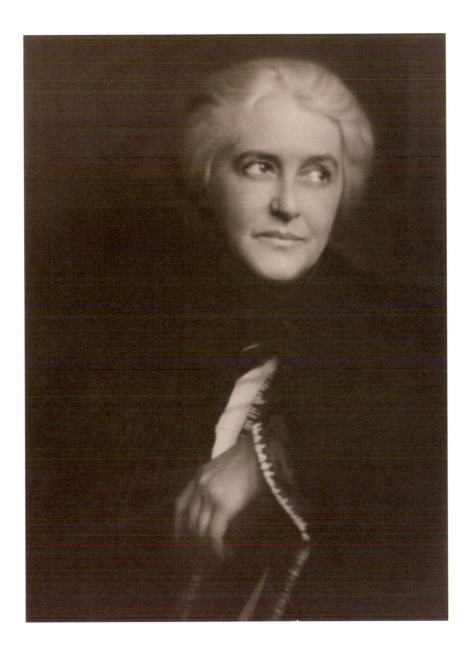

SARA BARD FIELD
(1883–1974)
Born Cincinnati, Ohio

In September 1915, Sara Bard Field—newly divorced from her first husband—embarked on a cross-country automobile trip from San Francisco to Washington, D.C. Her goal was to promote women's suffrage. At each stop along her route, rallies were held and signatures were added to a petition. Field often encountered suffrage opponents who heckled and disrupted these gatherings. Equally challenging were the poor road and weather conditions she endured in her open-air Oldsmobile. Four months after her departure, Field arrived at the White House, where she and fellow supporters delivered to President Woodrow Wilson more than half a million signatures to provide for a federal suffrage amendment. While Wilson did not back the amendment, this event was well received in the press and contributed to growing support that ultimately led to the ratification of the Nineteenth Amendment in 1920. (ALB)

114.

JOHAN HAGEMEYER (1884–1962)

Gelatin silver print, 23 × 16.6 cm
(9 1/16 × 6 9/16 in.), 1927

*National Portrait Gallery,
Smithsonian Institution*

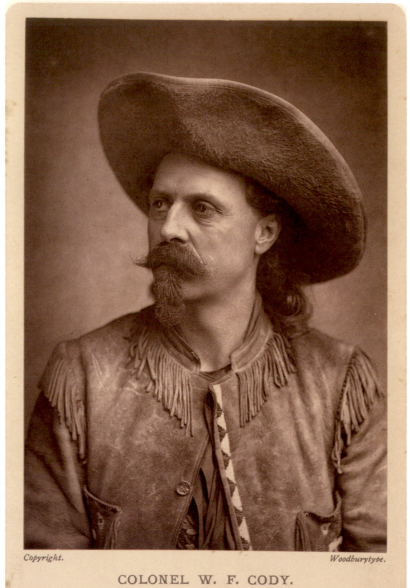

Copyright. Woodburytype.

COLONEL W. F. CODY.
"Buffalo Bill."

William F. Cody
(1846–1917)
Born Scott County, Iowa

115.

Unidentified photographer

Woodburytype, 14.1 × 9.7 cm
(5 9/16 × 3 13/16 in.), 1887

*National Portrait Gallery,
Smithsonian Institution*

William F. Cody did arguably more than any single individual to popularize the myth of the American West. Before achieving international fame as a showman, he worked a variety of short-term jobs, including serving as a Pony Express rider, an army scout, and a hunting guide. Nicknamed "Buffalo Bill" because of his prowess in hunting buffalo, Cody entered the world of entertainment after a dime novelist in New York wrote a story about his exploits in the West. A subsequent offer to appear on stage led first to a theatrical career and ultimately to the creation in 1883 of his touring Buffalo Bill Wild West show. For the next thirty years he was the centerpiece of this wildly popular display that combined rodeo and historical reenactment. This photograph was created in 1887, the year Cody first toured his Wild West show in Europe. (FHG)

→✴ **ANNIE OAKLEY.** ✴←
(LITTLE SURE SHOT.)

J. WOOD, Photo., 208 Bowery, N. Y.

ANNIE OAKLEY
(1860–1926)
Born Darke County, Ohio

Outfitted for this portrait in a homemade floral-embroidered skirt and matching blouse, sharpshooter Annie Oakley balanced and perfected the dual roles as a performer and a domestically well-versed woman during a time in which it was considered uncouth for proper women to use firearms or perform on stage. For seventeen years beginning in 1885, the year when this photograph is believed to have been taken, Oakley was a major attraction in Buffalo Bill's Wild West show. Widely admired for her shooting skills—the Lakota leader Sitting Bull gave her the nickname "Little Sure Shot"—she was also applauded for her adherence to Victorian etiquette, like riding sidesaddle. Oakley personified the western cowgirl who could outshoot a man during the day and cook a roast for her husband at night. (MEF)

116.

JOHN WOOD (active 1865–1890)
Albumen silver print,
14.2 × 10.2 cm (5 9/16 × 4 in.),
c. 1885

*National Portrait Gallery,
Smithsonian Institution; acquired
through the generosity of friends of the
Department of Photographs*

WILLIAM S. HART
(1870–1946)
Born Newburgh, New York

117.

UNIDENTIFIED PHOTOGRAPHER

Gelatin silver print,
23.9 × 18.8 cm (9 ⁷⁄₁₆ × 7 ⅜ in.),
c. 1917

*National Portrait Gallery,
Smithsonian Institution*

Having worked on cattle ranches as a young man growing up in the Midwest, actor William S. Hart brought a degree of authenticity to his roles as a western cowboy and an outlaw. An accomplished stage actor on Broadway, Hart moved to California in 1913 to act in *The Bargain,* the first of more than thirty western-themed movies in which he starred. Hart wanted his films to be as realistic as possible, and he insisted on performing his own stunts. In many of these works, crooked government officials interfere with the business of settling the frontier—a not-so-subtle commentary on contemporary western politics. By the mid-1920s, movies with more action, younger actors, and less symbolism eclipsed Hart's films. This portrait of Hart holding a revolver and wearing a Mountie-style hat and scarf captures the classic cowboy image that he popularized during the 1910s and 1920s. (MEF)

TOM MIX
(1880–1940)
Born Mix Run, Pennsylvania

Tom Mix began his career in entertainment working menial jobs for wild west shows in Oklahoma and Texas. However, his background in wrangling horses and his charismatic personality soon led to his discovery by Hollywood producers. Regarding the authenticity he brought to his work, Mix remarked, "If you don't believe in your role, then you won't impress the public." He starred in his first silent film in 1909 and eventually appeared in more than three hundred movies, principally in the western and action genres. Even when he was not acting, the actor maintained his on-screen persona and wore western-style clothing. By the late 1920s, when sound was introduced into films, Mix left the big screen to tour with several circuses in which he was the main attraction. This photograph was taken to publicize his work in the 1918 film *Mr. Logan, U.S.A.* (MEF)

118.

UNIDENTIFIED PHOTOGRAPHER

Gelatin silver print, 16 × 22.1 cm (6 5/16 × 8 11/16 in.), 1918

Prints and Photographs Division, Library of Congress, Washington, D.C.

GLORIA SWANSON
(1897–1983)
Born Chicago, Illinois

119.

KARL STRUSS (1886–1981)

Platinum print, 23.6 × 18 cm
(9 5/16 × 7 1/16 in.), 1919

*National Portrait Gallery,
Smithsonian Institution*

Known as the "Queen of the Screen," Gloria Swanson was one of Hollywood's first female stars. She often played the role of the seductive siren, a part that at times mirrored her own personal life. Married six times, she pursued her career as a silent film actress with great ambition. Swanson arrived in California in 1915 to work with Mack Sennett; however, she made her most lasting contribution with the famed Paramount director Cecil B. DeMille. Ever mindful of her public image, Swanson played an active role in choosing her leading men and approving her publicity. Numerous successful films made her one of the top-paid actresses of the day, though her popularity declined following the introduction of talkies in the late 1920s. This photograph by Karl Struss was created to promote her performance in DeMille's 1919 film *Male and Female*. (MEF)

CECIL B. DeMILLE
(1881–1959)
Born Ashfield, Massachusetts

Although Cecil B. DeMille trained as a stage actor and originally knew nothing about making motion pictures, he directed one of the first full-length films in Hollywood in 1914, an adaptation of a western play titled *The Squaw Man*. The previous year, DeMille had formed a partnership with Jesse Lasky and Samuel Goldwyn in the production company that later became Paramount Pictures. A pioneering director and producer, he made seventy films over the course of his career and, as one critic wrote in 1925, earned a reputation as "a fearsome figure who may be loved or hated, but who must always be obeyed." Challenging traditional storylines, his films often caused outrage among some who believed he sacrificed his own morality for commercial success. In this publicity photograph by Karl Struss, DeMille wears his trademark director's uniform, which included riding boots and pants. (MEF)

120.

KARL STRUSS (1886–1981)

Gelatin silver print, 21 × 16.2 cm (8 ¼ × 6 ⅜ in.), 1919

National Portrait Gallery, Smithsonian Institution

Karl Struss
(1886–1981)
Born New York City

121.

Edward Weston (1886–1958)

Toned platinum print,
18.9 × 20.6 cm (7 7⁄16 × 8 ⅛ in.),
1923

*National Portrait Gallery,
Smithsonian Institution*

Raised in New York and educated in the art of photography by Clarence White and Alfred Stieglitz, Karl Struss enjoyed critical success as a photographer before choosing to move to California in 1919 to start a second career in film. In addition to making publicity portraits of celebrities, he began working with director Cecil B. DeMille as a cinematographer. Struss served as the lead cameraman in many early silent films, including the epic drama *Ben-Hur* (1925). He was instrumental in establishing cinematography as a new field, and during a career that lasted more than fifty years he worked on more than 140 movies. While Struss was largely focused on cinematography, he still devoted time to fine art photography in California, where he befriended Edward Weston, the creator of this 1923 platinum print. (MEF)

CHRONOLOGY

1845 New York journalist John L. O'Sullivan writes an essay urging the United States to annex the Republic of Texas because it was America's "manifest destiny to overspread and to possess . . . the continent which Providence has given us for the . . . great experiment of liberty."

At the year's end Mexico severs diplomatic relations with the United States following the decision by the United States to annex Texas. President James K. Polk sends General Zachary Taylor to the Mexican border.

1846 In March John C. Frémont begins his third expedition into the West, during which he will proclaim California an independent republic. The "Bear Flag Revolt" ends quickly when U.S. naval forces arrive in Monterey and claim California for the United States.

In May war breaks out between Mexico and the United States when a Mexican force crosses the Rio Grande and attacks a U.S. cavalry patrol.

The United States acquires Oregon Territory from Britain in June, establishing the territory's northern border at the forty-ninth parallel.

Following the death of Joseph Smith by a mob in Carthage, Illinois, in 1844 and subsequent violence directed toward Mormon followers, Brigham Young leaves Illinois to establish a new settlement in the West.

1847 In January Mexican authorities surrender control of California.

General Zachary Taylor is victorious at the Battle of Buena Vista in February, and the Mexican army is forced to retreat. General Winfield Scott and his forces land at and occupy the town of Veracruz the following month.

In July Brigham Young arrives in the Great Salt Lake Valley in Utah with an advance party.

1848 In January James W. Marshall discovers gold in California's American River. When President James K. Polk announces the news in December, the California Gold Rush begins.

In February the Treaty of Guadalupe Hidalgo between the United States and Mexico is signed, thereby ending the Mexican War. It stipulates that Mexico transfer much of the present-day American Southwest for $15 million.

1849 Francis Parkman's *The Oregon Trail* is published.

More than eighty thousand forty-niners arrive in California by the year's end, nearly tripling the territory's population. Domingo Ghirardelli abandons prospecting and opens a general store in Stockton and later one in San Francisco, where he begins selling chocolate.

1850 California enters the Union as a free state following the passage of the Compromise of 1850.

President Millard Fillmore names Brigham Young the territorial governor of Utah.

Bayard Taylor's *Eldorado, or Adventures in the Path of Empire* is published.

New Mexico becomes a U.S. territory. French priest Jean Baptiste Lamy is made the bishop of the diocese of Santa Fe.

1851 The United States signs the Fort Laramie Treaty with representatives of various Plains tribes. The treaty calls for peace and divides the region into designated tracts for different Native groups. In return, the United States agrees to protect them and to grant each tribe $50,000 annually for the next fifty years.

1852 William Fargo and Henry Wells establish Wells, Fargo & Company to provide mail service and transportation to California.

Washington becomes a U.S. territory.

1853 James Gadsden, the U.S. minister to Mexico, negotiates the purchase of additional land in the Southwest for $10 million to be used for a proposed transcontinental railroad.

William Walker leads a "filibustering" expedition to Baja California and proclaims it the Republic of Lower California. Mexican forces drive him back over the border, and the plan is scuttled.

1854 The Kansas-Nebraska Act is passed, overturning the Missouri Compromise of 1820 and permitting each territory to choose whether it will permit slavery.

1855 Abolitionist John Brown and his followers engage in a series of deadly skirmishes with pro-slavery forces in Kansas.

1856 Explorer John C. Frémont is nominated as the first Republican candidate for the presidency but loses to James Buchanan.

Settler Olive Oatman is freed after five years of captivity with the Apaches.

1857 Kansas citizens reject the pro-slavery Lecompton Constitution.

After complaints regarding the Mormon practice of polygamy, President James Buchanan orders troops to Utah to ensure that federal laws are being obeyed. The "Mormon War" ends a year later.

1858 Gold is discovered in Colorado, and the Pikes Peak Gold Rush begins.

1859 Oregon enters the Union as a free state.

Silver is discovered in Nevada at the Comstock Lode.

The Atchison, Topeka, and Santa Fe Railroad is chartered.

Albert Bierstadt accompanies a surveying expedition led by General Frederick Lander to Wyoming and begins his career as a painter of the West.

1860 The Pony Express is established, providing regular mail service from St. Louis to San Francisco. The service ends a year later, eclipsed by a transcontinental telegraph line.

President Buchanan vetoes a proposed homestead bill that will provide federal land grants to western settlers. Later that fall Abraham Lincoln is elected president.

1861 In April the Civil War begins when southern states agree to secede from the Union.

Kansas enters the Union as a free state. Colorado and Nevada become U.S. territories. Texas joins the Confederacy, and Governor Sam Houston is forced out of office.

Photographer Carleton Watkins travels into the Yosemite Valley for the first time.

1862 In a series of legislative acts, President Abraham Lincoln passes the landmark Homestead Act, establishes the land grant college system, and signs legislation authorizing the creation of the transcontinental railroad along the forty-second parallel.

In the aftermath of a revolt by Dakota tribesmen in Minnesota, thirty-eight Dakotas are hanged in what stands as the largest mass execution in U.S. history.

An army of Texas Confederates invade New Mexico but are ultimately defeated by John Chivington's Colorado volunteer military regiment.

1863 On January 1, President Lincoln issues the Emancipation Proclamation.

Led by Colonel Patrick Edward Connor, a U.S. Army regiment attacks a Shoshone winter village in present-day Idaho. During the so-called Bear River massacre, approximately 250 Shoshones are killed.

Arizona and Idaho become U.S. territories.

1864 President Lincoln signs a bill granting the Yosemite Valley and the Mariposa Gove to the state of California, the first time such a designation is made for the preservation of public land.

Nevada enters the Union. Montana becomes a U.S. territory.

John Chivington heads an attack on a Cheyenne encampment; his forces kill nearly two hundred, leading to widespread criticism and a congressional investigation.

Colonel Christopher "Kit" Carson leads a campaign to subdue the Navajos in New Mexico. Following their surrender, eight thousand Navajos endure the infamous "Long Walk" from their homelands to the distant Bosque Redondo Reservation near Fort Sumner.

1865 The Civil War ends with the Confederate surrender in Virginia. General William T. Sherman takes command of the military in the West.

Mark Twain publishes his short story "The Celebrated Jumping Frog of Calaveras County."

In an editorial in the *New York Tribune,* Horace Greeley popularizes the expression "Go west, young man, go west." An Indiana journalist had uttered this phrase fourteen years earlier.

1866 Red Cloud and his Lakota followers attack U.S. forces along the newly established Bozeman Trail.

Cattlemen Charles Goodnight and Oliver Loving establish a seven-hundred-mile cattle trail from Fort Sumner, New Mexico, to Fort Worth, Texas.

Jesse and Frank James rob their first bank in Liberty, Missouri.

1867 Nebraska enters the Union.

The United States purchases Alaska from Russia.

The first cattle drive from Texas to the rail station in Abilene, Kansas, is conducted.

The Medicine Lodge Treaty is signed with several tribes from the southern plains, and reservations are designated in the so-called Indian Territory.

1868 The second Treaty of Fort Laramie is signed, bringing to an end "Red Cloud's War" and granting the Lakotas a reservation in parts of South Dakota, Wyoming, and Montana.

Wyoming becomes a U.S. territory.

The *Overland Monthly* magazine begins publication in San Francisco.

Ann Eliza Young marries Mormon leader Brigham Young, becoming his nineteenth wife. She files for divorce five years later and writes a popular exposé about Mormonism.

1869 John Wesley Powell leads the first American exploring expedition through the Grand Canyon.

In May the Central Pacific and Union Pacific railroads are connected at Promontory Point, Utah. The completion of the transcontinental railroad is marked with a great "Golden Spike" celebration.

Wyoming becomes the first territory or state to grant women the right to vote. Utah enacts this right the following year.

1870 A California court rules that a black child may not attend a white school.

Bret Harte publishes *The Luck of Roaring Camp and Other Sketches*.

1871 President Ulysses S. Grant signs the Indian Appropriations Act. Native American tribes will no longer be treated as sovereign nations but will be designated "wards" of the federal government.

Artist Thomas Moran joins Ferdinand V. Hayden's survey expedition into Yellowstone.

1872 Congress designates Yellowstone as America's first national park.

In November the Modoc War begins in northern California. Peace is negotiated by the following April.

Mark Twain publishes *Roughing It*.

1873 Benjamin "Pap" Singleton begins the effort to establish an African American community in Kansas for recently emancipated slaves. "Exodusters" begin to migrate to Kansas.

Congress passes the Timber Culture Act to encourage tree planting in the West.

Entrepreneur Fred Harvey opens his first restaurant for railroad passengers in Topeka, Kansas.

Levi Strauss patents his namesake jeans in San Francisco.

San Francisco premieres cable cars.

1874 Illinois farmer Joseph Glidden receives a patent for barbed wire.

George A. Custer leads an expedition into the Black Hills of present-day South Dakota, violating terms of the Treaty of Fort Laramie. His announcement of the discovery of gold prompts a gold rush.

1875 Comanche and Kiowa leaders surrender to U.S. authorities to mark the end of the Red River War.

1876 During the Black Hills War, Lakota warriors under the command of Sitting Bull and Crazy Horse fight U.S. troops in South Dakota, Wyoming, and Montana. At the Battle of the Little Bighorn, George Custer and his Seventh Cavalry are defeated; however, U.S. forces ultimately force the Lakotas to surrender.

Colorado enters the Union.

James "Wild Bill" Hickok is shot and killed while playing poker in Deadwood, Dakota Territory.

1877 Joseph leads his Nez Percé followers in retreat from U.S. military forces. Passing through Yellowstone National Park en route to Canada, Joseph ultimately surrenders to Nelson Miles only thirty miles from the border.

Congress votes to repeal the 1868 Fort Laramie Treaty.

1878 Military forces under General Oliver Howard force the Bannocks back onto their Idaho reservation, ending the Bannock War.

1879 The U.S. Geological Survey is founded, and Clarence King is named its first director. The Bureau of Ethnology—under the leadership of John Wesley Powell—is also created to study the Native peoples of the West.

Anthropologist Frank Hamilton Cushing begins a five-year sojourn among the Zunis in New Mexico.

Richard H. Pratt establishes the United States Indian Training and Industrial School in Carlisle, Pennsylvania, to educate and acculturate Native American children.

1880 Kansas lawmakers sign prohibition legislation outlawing the sale of alcohol.

1881 Sitting Bull and his Lakota followers return from Canada and surrender to U.S. authorities.

Helen Hunt Jackson publishes *A Century of Dishonor*.

Artist Frederic Remington makes his first trip to the West.

1882 The outlaw Jesse James is killed by Robert Ford, who hopes to collect a $5,000 reward.

Congress passes the Chinese Exclusion Act, prohibiting Chinese immigration and the naturalization of Chinese men and women already in the United States.

1883 Sarah Winnemucca publishes *Life Among the Piutes: Their Wrongs and Claims*.

The Northern Pacific Railroad—the second transcontinental railroad—is completed nineteen years after it was first authorized.

William F. "Buffalo Bill" Cody begins to tour his first Wild West show.

1884 After the recent deaths of his mother and his wife, Theodore Roosevelt travels to Dakota Territory with an interest in becoming a cattle rancher.

1885 Annie Oakley begins performing as a sharpshooter in Buffalo Bill's Wild West show.

Railroad magnate Leland Stanford founds a university in California in memory of his recently deceased son.

In Rock Springs, Wyoming, miners attack a community of Chinese workers, killing more than two dozen and requiring federal intervention.

1886 Apache leader Geronimo surrenders to U.S. authorities under the command of General Nelson Miles and is imprisoned at Fort Marion in Florida.

Artist Charles M. Russell exhibits his first western paintings in St. Louis.

1887 Congress passes the General Allotment Act, also known as the Dawes Act, imposing a private land ownership system on Native American tribes.

Congress passes the Edmunds-Tucker Act, disincorporating the Mormon Church and undermining its political and economic authority.

Photographer Frank J. Haynes accompanies the first American expedition into Yellowstone National Park during the winter.

William Cody's Wild West show makes its first tour of Europe.

1888 Cattle ranchers on the northern plains suffer huge losses following a harsh winter and a dry summer.

Anthropologist Franz Boas makes his first trip to the Pacific Northwest to study that region's Native communities.

1889 Paiute religious leader Wovoka begins to teach the Ghost Dance to followers, alarming settlers about possible renewed hostilities between Native tribes and American settlers.

President Benjamin Harrison decrees that unoccupied lands in Indian Territory are open to settlement, precipitating the Oklahoma Land Rush.

Washington, Montana, North Dakota, and South Dakota join the Union.

1890 Wyoming and Idaho enter the Union.

With the support of naturalist John Muir, Congress designates Yosemite a national park.

In December, Sitting Bull is killed in a confrontation with reservation police at his Standing Rock home. Two weeks later federal troops engage his fellow Lakotas, killing Chief Big Foot and roughly three hundred followers at Wounded Knee Creek in the last major military conflict during the "Indian Wars."

1891 The Forest Reserve Act is passed, allowing states to set aside public forests.

1892 John Muir helps to found the Sierra Club to "protect the nation's scenic resources."

The National Populist Party is formed, with a platform calling for government ownership of the railroads, free coinage of silver, and the secret ballot.

1893 Citing data from the 1890 census, historian Frederick Jackson Turner declares the closing of the western frontier at a meeting of the American Historical Association in Chicago.

Naturalists estimate that fewer than two thousand buffalo remain from a herd that once numbered more than twenty million. Rampant hunting—encouraged by a government-sponsored extermination program—is to blame.

The Western Federation of Miners is established following a labor dispute in Idaho.

1894 Congress passes the Carey Desert Land Act, granting one million public acres to each western state for the purpose of promoting agriculture.

Sears, Roebuck and Company begins its mail order business in Chicago.

1896 Utah enters the Union.

Nebraska congressman and populist William Jennings Bryan launches a presidential campaign, and his "Cross of Gold" speech against the gold standard makes him a favorite in the West. He loses the election to Republican candidate William McKinley.

1897 News of gold's discovery in Alaska prompts the last major gold rush. Writer Jack London joins other miners headed to the Klondike.

1898 Hawaii is annexed by the United States.

1899 Photographer Edward S. Curtis accompanies a scientific expedition to Alaska led by Edward H. Harriman.

 Following the conclusion of the Spanish-American War, the United States annexes the Philippines.

1900 Galveston, Texas, is devastated by a hurricane.

1901 Bank and train robbers Robert Parker ("Butch Cassidy") and Harry Longabaugh ("The Sundance Kid") escape to South America after a string of holdups.

 Frank Norris publishes *The Octopus: A California Story*.

 Oil is discovered in Texas.

1902 President Theodore Roosevelt signs the Newlands Reclamation Act, authorizing federal construction of dams and reservoirs in the West.

 Owen Wister publishes *The Virginian*.

1903 Jack London publishes *The Call of the Wild*.

 Mary Austin publishes *Land of Little Rain*.

 The first "western" film, *The Great Train Robbery*—directed by Edwin S. Porter—is released.

1904 Railroad magnate James J. Hill is found in violation of the Sherman Antitrust Act and forced to dissolve the holding company that controls his various business enterprises.

1905 The U.S. Forest Service is established, and Gifford Pinchot is named its first head.

 William "Big Bill" Haywood of the Western Federation of Miners helps to found the Industrial Workers of the World with the goal of uniting working-class laborers in one large union.

1906 San Francisco is devastated by a giant earthquake and fires, leaving 250,000 homeless.

 President Roosevelt signs the Preservation of American Antiquities Act, allowing for the protection of certain historic and natural landmarks.

 The "See America First" advertising campaign is launched to promote tourism in the West.

1907 Edward S. Curtis publishes the first of his twenty-volume photographic study, *The North American Indian*.

 Oklahoma enters the Union.

1908 Arizona's Grand Canyon is designated a national monument.

1909 The center of the burgeoning film industry begins to shift from New York to Los Angeles.

 Strikes led by the Industrial Workers of the World largely shut down the Montana timber industry.

 Tom Mix acts in his first silent film, *The Cowboy Millionaire*.

1910 Glacier National Park is established in Montana.

1911 The Society of American Indians is established by Charles Eastman and others to serve as an advocacy group for Native Americans.

Franz Boas publishes *The Mind of Primitive Man*.

1912 Arizona and New Mexico enter the Union.

Zane Grey publishes *Riders of the Purple Sage*.

1913 Cecil B. DeMille and others form a production company that will later become Paramount Pictures.

William S. Hart appears in his first western film, *The Bargain*.

The construction of the Los Angeles Aqueduct is completed under the supervision of engineer William Mulholland.

Willa Cather publishes *O Pioneers!*

1914 National Guardsmen and striking miners clash in Ludlow, Colorado, and eighteen are killed.

The Panama Canal is completed.

Edward S. Curtis releases his silent film *In the Land of the Head Hunters*.

1915 Sara Bard Field completes a cross-country automobile trip collecting signatures for a women's suffrage petition that she delivers to President Woodrow Wilson.

1916 Seattle businessman William Boeing founds the Boeing Airplane Company.

Congress creates the National Park Service.

Jeannette Rankin of Montana becomes the first woman elected to serve in the U.S. Congress.

1917 The United States enters World War I.

1918 The Native American Church is incorporated in Oklahoma with Frank Eagle as its first president.

1919 Labor strikes in Seattle effectively close the city.

1920 The Nineteenth Amendment—granting women the right to vote—is ratified.

The Mineral Leasing Act is passed, encouraging the development of mining on public lands in the West.

1921 Congress passes the Federal Highway Act, authorizing equal matching funds to states for highway construction.

In May a race riot breaks out in Tulsa, Oklahoma.

1922 An agreement is reached on the division of water to states through which the Colorado River flows.

1923 The sign HOLLYWOODLAND is built in the Hollywood hills to advertise the new housing market in the area.

Construction of the controversial Hetch Hetchy Dam in Yosemite National Park is completed.

A scandal over oil reserves at Teapot Dome in Wyoming reveals widespread corruption in the administration of recently deceased President Warren G. Harding.

1924 Congress passes the Indian Citizenship Act, extending citizenship to all Native Americans born in the United States or its territories.

As part of the National Origins Act, Congress establishes the U.S. Border Patrol to stop the flow of illegal immigrants crossing the border into the United States. This legislation continues the ban on Chinese immigration.

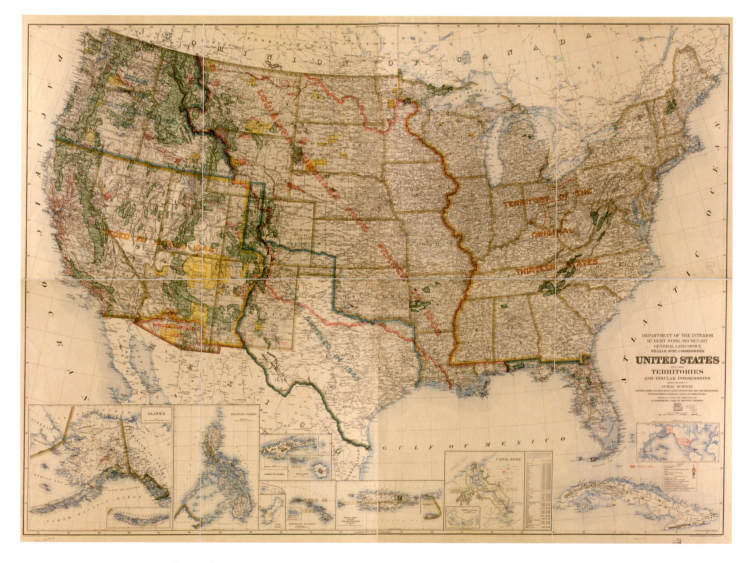

United States including territories and insular possessions, 1923
General Land Office
Geography and Map Division, Library of Congress, Washington, D.C.

For Further Reading

Western History

Aron, Stephen. *American Confluence: The Missouri Frontier from Borderland to Border State*. Bloomington: Indiana University Press, 2006.

Blackhawk, Ned. *Violence over the Land: Indians and Empires in the Early American West*. Cambridge, Mass: Harvard University Press, 2006.

Brooks, James. *Captives and Cousins: Slavery, Kinship, and Community in the Southwest Borderlands*. Chapel Hill: University of North Carolina Press, 2001.

Cronon, William. *Nature's Metropolis: Chicago and the Great West*. New York: W. W. Norton, 1991.

Deloria, Philip. *Playing Indian*. New Haven, Conn.: Yale University Press, 1998.

Faragher, John Mack. *Women and Men on the Overland Trail*. New Haven, Conn.: Yale University Press, 1979.

Goetzmann, William. *Exploration & Empire: The Explorer and the Scientist in the Winning of the American West*. New York: W. W. Norton, 1966.

Johnson, Susan. *Roaring Camp: The Social World of the California Gold Rush*. New York: W. W. Norton, 2000.

Limerick, Patricia. *The Legacy of Conquest: The Unbroken Past of the American West*. New York: W. W. Norton, 1987.

Montejano, David. *Anglos and Mexicans in the Making of Texas, 1836–1986*. Austin: University of Texas Press, 1987.

Ostler, Jeffrey. *The Plains Sioux and U.S. Colonialism from Lewis and Clark to Wounded Knee*. Cambridge, Mass.: Cambridge University Press, 2004.

Pascoe, Peggy. *Relations of Rescue: The Search for Female Moral Authority in the American West, 1874–1939*. New York: Oxford University Press, 1990.

Slotkin, Richard. *The Fatal Environment: The Myth of the Frontier in the Age of Industrialization, 1800–1890*. New York: Atheneum, 1985.

Smith, Sherry. *Reimagining Indians: Native Americans through Anglo Eyes, 1880–1940*. New York: Oxford University Press, 2000.

Spence, Mark David. *Dispossessing the Wilderness: Indian Removal and the Making of the National Parks*. New York: Oxford University Press, 1999.

Streeby, Shelley. *American Sensations: Class, Empire, and the Production of Popular Culture*. Berkeley: University of California Press, 2002.

Takaki, Ronald. *Strangers from a Different Shore: A History of Asian-Americans*. Boston: Little Brown, 1989.

Taylor, Quintard. *In Search of the Racial Frontier: African Americans in the American West, 1528–1990*. New York: W. W. Norton, 1999.

Truett, Samuel. *Fugitive Landscapes: The Forgotten History of the U.S.–Mexico Borderlands.* New Haven, Conn.: Yale University Press, 2006.

West, Elliot. *The Contested Plains: Indians, Goldseekers, and the Rush to Colorado.* Lawrence: University Press of Kansas, 1998.

White, Richard. *"It's Your Misfortune and None of My Own": A New History of the American West.* Norman: University of Oklahoma Press, 1991.

WESTERN PHOTOGRAPHY

Bernardin, Susan et al. *Trading Gazes: Euro-American Women Photographers and Native North Americans, 1880–1940.* New Brunswick, N.J.: Rutgers University Press, 2003.

Castleberry, May et al. *Perpetual Mirage: Photographic Narratives of the Desert West.* New York: Abrams, 1996.

Faris, James. *Navajo and Photography: A Critical History of the Representation of an American People.* Albuquerque: University of New Mexico Press, 1996.

Fleming, Paula, and Judith Luskey. *The North American Indians in Early Photographs.* New York: Harper & Row, 1986.

Gidley, Mick. *Edward S. Curtis and the North American Indian, Incorporated.* New York: Cambridge University Press, 1998.

Goodyear, Frank. *Red Cloud: Photographs of the Lakota Chief.* Lincoln: University of Nebraska Press, 2003.

Hales, Peter. *William Henry Jackson and the Transformation of the American Landscape.* Philadelphia: Temple University Press, 1988.

Jensen, Richard, R. Eli Paul, and John Carter. *Eyewitness at Wounded Knee.* Lincoln: University of Nebraska Press, 1991.

Johnson, Drew Heath, and Marcia Eymann, eds. *Silver & Gold: Cased Images of the California Gold Rush.* Iowa City: University of Iowa Press, 1998.

Kelsey, Robin. *Archive Style: Photographs and Illustrations for U.S. Surveys, 1850–1890.* Berkeley: University of California Press, 2007.

Kilgo, Dolores, A. *Likeness and Landscape: Thomas M. Easterly and the Art of the Daguerreotype.* St. Louis: Missouri Historical Society Press, 1994.

Lee, Anthony. *Picturing Chinatown: Art and Orientalism in San Francisco.* Berkeley: University of California Press, 2001.

Nickel, Douglas. *Carleton Watkins: The Art of Perception,* New York: Abrams, 1999.

Phillips, Sandra et al. *Crossing the Frontier: Photographs of the Developing West, 1849 to the Present.* San Francisco: Chronicle Books, 1996.

Respini, Eva. *Into the Sunset: Photography's Image of the American West.* New York: Museum of Modern Art, 2009.

Sandweiss, Martha. *Print the Legend: Photography and the American West.* New Haven, Conn.: Yale University Press, 2002.

Williams, Carol. *Framing the West: Race, Gender, and the Photographic Frontier in the Pacific Northwest.* New York: Oxford University Press, 2003.

INDEX

Faces *of the* Frontier
Photographic Portraits from the American West, 1845-1924

Pages i and 33: Details of *Map of the United States of America . . .* (1849), by George Woolworth Colton (1827–1901). Geography and Map Division, Library of Congress, Washington, D.C.

Frontispiece: Detail of *Self-portrait* (1872), by William Henry Jackson (catalogue, p. 79).

All National Portrait Gallery images and those on pages 44, 51, 103, and 133 photographed by Mark G. Gulezian

Copyedited by Jody Berman

Text design and composition by Julie Rushing
 Set in Chaparral Pro

Jacket design by Tony Roberts

Image prepress by University of Oklahoma Printing Services

Printed by CS Graphics Pte. Ltd., Singapore
 Printed on Gold East Matt